POSE!

1,000 Poses for Photographers and Models

D1217914

POSE!

1,000 Poses for Photographers and Models

rockynook

MEHMET EYGI

POSE!
1,000 Poses for Photographers and Models
Mehmet Eygi

Editor: Joan Dixon
Translation: Jeremy Cloot
Interior design: Christine Netzker
Production layout: Kim Scott, Bumpy Design
Cover design: Aren Straiger
Project manager: Lisa Brazieal
Marketing coordinator: Mercedes Murray

ISBN: 978-1-68198-428-5
1st Edition (1st printing, November 2018)

English language edition © 2019 by Rocky Nook, Inc.
Authorized translation from the German edition:
© 2016 by Rheinwerk Verlag GmbH, Bonn, Germany
Title: "POSEN! Das Buch für Fotografen und Models" by Mehmet Eygi
(German ISBN: 978-3-8362-4040-6)

Rocky Nook, Inc.
1010 B Street, Suite 350
San Rafael, CA 94901
USA

www.rockynook.com

Distributed in the U.S. by Ingram Publisher Services
Distributed in the UK and Europe by Publishers Group UK

Library of Congress Control Number: 2018952203

Preface

What? Yet another posing book? There are already quite a few such books available, and it is no longer news that a photographer has to work hard to get a model to pose right. However, I have many things to share that are sure to make your next shoot a success!

What is different about this book?
This book features an array of models demonstrating over 1,000 poses, and it includes sections on themes such as Beauty, Curvy Boudoir, Business, Sports, and Children. However, what is really exciting are the common threads you will recognize as you work through the poses, such as best practices for hands, feet, and head positions, as well as things to watch out for.

Poses for any model and every photographic idea
This book isn't simply about giving you a bunch of poses to copy. It is designed to help you gain the knowledge and intuition you need to work instinctively. You will learn about the nuances of beauty, fashion, and business poses, and you'll get to know tricks and techniques that you can apply in any situation. Every section includes tips on how to turn each pose into a dozen new ones—all you need to do is work systematically on your skills.

Successful posing, quick and easy
Whether you work behind the camera or in front of the lens, you will learn all about professional posing and how to work with confidence. Once you are up to speed, you can concentrate on the important stuff, which is creating beautiful, persuasive, and surprising images.

Have a great shoot!
Mehmet Eygi

Table of Contents

Preface, v About the Author, viii Using This Book, ix

WOMEN

	POSES	PAGE
Portraits	001–018	4
Beauty	019–030	24
Fashion	031–052	38
Lingerie	053–074	62
Implied Nude	075–082	86
Curvy	083–092	96
Curvy Boudoir	093–102	108
Sports	103–112	120
Business	113–122	132
Wall	123–134	144

MEN

	POSES	PAGE
Portraits	135–144	160
Fashion	145–158	172
Implied Nude	159–166	188
Sports	167–175	198
Business	176–187	208
Wall	188–193	222

COUPLES

	POSES	PAGE
Portraits	194–205	232
Fashion	206–213	246
Implied Nude	214–220	256
Sports	221–226	264

EXPECTING

	POSES	PAGE
Baby Belly Single	227–234	274
Baby Belly Couple	235–241	284

FAMILIES

	POSES	PAGE
Mom, Dad, and Baby	242–251	294
New Family	252–257	306
Children	258–267	314

About the Author

Mehmet Eygi is an entrepreneur, photographer, creative director, and consultant based in Cologne, Germany. After studying communications, product design, and photography, he worked for large international photo studios as a consultant and creative director. One of his responsibilities was to review photo shoots with clients. What began as a means of quality control soon developed into a passion for people photography. After photographing nearly a thousand different subjects, Mehmet began to recognize a common problem: Photographers and models each have their own level of posing skills, and this determines the results of a photo shoot.

Mehmet decided to develop standardized practices for posing techniques. He self-published an eBook to teach these essential lessons, and the book immediately took off. His approach proved to be so successful that publishers have brought the book to market in German and French, and now in English.

With his new company, Sedcard24.com, Mehmet has created a specialized marketing tool for models and actors: printed and digital comp cards for use as a quick presentation of their portfolios. He is currently building a search engine for models, which will make it easy for photographers all over the world to find models nearby.

Using This Book

Three **variations** on the main pose show how the look and feel of the pose can be varied.

The **main image** demonstrates the basic pose and includes tips for the model and the photographer.

The **poses** are numbered sequentially to help you find your way through the book.

There are three **icons*** that tell you how versatile a pose is.

This is the **description** of the current pose, which also includes general tips on posing for the current section's theme. This part is for the photographer who is directing the model.

#019

FRAME A FACE

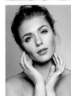
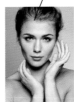
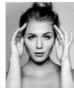

The title says it all. Here, the model uses her hands and fingers to create an aesthetically pleasing frame for her face. Unlike the previous *Framing a Face* pose (#017), this time she barely touches her face. The gesture is not designed to accentuate the model's looks, but rather the purity of her skin. This is why it is best to imply skin contact with just a single finger of each hand. Avoid having her press on or dent her skin with her fingers.

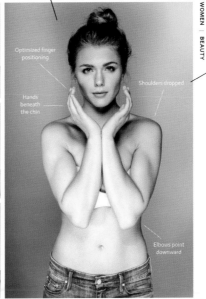

WOMEN | BEAUTY

Optimized finger positioning

Hands beneath the chin

Shoulders dropped

Elbows point downward

25

Here you will find **tips** for the model and the photographer. Note which side of the body the tip refers to and—for example—whether just one or both shoulders are mentioned. References to front, back, right, and left are as seen from the model's viewpoint. Note that these references may no longer apply if you alter the position of the camera.

*

 This pose can be successfully photographed from a variety of camera angles.

 This pose works universally for women, men, and children.

 This pose is also ideal for curvy models.

WOMEN

Portraits | Beauty | Fashion | Lingerie |
Implied Nude | Curvy | Curvy Boudoir |
Sports | Business | Wall

PORTRAITS

Always accentuate a model's most attractive attributes, and work with the characteristics that make each individual special.

001

LEGS TOGETHER

Poses with legs and feet close together have a soft, feminine feel. Once you have positioned the model's legs, concentrate on her torso and arms. Combined with a good head position and an appropriate facial expression, you will end up with a nice soft pose. A straight back is just as important here as it is in the more masculine version (see #002).

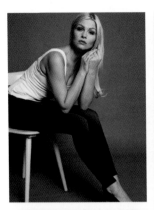

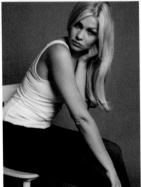

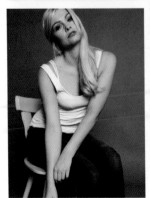

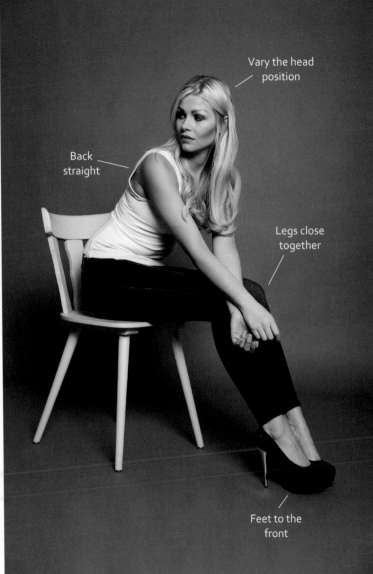

Vary the head position

Back straight

Legs close together

Feet to the front

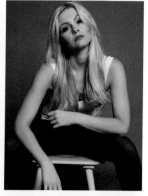

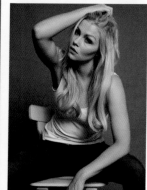

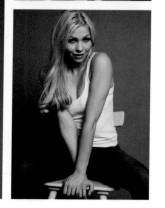

Back straight

Elbows in

Legs apart

Feet to the front

A TOUGH ATTITUDE

Compare the difference between this pose and #001. With her legs apart, the model presents a more confident, masculine look. This is because the pose is more rigid and the model commands more space. The model can rest her hands or elbows on her thighs, or try out different positions for her hands.

#005

WATCH YOUR BACK

Is a straight back always exactly what you want in a pose? A straight back makes a model look strong, confident, and resolute, but what about poses that present a more emotional, casual, or thoughtful look? Compare the main image with variation #1 to see the difference that even a slightly slumped position produces. Changes like this enable you to control the energy level of a pose.

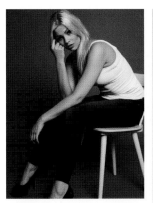

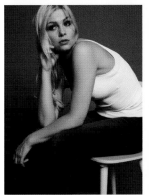

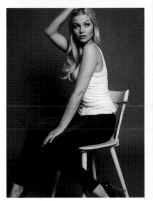

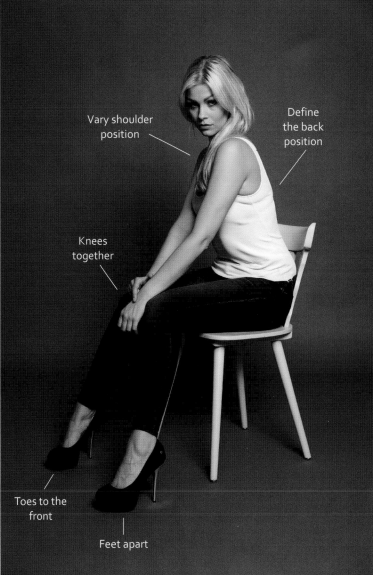

Vary shoulder position

Define the back position

Knees together

Toes to the front

Feet apart

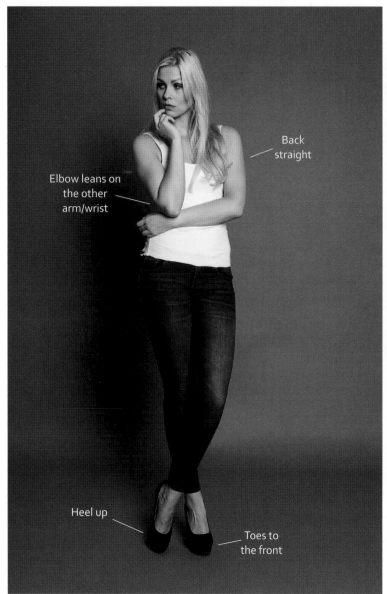

Back straight

Elbow leans on the other arm/wrist

Heel up

Toes to the front

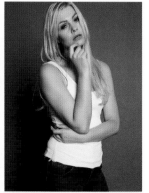

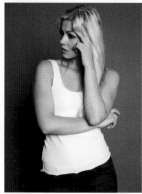

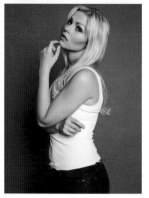

THE THINKER

Portrait poses often involve resting one arm on the other. One hand, finger, or fist is sometimes positioned at the model's temple, under her chin, or supporting her jaw. An experienced model's free hand will also look good. Make sure your model doesn't rest her elbow in the palm of her other hand, however, as this often looks unnatural and can easily spoil an image. Ideally, she should rest her elbow on or in front of her other wrist. Make sure she positions the fingers of both hands elegantly.

#007

THINKING ABOUT...

This a great, natural-looking pose. The model isn't trying to strike a perfect pose that carries a message, but instead communicates an emotion. To help your model with expressions, try calling out adjectives such as surprised, contented, happy, disappointed, hurt, arrogant, or thoughtful. Everyone has memories of these kinds of feelings that they can call up and use to shape a pose.

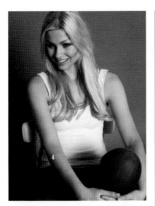

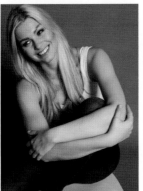

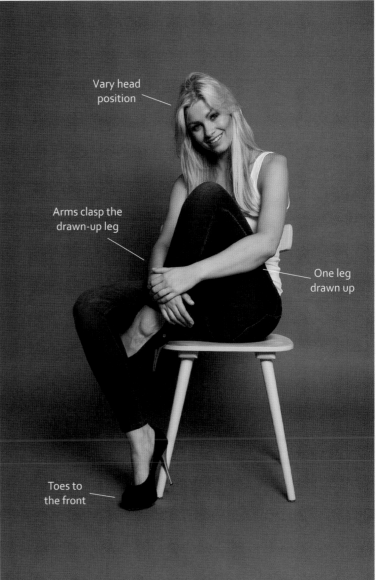

Vary head position

Arms clasp the drawn-up leg

One leg drawn up

Toes to the front

11

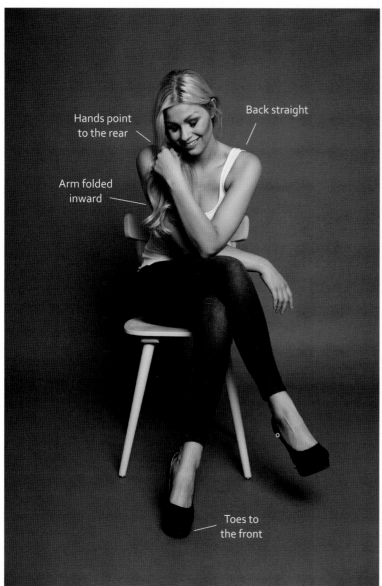

Hands point to the rear

Back straight

Arm folded inward

Toes to the front

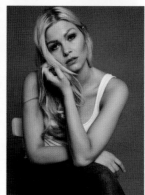

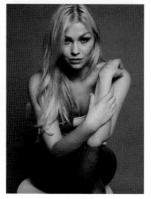

ELBOWS ON LEGS

In a sitting position, with her elbows on her legs, your model can let her hands fall loosely or draw them up and back toward her chin, neck, or hair. For this pose, it is important that the model leans forward while retaining a degree of tension in her torso so that she doesn't droop. Make sure that hand contact with her chin or cheek is light to avoid producing dips or folds in her skin. The same applies to her arms and elbows if she rests them on her legs.

#009

SHY GIRL

If you want to communicate a mood that is playful, shy, or just plain cute, using an unusual stance can help accentuate the effect. In the main image, the model's hands underscore the "cute" aspect of the pose. These kinds of things are usually personal habits that a model contributes to a pose without actually thinking about it. With a little practice, and with the help of a few instructions, you can get any model to play along. The important thing is getting her to vary her facial expression while keeping the expression subtle.

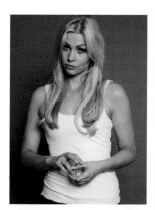

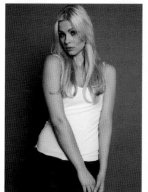

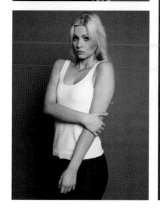

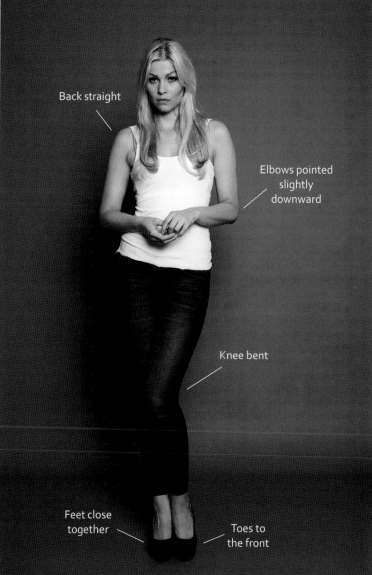

Back straight

Elbows pointed slightly downward

Knee bent

Feet close together

Toes to the front

13

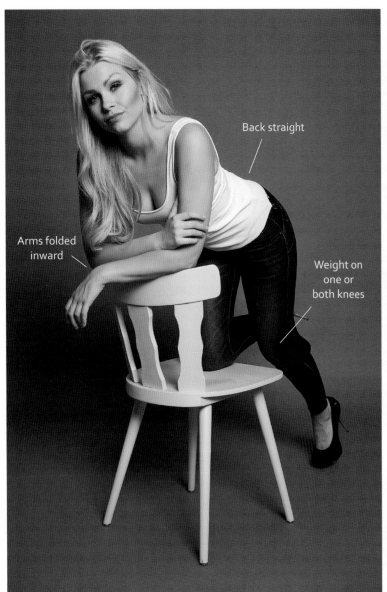

Back straight

Arms folded inward

Weight on one or both knees

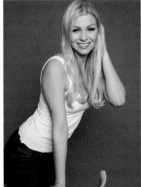

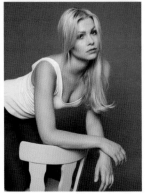

#010

LEAN ON

Ask your model to imagine that the chair is a window ledge or the rail on a balcony or bridge. On location, you can use the local infrastructure to create new and interesting poses. Whatever your model is leaning on, make sure she keeps her back straight. If you want to give this shot a sexy edge, you can include the model's behind. If not, you can simply adjust your framing as required.

#011

BARSTOOL

The great thing about using a stool is that your model cannot lean back. If she did, it would bring her feet, legs, and tummy closer to the camera than her face. Decide how straight you want her back to be, and how it best suits your overall idea. You can then decide whether to have her pose her legs in a feminine, masculine, symmetrical, or asymmetrical way. Finish up by positioning her hands accordingly.

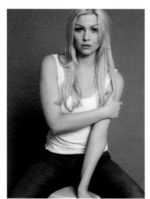

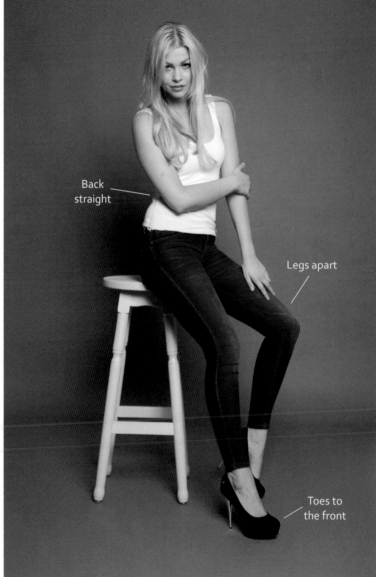

Back straight

Legs apart

Toes to the front

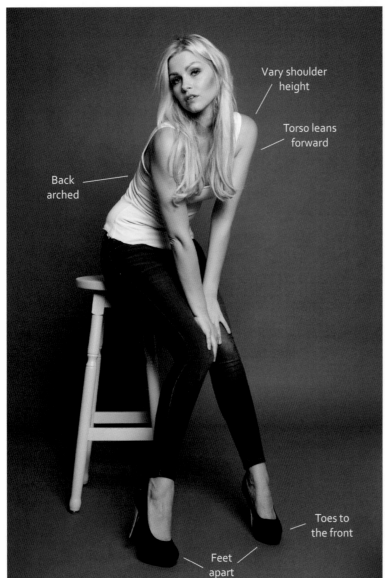

Vary shoulder height

Torso leans forward

Back arched

Toes to the front

Feet apart

BARSTOOL II

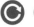

As in the previous pose, your model shouldn't lean back—otherwise her legs will be closer to the camera than her face. In contrast, leaning forward works very well. The multi-angle icon is there for a reason. Apart from the positions of her arms and head, there are plenty of various camera angles and positions you can try out with this pose. In addition to moving around while you shoot, you can vary the height of the camera.

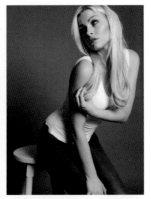
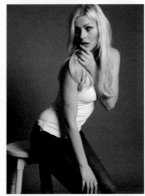
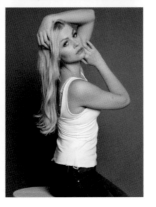

#013

HEADS UP

Ⓤ ➕

The model's facial expression and head tilt is, of course, one of the main factors that determine the emotion communicated by an image. However, it is not always easy to get it right. The two upper variations show how tilting her head to the side or keeping it straight makes the difference between an emotional and a businesslike look. This may seem obvious, but it is an extremely important aspect of a pose. You will see later how it affects a whole range of poses.

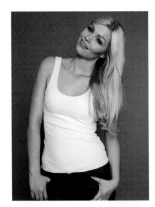

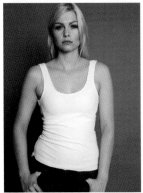

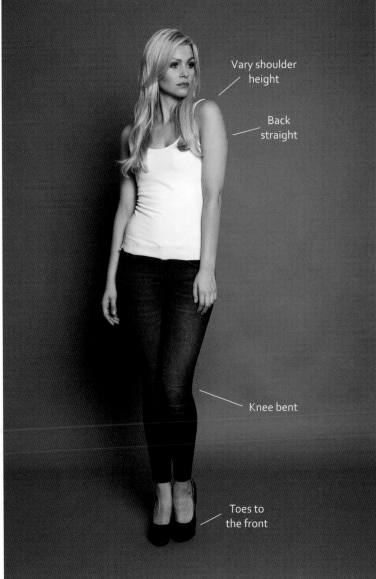

Vary shoulder height

Back straight

Knee bent

Toes to the front

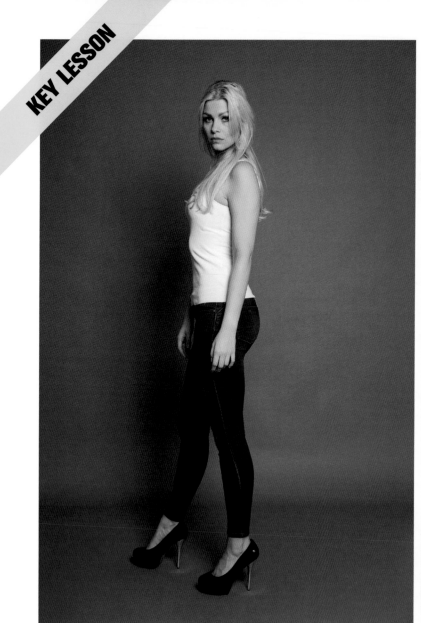

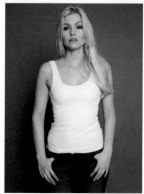

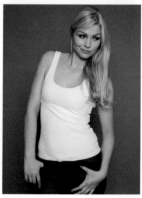

CONNECT!

The direction of your model's gaze, and the way she positions her chin and shoulders, determine how the pose connects with the viewer. If all three point directly at the viewer, it creates a strong connection and gives each aspect equal weight. This is particularly clear in variation #2. In variation #1, the model's averted gaze automatically attracts the viewer to her torso and/or her clothing. In the main image, her torso is turned to the side, but her chin and eyes point straight at the camera, thus putting more emphasis on her face.

#014

GROUNDED

This is one of the oldest and simplest poses, but it can still be used to create top-notch images if you get it right. Start with both knees pointed down (cross legged) and try out various hand positions before you get your model to raise one knee and, once again, vary the position of her hands. You can then try raising both knees, and so on.

This gradual approach to changing positions prevents you from switching poses too quickly, and you are sure to learn plenty about the nuances you can create while you practice.

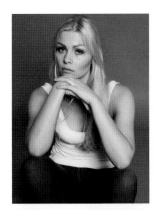

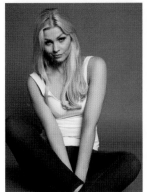

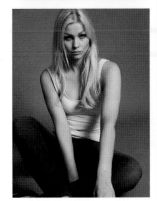

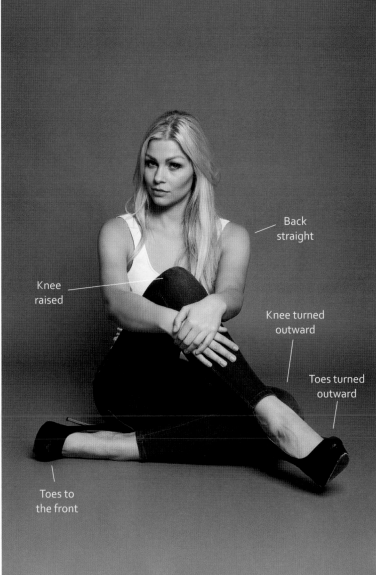

Back straight

Knee raised

Knee turned outward

Toes turned outward

Toes to the front

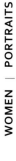

Vary shoulder height

Back arched

Knee bent

Toes to the front

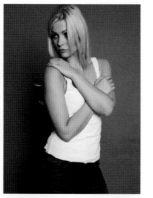

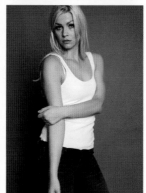

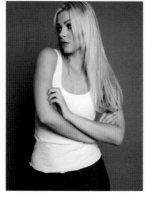

NO!

Hands positioned in front of the torso work like a shield and send out a defensive signal. This is why this pose works well in portrait and nude situations, but isn't suited to fashion shoots where the clothing is the star and mustn't be covered up. Varying this pose with differing shoulder heights adds another dynamic element.

#016

IN PROFILE

Elbows that point downward create a calmer overall atmosphere. Variation #3 shows how raised elbows change the feel of the image; where the arm position creates a frame, and the 45-degree angle charges the image with new energy. Whichever approach you take, make sure your model doesn't cover the space beneath her chin with her hair, fingers, shoulders, or other parts of her body. The first two variations show the effects produced by raising her elbows to different degrees.

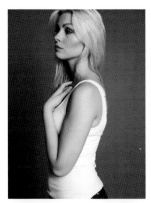

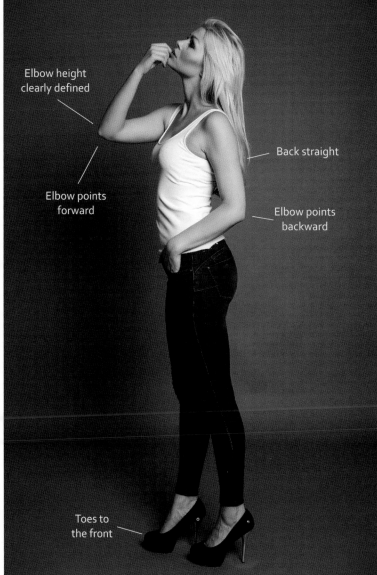

Elbow height clearly defined

Back straight

Elbow points forward

Elbow points backward

Toes to the front

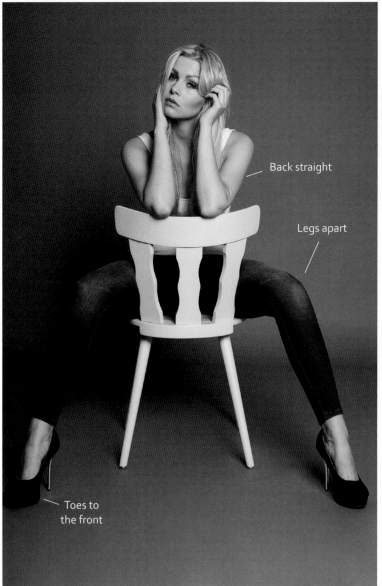

Back straight

Legs apart

Toes to
the front

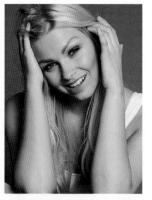

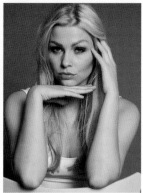

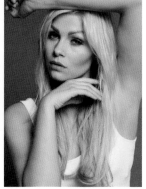

#017

FRAMING
A FACE

 +

A reversed chair, a table, or your model's own knees are just some of the things she can use to rest her elbows and frame her face. Let her move her arms freely and try things out. She can vary the height of her elbows or the position of her hands relative to her head. However, make sure she doesn't look cramped, and make sure her elbows point downward or to the side. Her elbows should never point directly toward the camera. Doing so would make her upper and lower arms look unnaturally short.

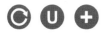

TOUSLED

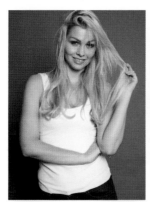

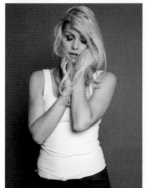

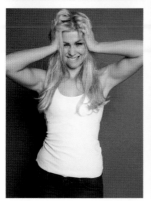

If a model's hair falls over her face or is blown by the wind (or a fan), the viewer will automatically concentrate harder on what the image is saying. Curiosity will make viewers try to look past her hair to the face beneath. Save shots that spoil your model's hairdo for the end of the shoot.

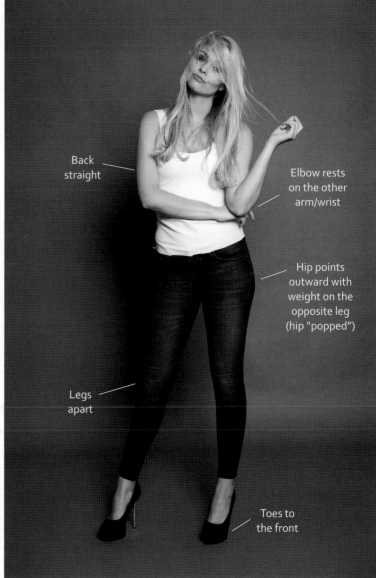

Back straight

Elbow rests on the other arm/wrist

Hip points outward with weight on the opposite leg (hip "popped")

Legs apart

Toes to the front

BEAUTY

Beauty poses are all about accentuating a model's inherent good looks. However, they can also be used deliberately to draw attention to makeup and hair styling.

#019

FRAME A FACE

The title says it all. Here, the model uses her hands and fingers to create an aesthetically pleasing frame for her face. Unlike the previous *Framing a Face* pose (#017), this time she barely touches her face. The gesture is not designed to accentuate the model's looks, but rather the purity of her skin. This is why it is best to imply skin contact with just a single finger of each hand. Avoid having her press on or dent her skin with her fingers.

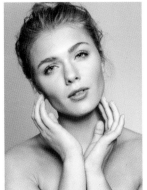

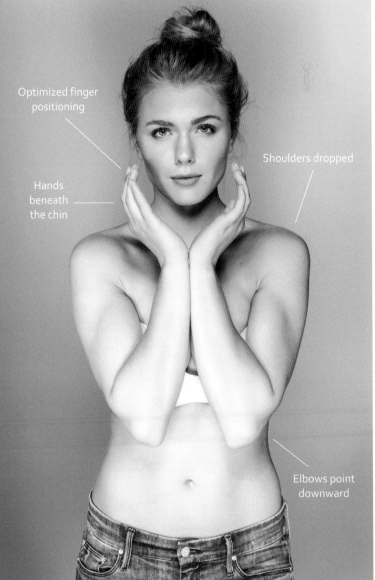

Optimized finger positioning

Shoulders dropped

Hands beneath the chin

Elbows point downward

25

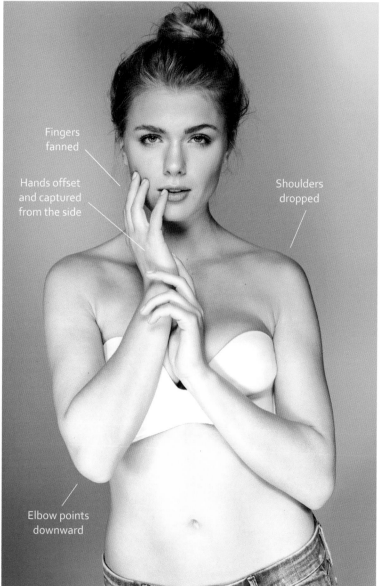

Fingers fanned

Hands offset and captured from the side

Shoulders dropped

Elbow points downward

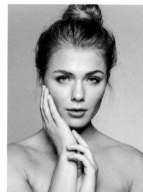

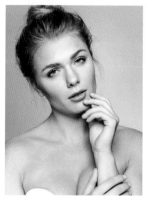

HAND ON HAND

Beauty poses are a staple in facial product advertisements, so the model's hands (which she uses to apply the product) play a crucial role. Contact between her hands and face should only be implied (see also pose #019). Always capture the hand itself from the side, so that it looks as slim as possible and doesn't distract from her face. Make sure her fingers look elegant and that they are fanned.

#021

HANDS TOWARD THE BODY

If you want to make the most of a pose, you need to learn about body language. Turning the palms of her hands and her fingers toward her body give your model a sensitive, almost vulnerable look. Hands and fingers turned away from the body often send out a defensive signal. Both approaches are fine, but you have to know that simple changes like this have a profound effect on how the viewer perceives an image. So, now's the time for you to choose.

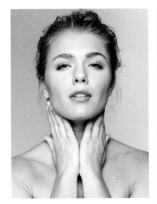

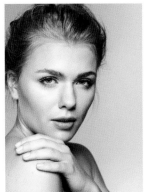

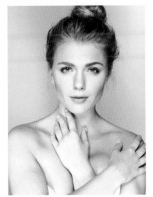

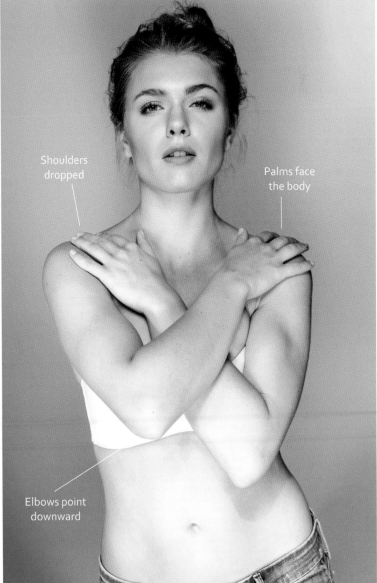

Shoulders dropped

Palms face the body

Elbows point downward

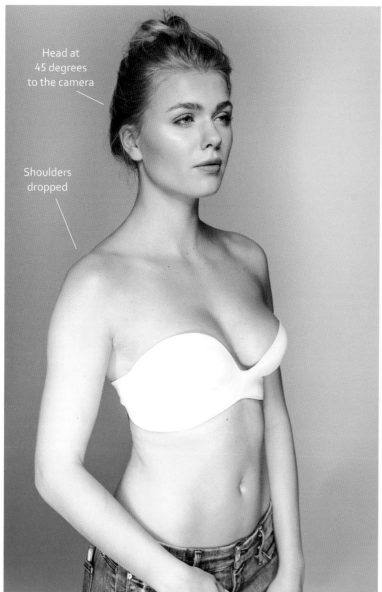

Head at
45 degrees
to the camera

Shoulders
dropped

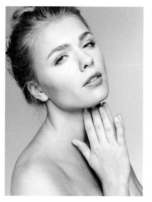

022

45-DEGREE ROTATION

A pose that is at a 45-degree angle from the camera adds tension and extra energy into a beauty pose. A raised chin gives the pose a "hard" look that indicates arrogance, while a lowered chin produces a softer, more vulnerable look. You can underscore this effect using what you learned in pose #021. In other words, combining a lowered chin with hands that face toward the model's body makes the pose softer than it would with a lowered chin alone. In this case, it is essential that the eye farthest from the camera is still clearly visible.

EYES CLOSED

Closed eyes can convey a soft or vulnerable look, but can also be used together with a contented facial expression to imply well-being. In beauty shots, closed eyes ensure that the viewer is not distracted by eye contact and can concentrate fully on the model's makeup. This is a great pose for showcasing a makeup artist's work.

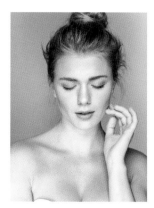

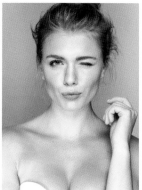

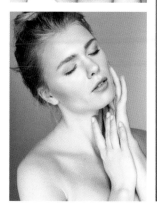

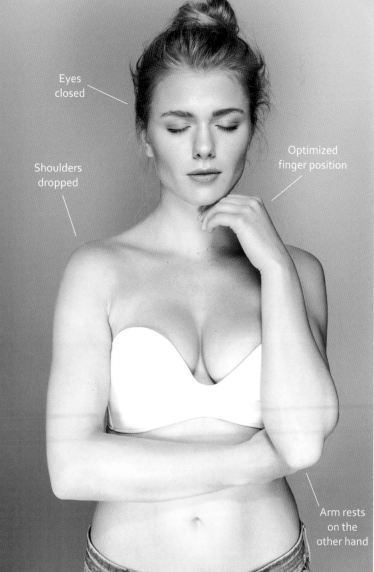

Eyes closed

Shoulders dropped

Optimized finger position

Arm rests on the other hand

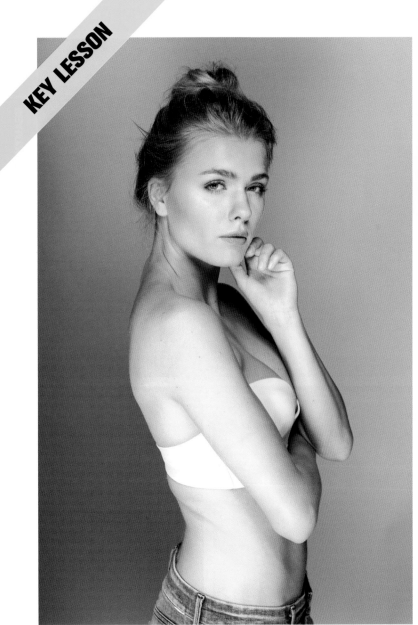

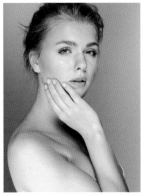

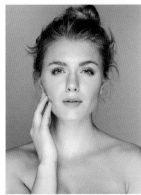

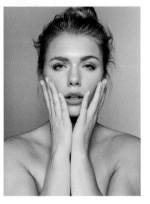

SHOWING YOUR CHIN

Many poses require the model to position her hands close to her face, but if she covers her entire chin with her hand, it makes her face and neck look like a single, large feature. Also, her hand is closer to the camera than her face, which makes her hand look disproportionately large and distracts the viewer (variation #1). If you are shooting a profile, work with the hand farthest from the camera. If you are working with a head-on pose, make sure your model covers only one side of her chin or jawline (variation #2). In variation #3, she is covering both sides of her chin, which may be OK if you intend to accentuate the fingernails, which are now clearly on display.

#026

VANISHING CREAM

Commercial beauty shots are largely created to advertise cosmetic products, which is why the model's hands are often positioned to look as if she is applying some kind of lotion. The important thing to watch for is that she doesn't do this like she would at home, but instead uses just her fingertips. Make sure she touches her face very lightly. This pose is particularly effective if the model turns her face and body slightly to the side, as in variation #2.

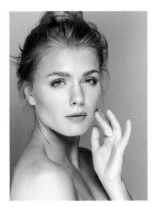

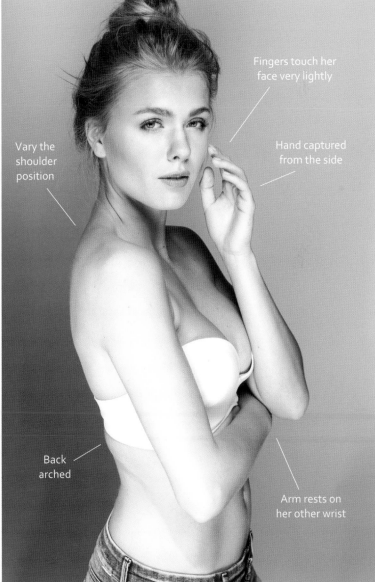

Fingers touch her face very lightly

Vary the shoulder position

Hand captured from the side

Back arched

Arm rests on her other wrist

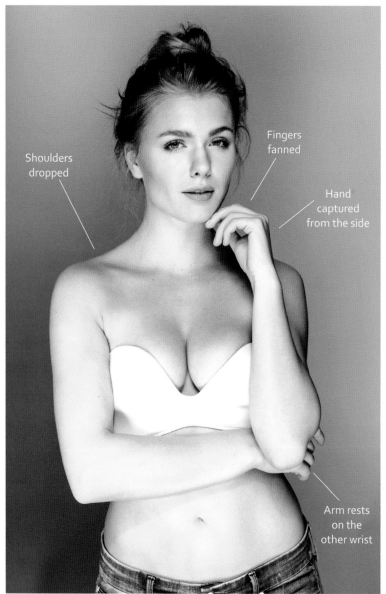

Shoulders dropped

Fingers fanned

Hand captured from the side

Arm rests on the other wrist

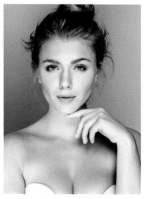

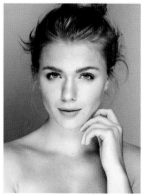

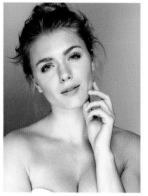

THE THINKER

Fingernails and hands are an important part of many beauty shots, and this pose shows a number of different ways to approach this kind of assignment. One tried-and-trusted pose is this slight variation on #006. As usual in beauty situations, the model's hands need to appear light and graceful. To achieve this effect, she should fan her fingers elegantly or use just one finger. Make sure she doesn't cover too much of her chin (see the Key Lesson on page 32).

#028

CLOSEUP

Facial closeups are great for models who have a symmetrical face. The viewer is not distracted by the surroundings or the lighting and can concentrate fully on the model's face and/or makeup. Closeups, too, can be enhanced using a pointing finger. Your model can then close her eyes, look to the side, or use her hands to frame her face.

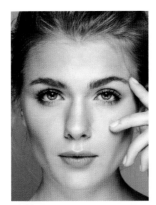

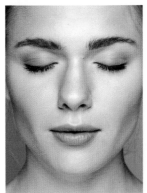

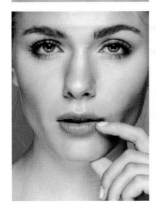

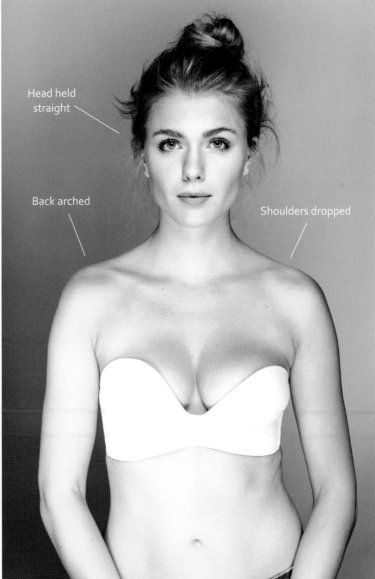

Head held straight

Back arched

Shoulders dropped

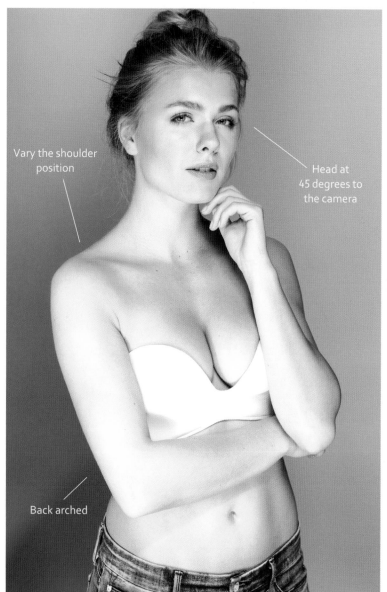

Vary the shoulder position

Head at 45 degrees to the camera

Back arched

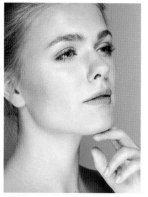

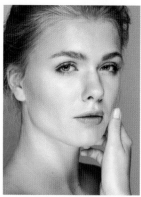

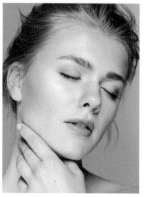

CLOSEUP II

Admittedly, a closeup in which the model is positioned at an angle to the camera isn't easy to photograph. However, if used with subtle lighting, it is a great way to showcase lipstick or mascara. In this case, body language is less important than choosing the right camera height, camera angle, and crop. Try plenty of different combinations until you find just the right one.

#030

SHOULDER AND CHIN

You can influence the effect of a pose by varying the position of the model's shoulders. If she is to make a softer, more emotional or feminine impression, get her to move her shoulder and chin closer together, as in variations #1 and #3. If you want to produce a cooler, more confident look, get her to move her chin away from her shoulder, as shown in the main image and variation #2. Don't try to force the pose using just her chin, but instead try different combinations of chin and shoulder positions.

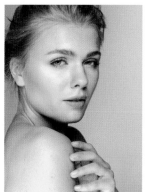

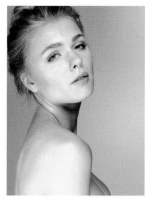

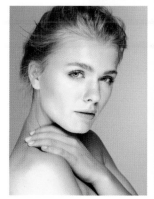

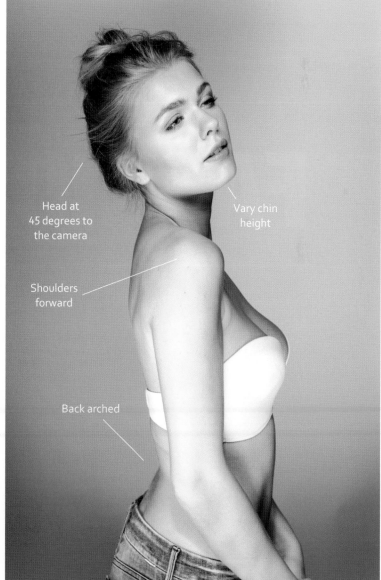

Head at 45 degrees to the camera

Vary chin height

Shoulders forward

Back arched

FASHION

In fashion photos, the model's job is to present clothing and accessories, such as shoes and handbags, in a compellingly attractive way. Sexy and full of energy or cool and casual? The choice is yours!

#031

POWER POSE

✚

The energy inherent in many fashion photos is fuelled by the points and angles that make up the pose. As we have already seen, a head held high conveys confidence and decisiveness, while elbows turned outward add additional energy to a pose. The even distribution of the model's weight and the acute angle this produces between her legs make this a really strong pose. Pose #032 illustrates the opposite effect.

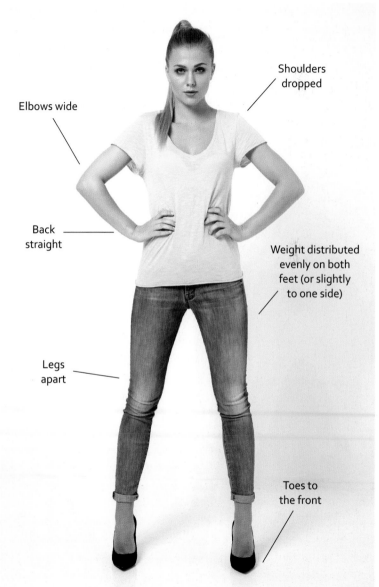

Elbows wide

Shoulders dropped

Back straight

Weight distributed evenly on both feet (or slightly to one side)

Legs apart

Toes to the front

39

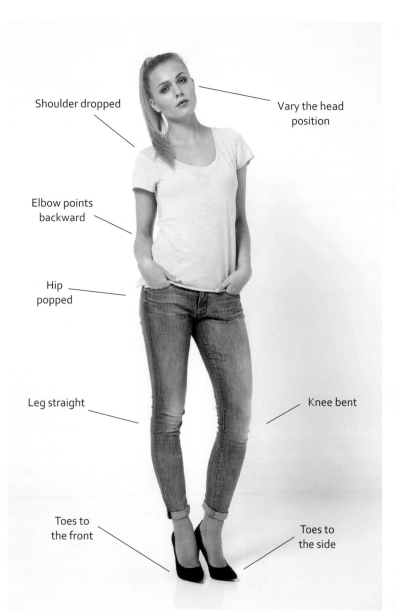

Shoulder dropped

Vary the head position

Elbow points backward

Hip popped

Leg straight

Knee bent

Toes to the front

Toes to the side

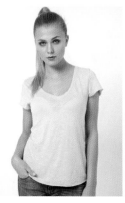

#032

CASUAL AND RELAXED

Here, our model lets her elbows point down and back, leans her head slightly to one side, and relaxes the position of her legs. What effect does this have? All of the sharp points and angles from the previous pose have disappeared, and the pose has transformed from strong and confident to relaxed and emotional. Unlike the previous pose, this one works with both serious and friendly facial expressions.

#033

COOL AND CONFIDENT

Women standing with their legs apart convey a confident, masculine look. This pose takes on a feminine touch if the model turns the toes of one foot outward to emphasize the S-shaped curve of her body. She can further emphasize this effect if she grabs her waist with one hand, and further still by lowering her shoulder on the side where she her hip is popped.

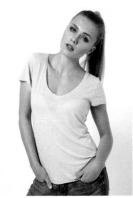

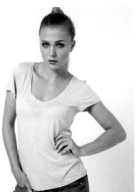

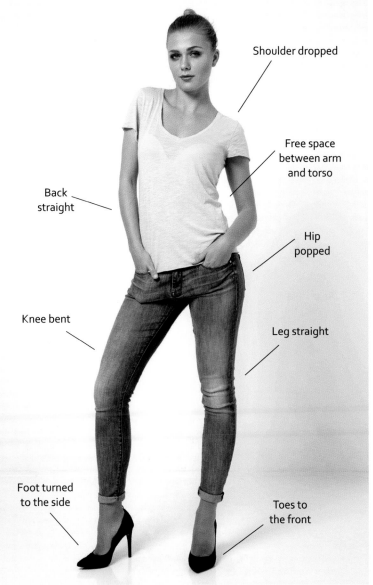

Shoulder dropped

Free space between arm and torso

Back straight

Hip popped

Knee bent

Leg straight

Foot turned to the side

Toes to the front

41

Elbows point
downward or
to the rear

Shoulders
dropped

Back
stretched

Curve between
her lower back
and her behind
not hidden

Rear knee
bent

Front leg
straight

Feet to
the front

Rear foot
behind the other

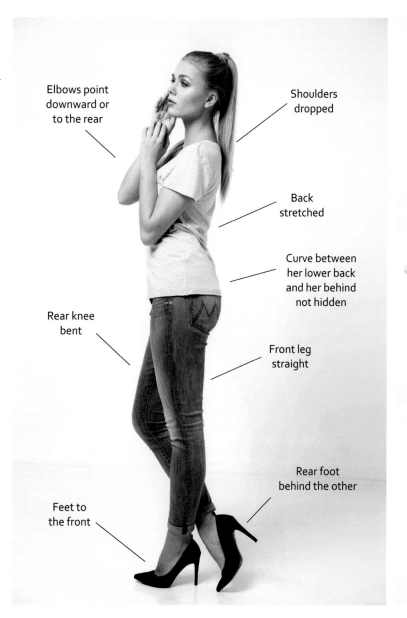

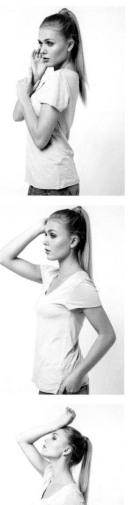

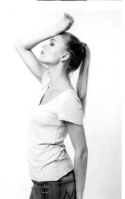

STANDING PROFILE

U

Seen from the side, the curve formed by a woman's behind and her lower back can be very sexy indeed. For this pose to work, make sure your model arches her back so that it forms a hollow. She needs to wear high heels or stand on tiptoes to emphasize her curves. Make sure that the curve she makes is smooth and uninterrupted.

035

SEXY CURVES

Curves make every woman look sexy. Make sure your model makes a smooth curve between her waist and her hip and that at least one side isn't hidden. In the main image, she is resting her right arm on her hip. In variation #1, her arms are positioned in front of her torso but her curves are still visible. In variation #2, her rear arm disappears behind her curves, whereas variation #3 shows what happens if she covers up her curves on both sides. This seriously detracts from the effectiveness of the pose.

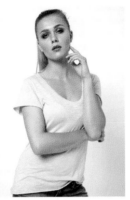

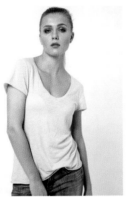

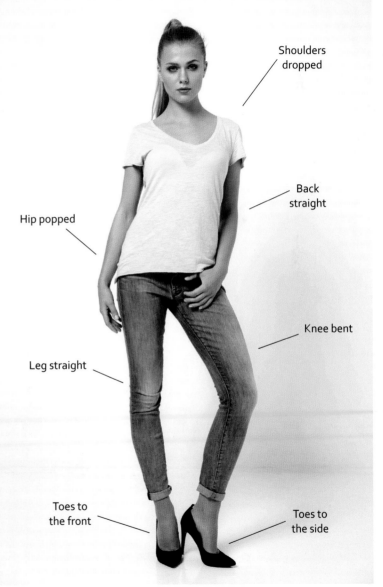

Shoulders dropped

Back straight

Hip popped

Knee bent

Leg straight

Toes to the front

Toes to the side

43

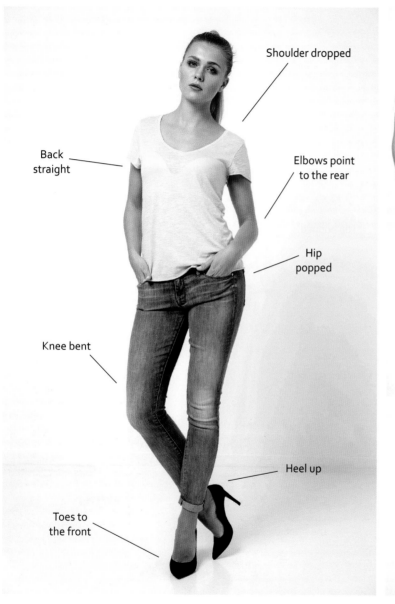

Shoulder dropped

Back
straight

Elbows point
to the rear

Hip
popped

Knee bent

Heel up

Toes to
the front

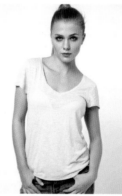

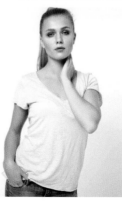

#036

STANDING COMFORTABLY

Ⓤ ➕

This is a relaxed, natural pose that is perfectly suited to full-length shots, especially on fashion shoots. Don't be fooled by the relaxed look of this pose—as a model, she has to control every aspect of the pose to keep her entire body straight, and she needs a good feel for the right moment. Tilting her head to the side emphasizes the relaxed feel. Photographers should get the model to vary the distance between her arms and her body to keep the space there empty. The required distance will depend on your model's figure.

#041

FRAMING A BODY

Space defines a model's figure. If you are showcasing a model's curves, you can emphasize them by not covering them up, and then underscore the effect by framing her body with her arms. This trick works equally well for head-on and profile poses. If you are photographing your model from the side, make sure her distant arm doesn't spoil the lines you create in the rest of the shot.

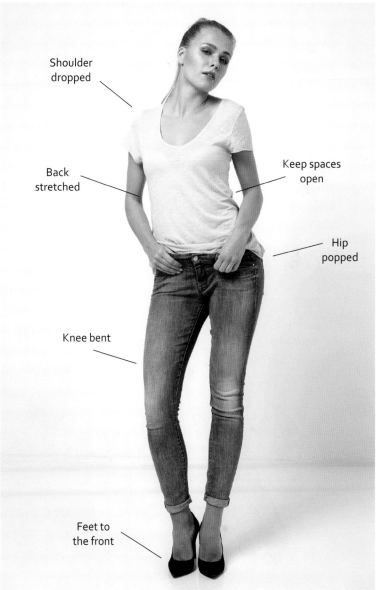

Shoulder dropped

Keep spaces open

Back stretched

Hip popped

Knee bent

Feet to the front

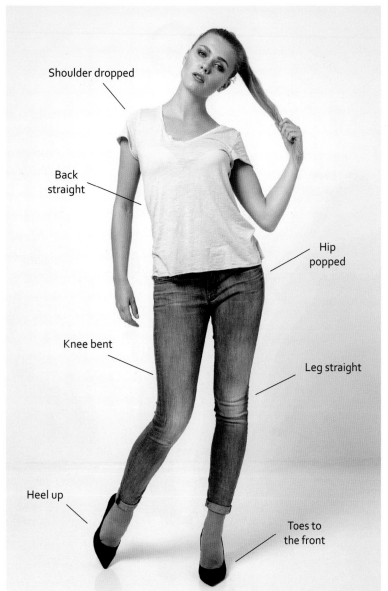

Shoulder dropped

Back straight

Hip popped

Knee bent

Leg straight

Heel up

Toes to the front

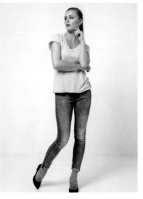

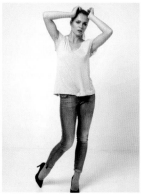

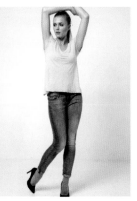

THE FORGOTTEN LEG

This is a popular fashion pose that is often used in advertising shots for shoes, jeans, and mini skirts. The "dragged" rear leg is slightly out of place and forces the viewer to take a closer look at the model's leg and, therefore, her clothes, too. It's a great way to accentuate specific types of clothing.

#043

PRODUCT PLACEMENT

While we are on the subject of presenting clothes, here are few posing options for accessories such as handbags or sunglasses. Clients usually prefer shots in which the model isn't looking directly at the camera, while the handbag (or other item) is pointed at the viewer. This is a pose that puts the product in focus, not the model.

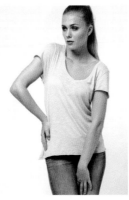

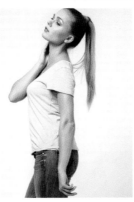

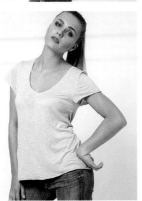

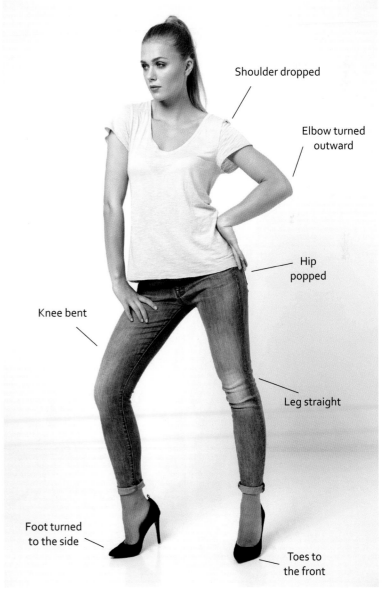

Shoulder dropped

Elbow turned outward

Hip popped

Knee bent

Leg straight

Foot turned to the side

Toes to the front

51

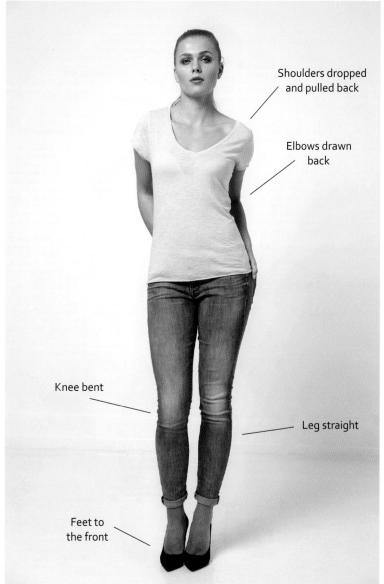

Shoulders dropped and pulled back

Elbows drawn back

Knee bent

Leg straight

Feet to the front

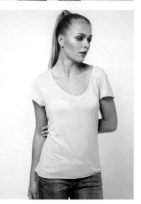

#044

A CLEAR VIEW

U

In this pose, the viewer has a clear view of the model's body (compare it with #015). Her arms are either behind or positioned away from her torso. Once again, this a great pose for fashion shoots, because there is nothing obscuring the view of the clothing and nothing directs the viewer's gaze toward her face or away from her clothes. The model herself also conveys a more communicative attitude.

#045

ELBOWS

The energy a pose transmits depends on the way the model positions various parts of her body, and elbows are crucial. The position of her elbows and the direction in which they are pointed influences the overall energy level of a pose. If her elbow points downward (as in variation #1), the pose looks calm and gentle, whereas an elbow positioned at head height and turned to the side (as in the main image and the other two variations) gives the resulting pose a lot more energy.

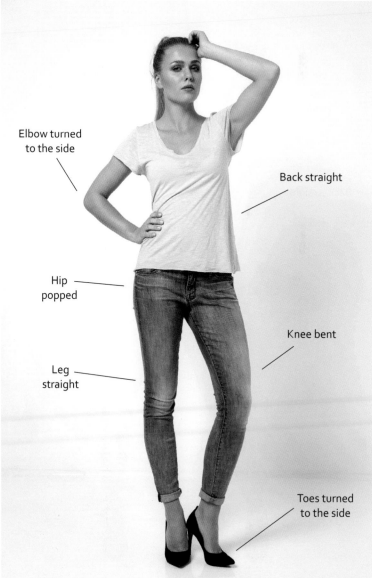

Elbow turned to the side

Back straight

Hip popped

Knee bent

Leg straight

Toes turned to the side

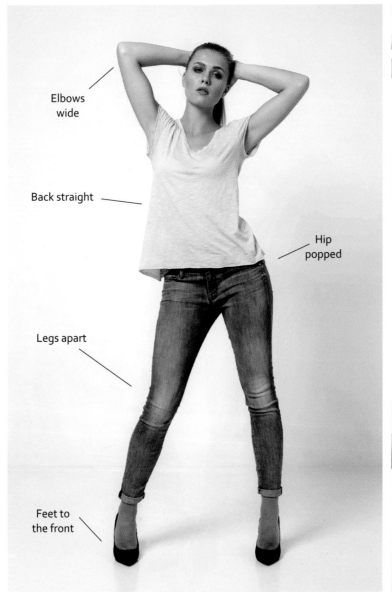

Elbows wide

Back straight

Hip popped

Legs apart

Feet to the front

HANDS AND ELBOWS

Combining hand and elbow tricks emphasizes the attributes demonstrated in the previous pose. You can position your model's elbows symmetrically or offset, depending on the concept you are working on and the way you want the pose to look. The important things are to make a decision and give clear instructions to your model. Sharp angles contribute energy to the pose (as in the main image and variations #1 and #3), while the pose without any angles (variation #2) is much more relaxed.

#047

LADYLIKE

In this pose, it is essential that your model sit diagonally to the camera. This ensures that her outfit remains in focus. If it were shot head-on, her arms, knees, and hands would obscure the view of her clothes. A diagonal position also helps to prevent foreshortening effects (see the Key Lesson on page 58), regardless of whether she rests her arms on her legs or on the chair.

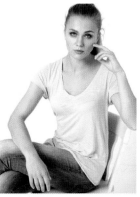
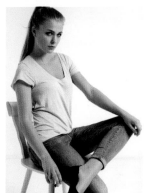
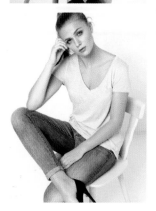

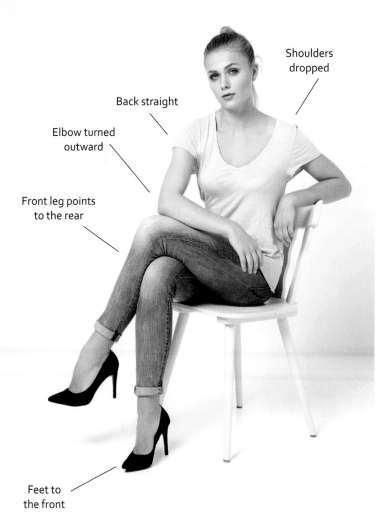

Shoulders dropped

Back straight

Elbow turned outward

Front leg points to the rear

Feet to the front

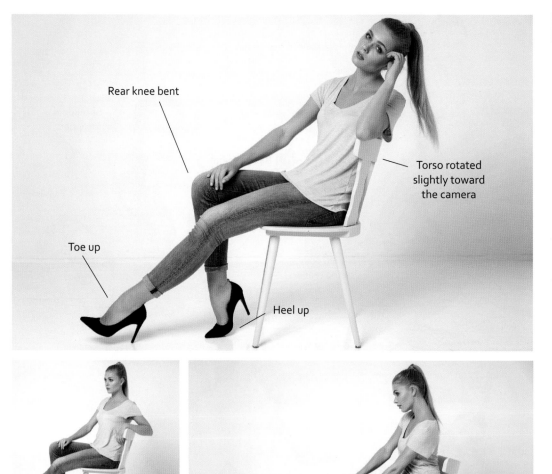

Rear knee bent

Torso rotated slightly toward the camera

Toe up

Heel up

WAITING ROOM

U

On a fashion shoot, there has to be a good reason for photographing a sitting model in profile—for example, an item of clothing has features that are clearly recognizable only from the side. An obvious case is a dress with a side slit (a pose that is immediately more sexy too). A more complex reason might be extreme leg positions that accentuate the flexibility of a pair of pants or leggings (see also #038).

#049

SQUATTING

It is not always easy for a model to retain her balance in squatting poses. Resting one knee on the floor can help. Whichever variation you choose, it is essential that she keep her back straight. The advantage of this pose is that she then only has to concentrate on the position of her arms and hands and has to develop new ideas to keep things interesting.

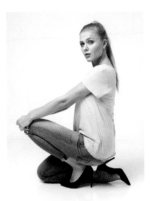

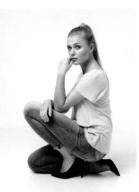

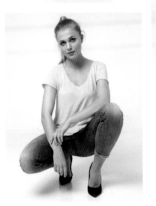

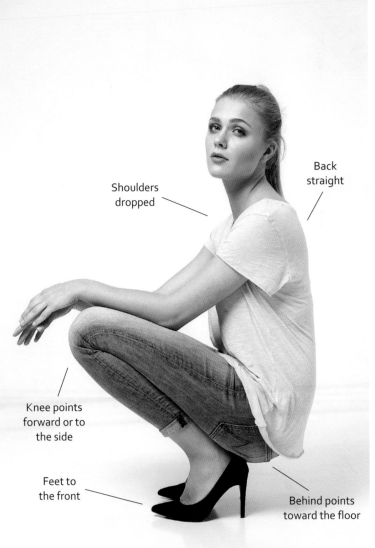

Shoulders dropped

Back straight

Knee points forward or to the side

Feet to the front

Behind points toward the floor

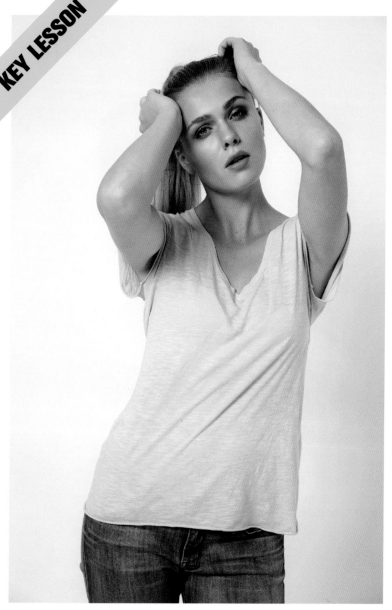

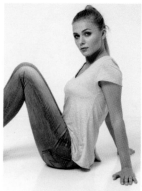

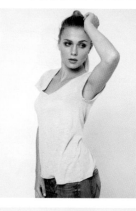

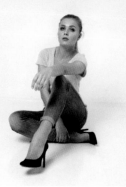

DANGER: FORE-SHORTENING!

The poses illustrated here are all completely different, but they all have one thing in common. Can you see what it is? It is the foreshortening effect. This effect often makes arms, fingers, legs, and other parts of a model's body appear shorter and fatter than they really are. You can minimize this effect by making sure arms, fingers, and legs are positioned almost at right angles to the camera. For example, if a model is unhappy about the size of her arms, you can use this effect to make the offending body part recede into the background.

#050

BARSTOOL CASUAL

This is a casual fashion pose that is great for showcasing all kinds of clothing. Make sure your model's arms don't cover her torso or her clothes. A straight back is essential for accentuating her top and helps her project a confident look—an effect that most fashion clients insist on.

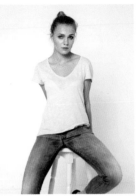

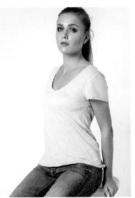

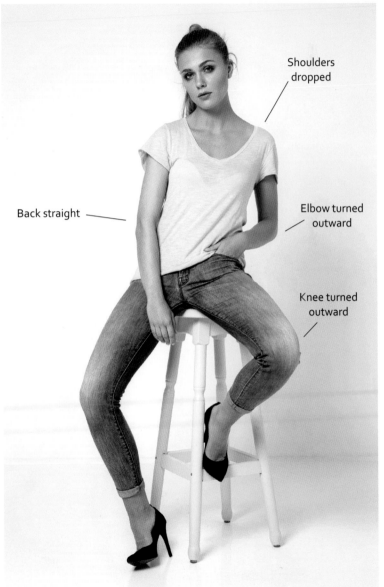

Shoulders dropped

Back straight

Elbow turned outward

Knee turned outward

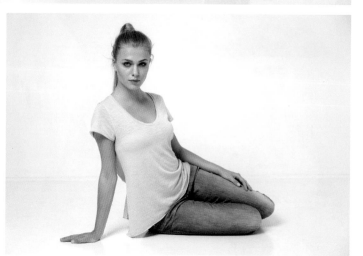

Knee raised

Back straight

Toes to the front

Fingers turned outward

Hand, leg, and foot form a single line

051

ON THE FLOOR

Things that work well for standing and sitting poses are also fine for floor-based reclining (or semi-reclining) positions too. In other words, the more sharp angles the model makes, the more energy the pose will have. The main image clearly demonstrates this approach, while the variation at bottom right shows what happens when she tones down the angles. This image exudes a lot more calm than the others.

#052

ARMS AND BACK

 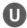

If your model braces her position using one or both arms, there are a couple of things you have to watch out for. She shouldn't stretch her arms too much, and she mustn't let her spine slump, as both these things don't look good. Furthermore, the way elbows rotate inwards when you fully stretch your arms tends to provoke a negative reaction in the viewer. Because it is supporting the model's weight, a fully stretched arm also looks tense and thicker than normal.

Knees raised

Back straight

Toes to the front

Fingers turned outward

LINGERIE

There are three major factors to watch out for in lingerie and semi-nude poses. The model has to pull in her tummy, keep her back straight, and retain a sufficient level of tension in the rest of her body. Read on for more details.

#053

AGENT PROVOCATEUR

Let's begin with some sitting poses. Can you see the major difference between this pose and #047? In the earlier pose, the model uses her arms to support her weight or create a frame. In images that are designed to be sexy, a model's arms are often used to emphasize her bust, either by applying a subtle push-up effect and/or by creating a frame.

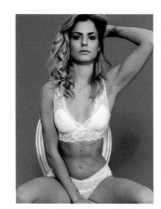

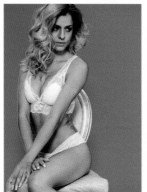

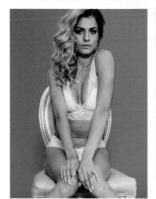

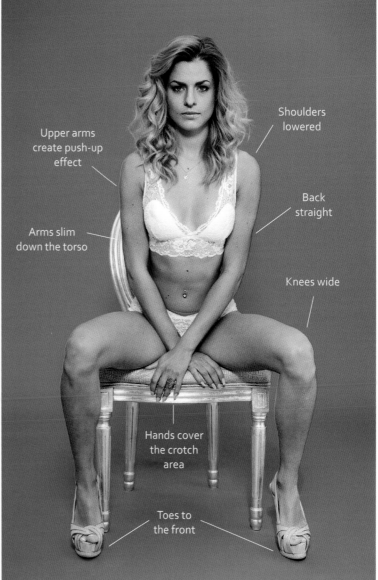

Upper arms create push-up effect

Shoulders lowered

Arms slim down the torso

Back straight

Knees wide

Hands cover the crotch area

Toes to the front

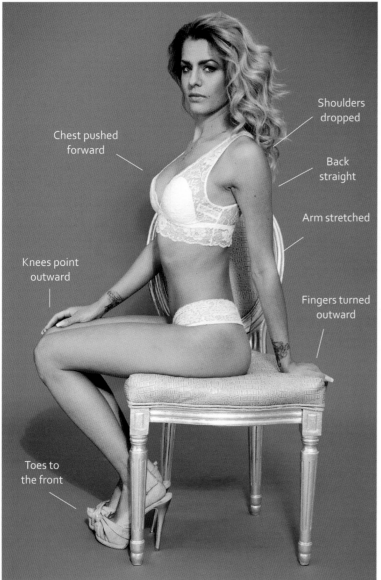

Shoulders dropped

Chest pushed forward

Back straight

Arm stretched

Knees point outward

Fingers turned outward

Toes to the front

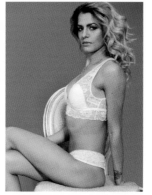

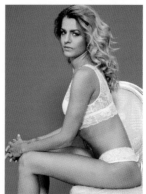

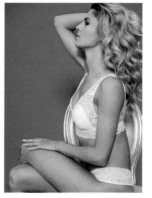

#054

IN PROFILE

If you are capturing a profile shot, the model must keep her back as straight as possible. Only then does the pose exude the appropriate energy. Photographer and model can get creative together and develop new hand and arm positions that enhance the pose. Your model can use her arms to conceal potential flaws or perhaps play with her bra straps to draw attention to her bust. Try out plenty of variations, and don't switch too quickly to the next pose before you have exhausted the current one.

#055

UNORTHODOX SITTING

Use chairs and other lounge furniture in unorthodox ways. Try rotating the chair, or get your model to turn around. Don't be scared to try crazy or even uncomfortable positions. Whichever pose you end up with, make sure your model offsets her legs. This ensures that they look longer and more energized. She can use her hands to support her body weight or to conceal her tummy, hips, or calves.

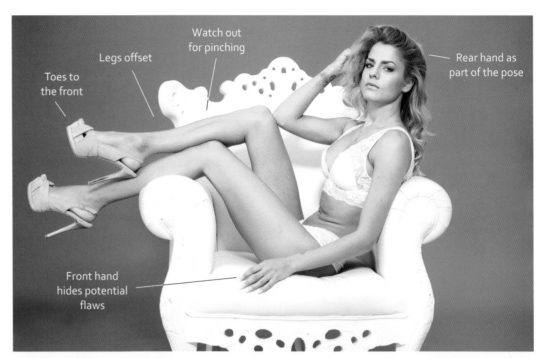

Toes to the front

Legs offset

Watch out for pinching

Rear hand as part of the pose

Front hand hides potential flaws

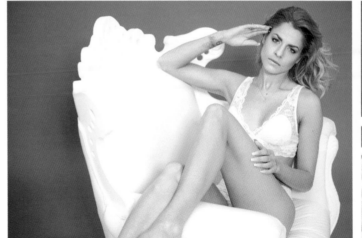

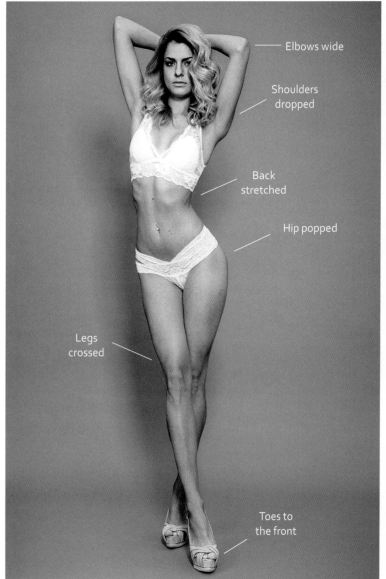

Elbows wide

Shoulders dropped

Back stretched

Hip popped

Legs crossed

Toes to the front

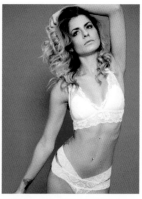

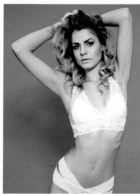

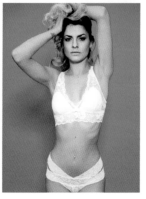

056

MORNING STRETCH

This standing stretch creates a wonderful curve through the model's waist and hips. Don't just photograph her standing still, but take some shots while she is moving into position, too. The basis of this pose is a relaxed but full stretch, the way you would when you get out of bed. Placing the leg opposite the popped hip in front of the other leg emphasizes the overall curve effect.

#057

BOOBY TRAP

We have already talked about framing in several of the earlier poses. This page demonstrates other ways to emphasize your model's bust in standing poses. She can use her upper or lower arms to create a subtle push-up effect, and you can vary her shoulder height to suit the required energy level (remember those sharp angles!). To prevent her face and bust competing for the viewer's attention, she can avert her gaze or turn her head to the side.

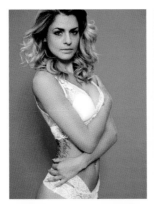

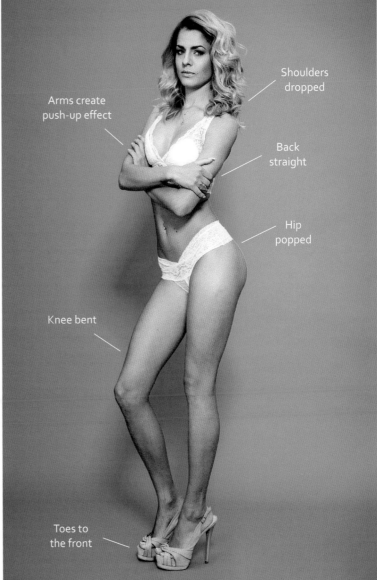

Shoulders dropped

Arms create push-up effect

Back straight

Hip popped

Knee bent

Toes to the front

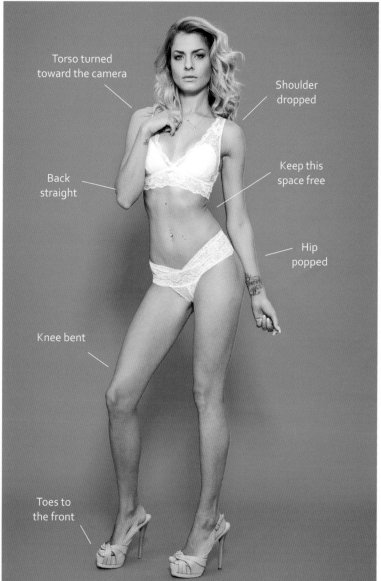

Torso turned
toward the camera

Shoulder
dropped

Back
straight

Keep this
space free

Hip
popped

Knee bent

Toes to
the front

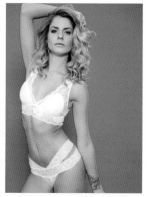

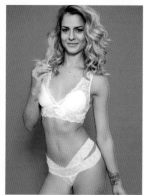

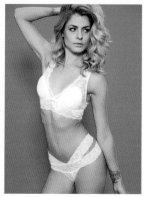

CURVES, CURVES, CURVES

Curves are one of the basic elements of sexy photos. And I don't just mean the curve of your model's behind or her bust; I mean the long transitional curves between her hips and back, or from her waist to her hips. Try not to cover or visually interrupt these curves. This rule isn't set in stone, but practice doing things "right" before you start breaking rules.

TURN 1 INTO 10

Take a pose like the kneeling-on-the-bed pose shown here, and then try to think in categories so that you can derive 10 new poses from the basic position. Try to cover all the options for each individual pose before you move on to the next. In the main image, the model has her knees together and rests on her behind, but moving her knees apart (variation #1) instantly adds sex appeal. And raising her derrière makes it even more provocative.

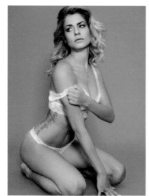

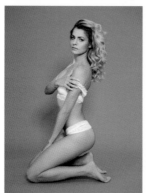

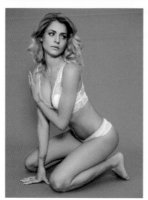

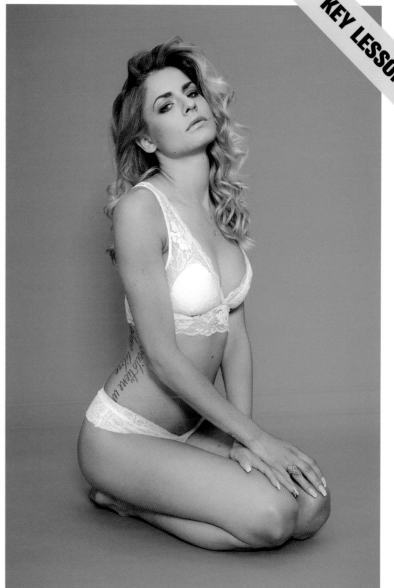

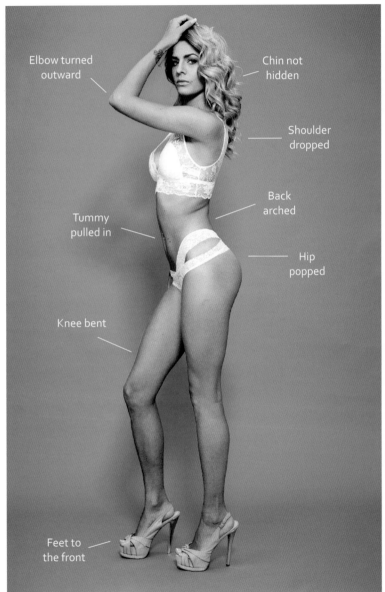

Elbow turned outward

Chin not hidden

Shoulder dropped

Back arched

Tummy pulled in

Hip popped

Knee bent

Feet to the front

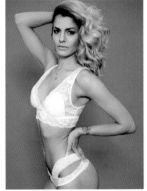

THE ENERGY ANGLE

A model doesn't always need both arms to create a frame. As you can see, there are various ways to use one arm to add right angles and triangles (and thus plenty of energy) to the shape of a pose. The only drawback here is that she can't use her arms to emphasize or push her bust.

060

MAKE USE OF THE BRA

Now and again, photographer and model both need a pose that doesn't require too much effort or concentration. Let your model play with her bra straps—for instance, simply by touching them, playing with them, or letting them fall. All the while, she can position her hands closer to her head or tousle her hair.

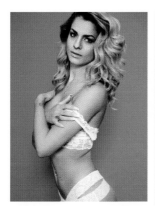

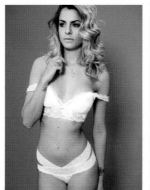

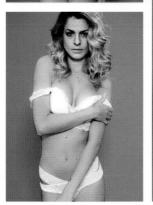

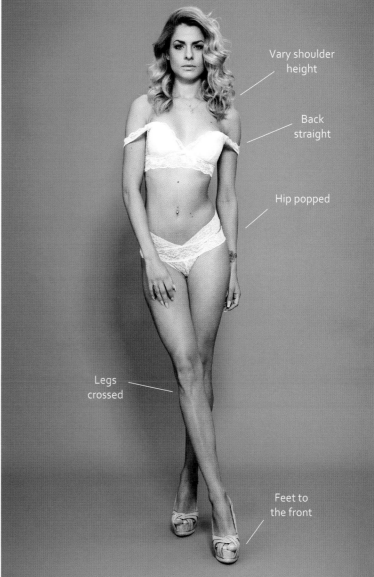

Vary shoulder height

Back straight

Hip popped

Legs crossed

Feet to the front

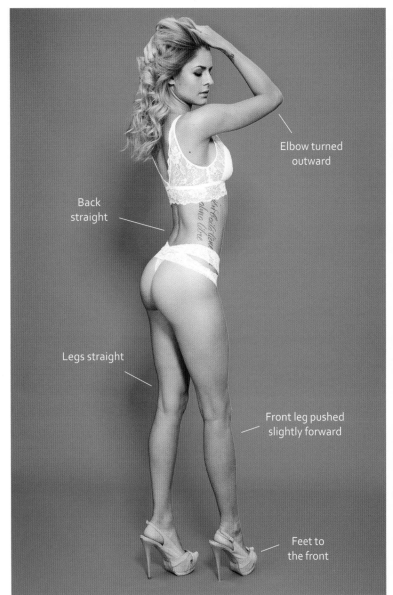

Back
straight

Elbow turned
outward

Legs straight

Front leg pushed
slightly forward

Feet to
the front

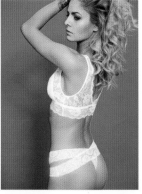

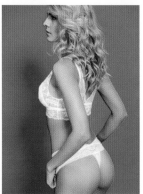

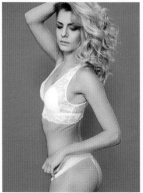

061

OVER THE SHOULDER

Poses where the model looks over her shoulder tend to produce ugly wrinkles in the skin of her neck. However, there are plenty of ways to work around this effect. You can get your model to turn her torso slightly toward the camera to relax her neck a little, or ask her to drop the shoulder closest to the camera. If all else fails, she can cover her neck with her hair.

#062

FROM BEHIND

High heels are a great help if you want to emphasize your model's behind. Heels encourage her to keep her back straight and accentuate the curves of her body. If you don't have any heels handy, she can either stand on tiptoes or balance on the balls of her feet.

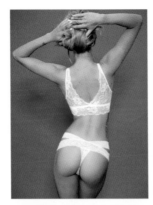

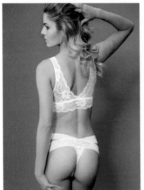

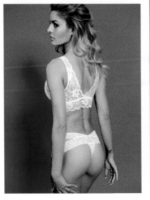

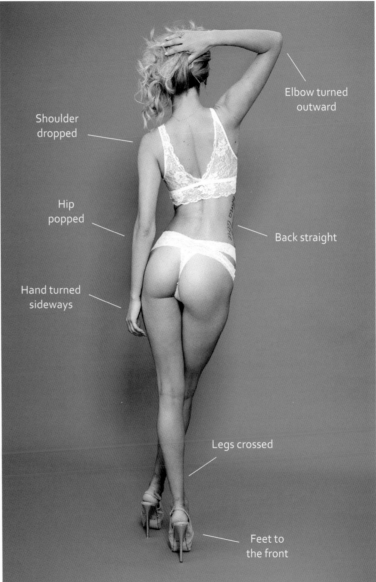

Shoulder dropped

Elbow turned outward

Hip popped

Back straight

Hand turned sideways

Legs crossed

Feet to the front

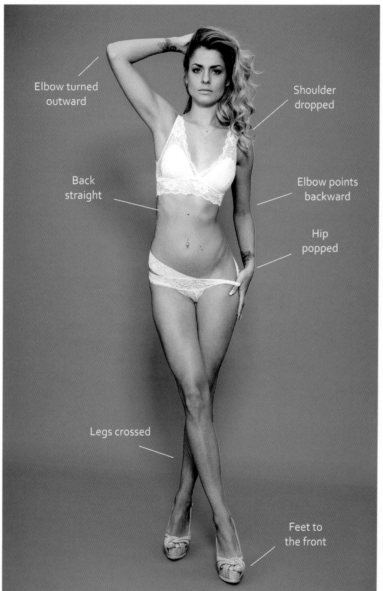

Elbow turned
outward

Shoulder
dropped

Back
straight

Elbow points
backward

Hip
popped

Legs crossed

Feet to
the front

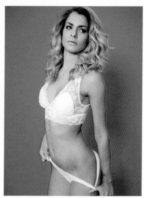

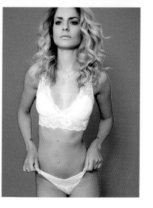

#063

LINGERIE GAMES

We have already taken a close look at how to draw attention to a bra, so now let's have a look at how to bring panties into focus. Depending on the idea you are working on, you can get your model to simply grab her panties or pull one side up or down. You can then combine the resulting effect with a different pose. A model playing with her panties presents a provocative image, so if you do use this approach, make sure the pose really does suit the theme of the shoot.

#064

BEHIND AN ARM

Digital image editing makes it possible to correct just about any flaw, or even to alter your model's figure. But is that really what studio photography is about? Image editing requires time that most busy photographers don't have, so it makes sense to capture images that are as near perfect as possible from the get-go. A model can use her arms to help the photographer in plenty of ways—for example, by hiding her tummy, pushing her bust, or framing her torso.

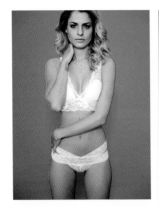

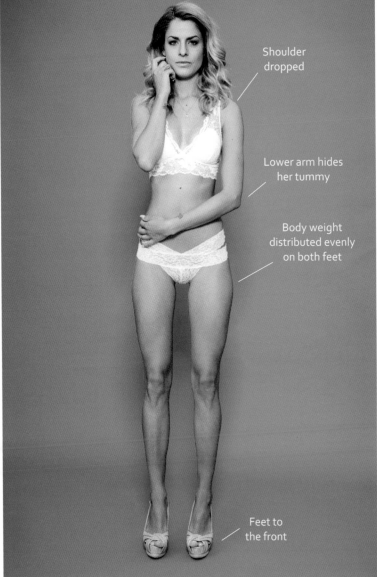

Shoulder dropped

Lower arm hides her tummy

Body weight distributed evenly on both feet

Feet to the front

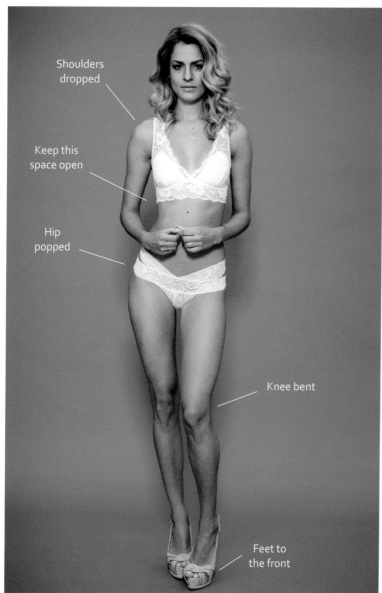

Shoulders dropped

Keep this space open

Hip popped

Knee bent

Feet to the front

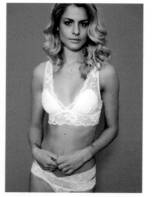

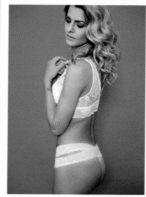

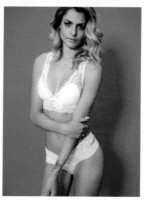

QUIET HANDS

Poses don't always have to be extravagant or full of energy. Sometimes, just a hint of an emotion or simply capturing the right moment is all it takes to produce a really special image. Subtle-looking poses often appear less contrived and more natural, and they also lead the viewer to pay more attention to the model's face. Get your model into a more modest pose, and then concentrate fully on her facial expression.

#066

CURVES AND 45-DEGREE ANGLES

A model's curves become especially accentuated when she stands at an angle to the camera. This is because her bust and her behind balance each other out and guide the viewer's gaze along the length of her body. Make sure her arms and hands don't interrupt these curves.

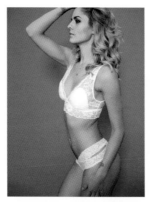

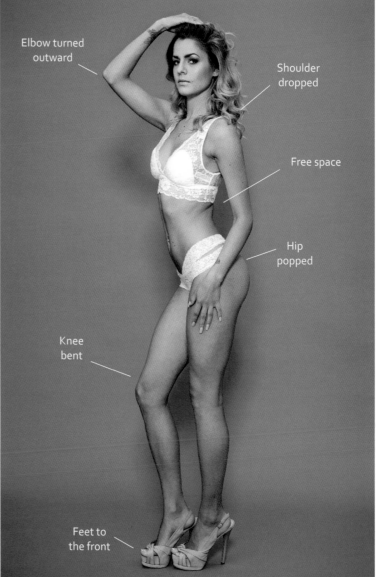

Elbow turned outward

Shoulder dropped

Free space

Hip popped

Knee bent

Feet to the front

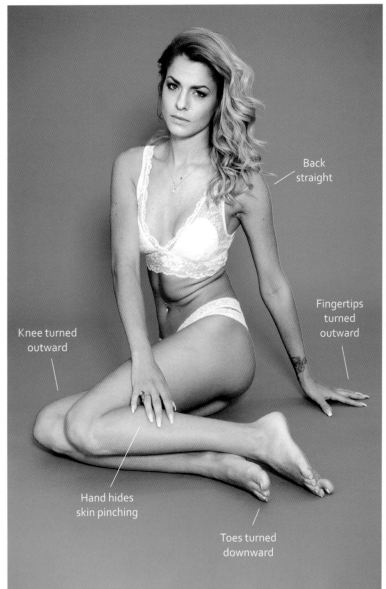

Back straight

Fingertips turned outward

Knee turned outward

Hand hides skin pinching

Toes turned downward

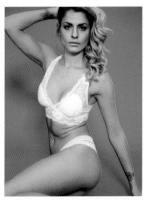

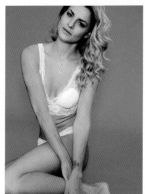

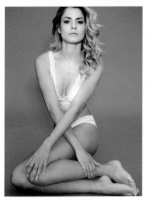

MERMAID

Limbs bent at acute angles run the risk of pinching—for example if your model's calf and thigh are too close together. This can occur all too easily in reclining poses. If you want to save yourself a lot of work with the Adobe Photoshop Liquify tool, you need to give your model clear instructions that will help her avoid this trap. She has to either pose perfectly or use her hands to hide any problem zones.

MERMAID II

This is a semi-reclined version of the previous pose. If you want your model to keep her legs low, the foremost knee has to touch the floor. This keeps the pose looking slim and also produces a nice overall curve. She can lean on her fingertips or the palm of her hand, depending on the requirements of the shoot. Whichever choice you make, it is essential that she point her fingers to the side to avoid foreshortening.

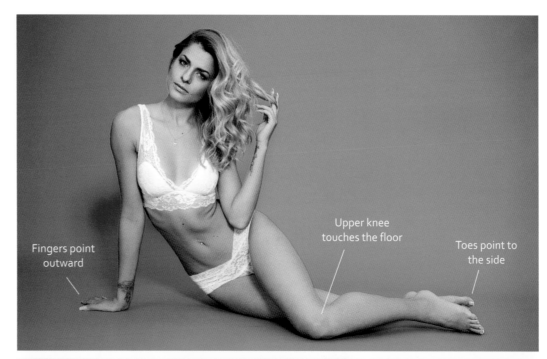

Fingers point outward

Upper knee touches the floor

Toes point to the side

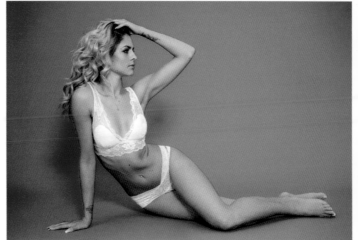

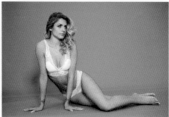

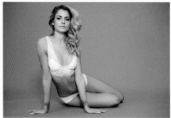

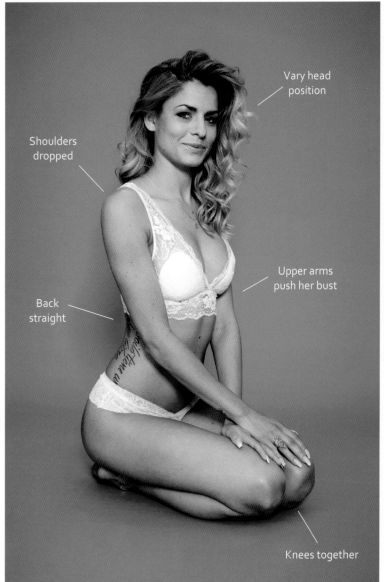

Vary head position

Shoulders dropped

Upper arms push her bust

Back straight

Knees together

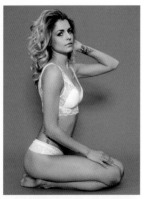

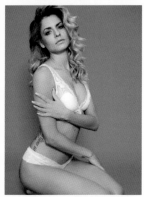

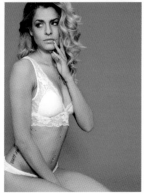

KNEELING

Kneeling poses, too, run the risk of pinching skin between the model's thighs and calves. Here, she has her legs together, which is a more defensive, feminine pose (for a legs-apart variation see the next page). The overall effect is similar to poses where the model sits in a chair.

#070

KNEELING II

The same pose becomes more provocative if the model spreads her knees a little, and she can raise the sexiness level even further if she plays with her bra straps or her panties. If you move around while shooting a pose like this, you can include her behind, which is strongly accentuated by this particular pose.

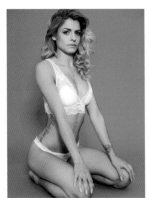

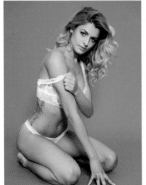

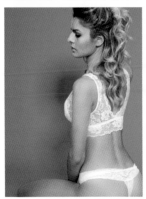

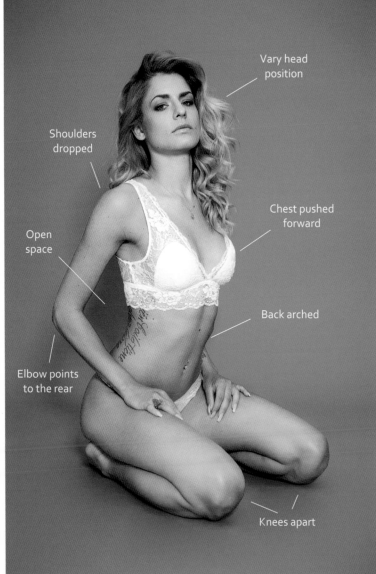

Vary head position

Shoulders dropped

Chest pushed forward

Open space

Back arched

Elbow points to the rear

Knees apart

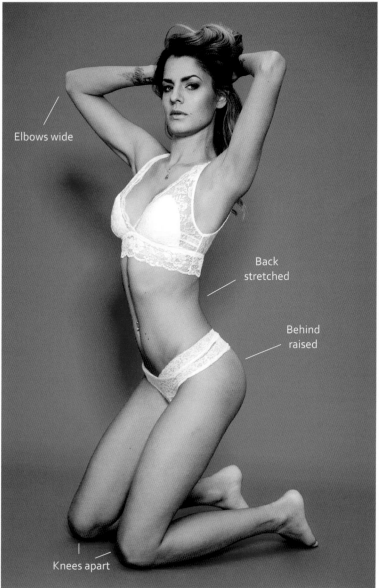

Elbows wide

Back
stretched

Behind
raised

Knees apart

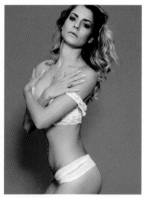

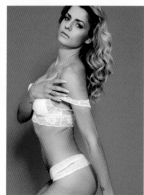

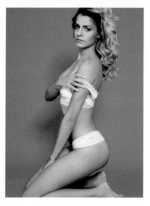

KNEELING III

In this variation on the kneel-
ing pose, our model raises her
behind. The almost 90-degree
angle made by her lower legs
and her stretched back intro-
duce tension into the pose and
make the model look more
self-assured. If the shot requires
your model to support her
weight with her arms or hold
one arm with the opposite hand,
you should use the opportunity
to give her bust a push.

#072

CLOSED SEXY

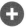

This pose is suitable for models who are less confident about the look of their tummy or hips, or for those who simply don't want to show too much skin. The raised knee hides her tummy, and she can then use her arms to disguise her legs. She can either clasp her arms around her legs or steer the viewer's attention toward her face by raising a hand to her head.

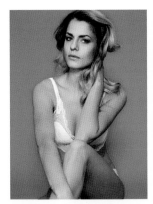

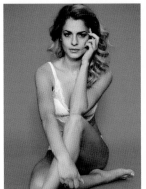

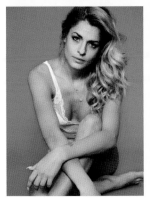

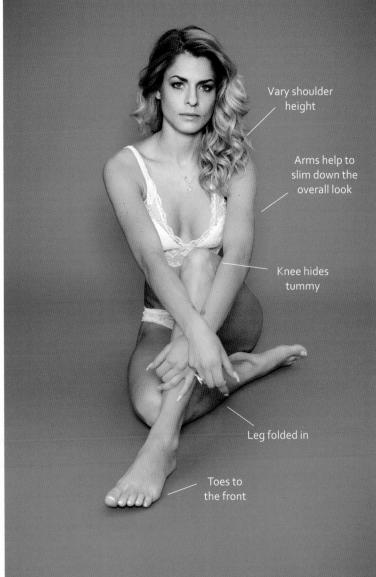

Vary shoulder height

Arms help to slim down the overall look

Knee hides tummy

Leg folded in

Toes to the front

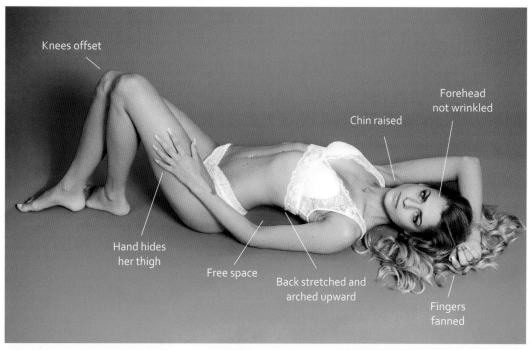

Knees offset

Forehead
not wrinkled

Chin raised

Hand hides
her thigh

Free space

Back stretched and
arched upward

Fingers
fanned

ON YOUR BACK

Lingerie poses should always show your model's curves in the best possible light. If she is lying on her back, she can enhance her curves by forming a hollow with her back or, if she is lying on her side, by popping the visible hip. Make sure the curves of her bust and behind are not covered by her hands or arms.

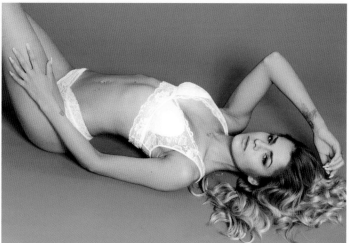

#074

ON YOUR SIDE

 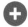

This boudoir-style pose is developed from a traditional face-down pose, but requires the model to turn her behind either directly toward or away from the camera. The main image and variation #1 (on lower left) are examples of the former, while variations #2 and #3 show how shooting from her other side effectively accentuates the curve formed by her waist and hips. If your model is lying on her front, she needs to raise her behind up a little.

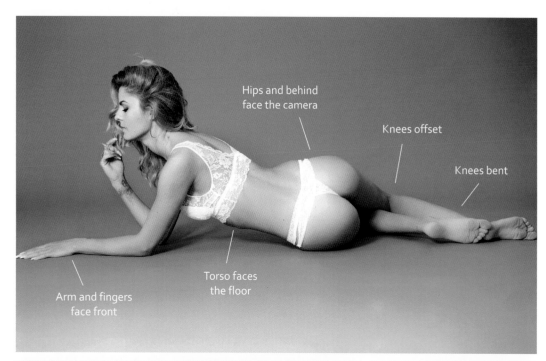

Hips and behind face the camera

Knees offset

Knees bent

Torso faces the floor

Arm and fingers face front

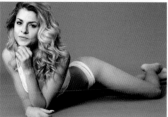

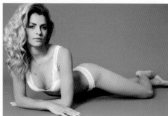

IMPLIED NUDE

Moving on from lingerie poses, we are now going to take a look at implied nudes. Many of the basic rules are the same as before, but the really interesting question lies in making the model appear nude without her actually baring all. We all need our little secrets!

075

CROSSED LEGS

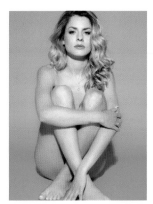

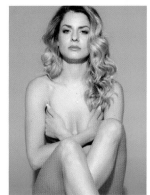

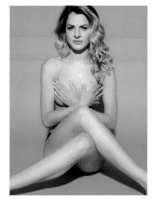

Poses are there to fuel the viewer's imagination, even if the image doesn't actually reveal everything. In this pose, your model can cover her bust in a number of ways. Using her arms makes the trick quite obvious, whereas using her knees or legs appears more casual and spontaneous. Changing the distance between her knees and her body provides plenty of variation, but you can position her arms on, between, or around her legs, too. Her legs can also hide her tummy, which will always shown some folds in this pose.

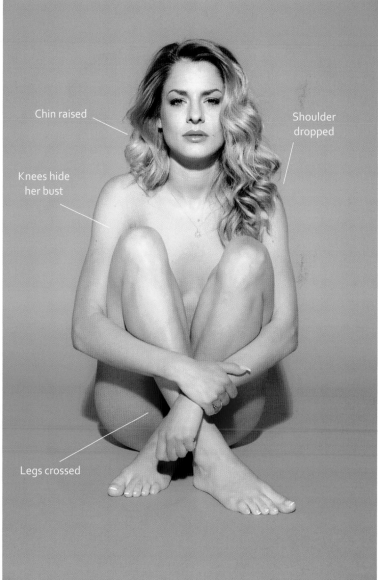

Chin raised

Shoulder dropped

Knees hide her bust

Legs crossed

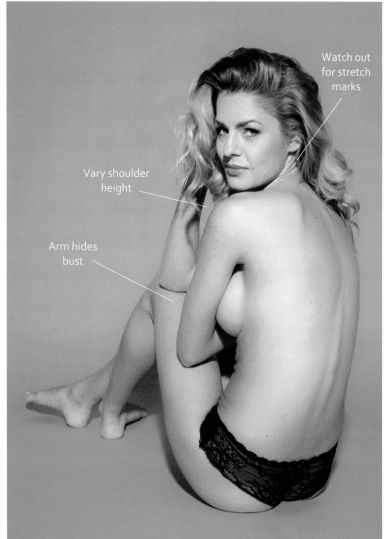

Watch out
for stretch
marks

Vary shoulder
height

Arm hides
bust

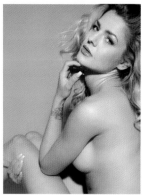

SEXY BACK

A woman's back is often one of her best features, but you have to be careful about the emotions and energy you communicate when capturing this type of shot. If you are looking for a relaxed look, you can definitely put her in a sitting position, while getting her to kneel introduces more excitement into the pose and allows her to stretch her back more. Or have the model sit and lean back.

WORK SYSTEM- ATICALLY

Categorizing your poses and working systematically will help you stay in control of a shoot while simultaneously giving you new ideas. What do you see here? In just a few images, we explore cover-up variations that include using one hand, one arm, both arms, one arm and one hand, and using the model's hair. Never switch spontaneously between different basic poses, but instead approach each pose calmly and systematically. This will help you navigate your way through a complex shoot and ensure that you get the most out of each individual position.

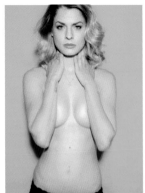

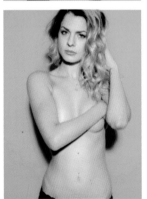

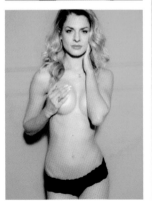

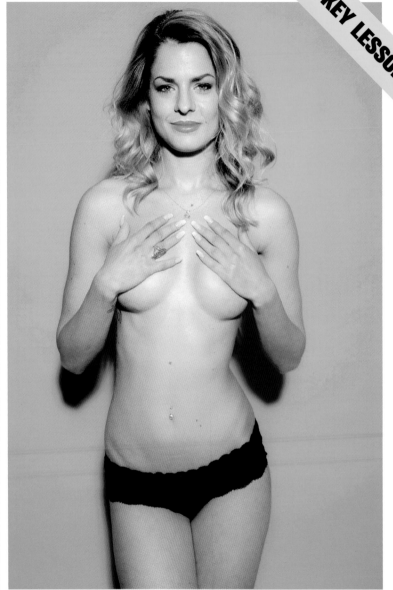

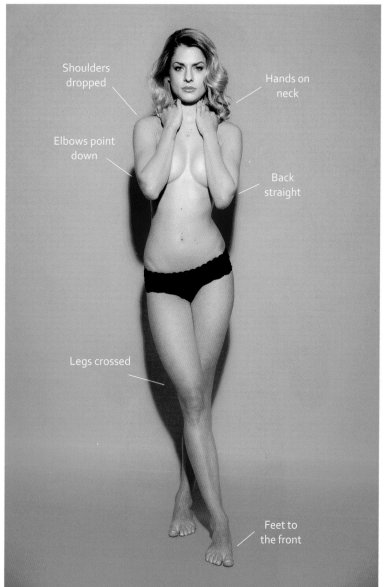

Shoulders dropped

Hands on neck

Elbows point down

Back straight

Legs crossed

Feet to the front

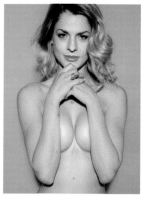

SYMMETRY

If your model uses her hands or arms to cover up, she should always use the opportunity to push her bust. If you shoot a pose like this head-on, you have to work very carefully and make sure her breasts appear symmetrical. Symmetrical poses are unforgiving when it comes to accentuating the differences between a woman's breasts. If necessary, the photographer should guide the model from the camera's point of view while making sure her nipples remain covered at all times.

#078

ONE ARM

Using just one arm as a cover changes the previous pose to an asymmetrical one and is a lot more dynamic. While symmetrical poses tend to look artificial (or artistic), asymmetrical poses appear more natural and emotional. However, with asymmetrical poses, you still need to make sure that both breasts look good and that your model doesn't produce any unattractive pinching or skin folds between her arm and her bust.

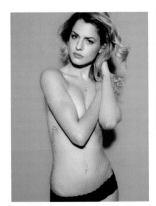

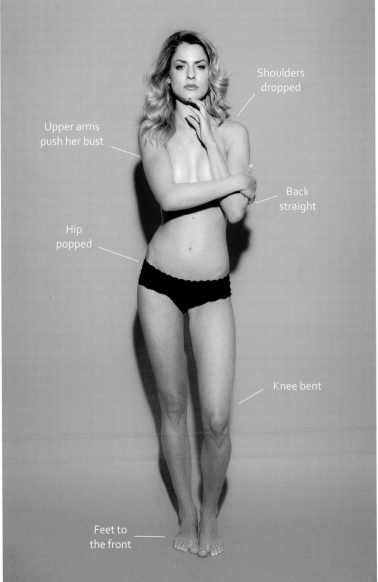

Shoulders dropped

Upper arms push her bust

Back straight

Hip popped

Knee bent

Feet to the front

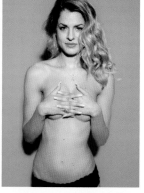

Elbows point
downward

Back
straight

Legs
crossed

Feet to
the front

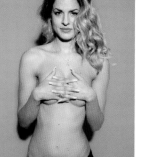

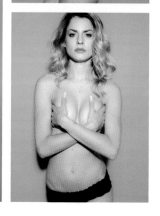

TWO HANDS

If your model uses both hands to cover her breasts, she retains maximum flexibility when it comes to creating a push-up effect. Whether she covers her bust from above (as shown in the main image) or from below, she should always lift her breasts a little, or at least apply some pressure to make her bust look firm. Variation #2 shows how effective this approach can be when photographed from the side.

#080

ONE HAND

We already discussed that right angles and 45-degree angles enhance the energy in a pose, and you can use this effect in implied nude poses too. If your model uses only one hand to cover her bust, the other hand is free to add vitality to the rest of the pose. She can place her hand on her hip or cover her tummy, or use her arm to frame her face. If she is still wearing any clothes, she can use it to interact with them. There are no limits to the ways you can modify your ideas.

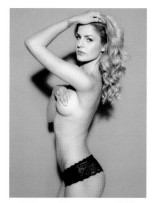

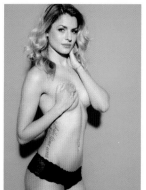

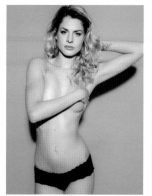

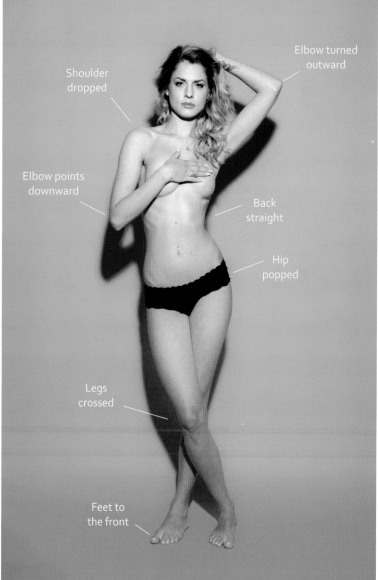

Shoulder dropped

Elbow turned outward

Elbow points downward

Back straight

Hip popped

Legs crossed

Feet to the front

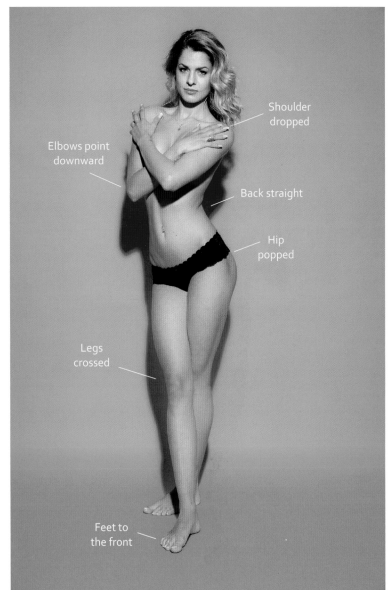

Shoulder dropped

Elbows point downward

Back straight

Hip popped

Legs crossed

Feet to the front

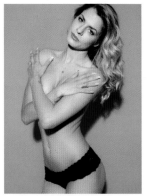

CROSSED ARMS

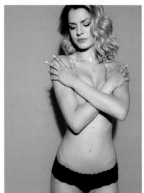

If your model crosses her arms, look out for pinching in her upper and lower arms as well in her bust. In this pose, her elbows point downward to prevent unwanted foreshortening (see the Key Lesson on page 58). Try out various leg positions and vary your camera angle. This will help keep the pose lively and dynamic.

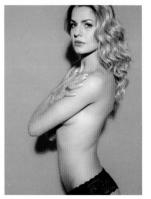

082

FROM BEHIND

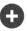

The implied nude approach works just as well if you photograph your model from behind. For this pose, keeping her chin close to her shoulder gives the pose a feminine, almost vulnerable feel. However, make sure your model doesn't completely cover her jawline (see the Key Lesson on page 32.) Folds in the skin of her neck are best covered using her hair (if it is long enough).

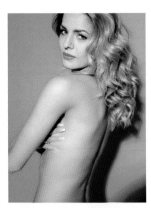

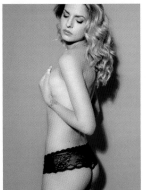

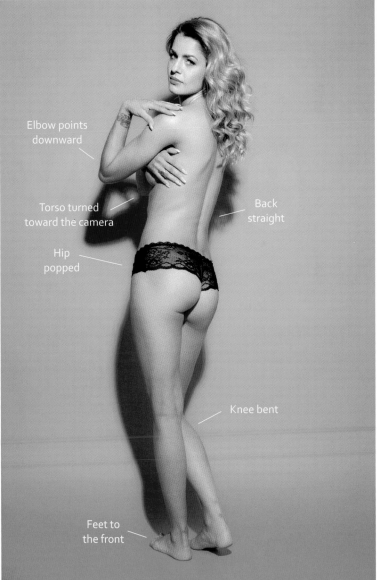

Elbow points downward

Torso turned toward the camera

Back straight

Hip popped

Knee bent

Feet to the front

CURVY

The following pages show some of the best ways to pose curvy models, as well as how to use each pose to hide what the viewer isn't meant to see. But don't forget to make the most of all those beautiful curves, too.

#083

CHAIR GAMES

Some poses that automatically look good with slim models can be easily adjusted to look great with curvy models, too. Take a close look at the images on this page and check out the way the position of the model's arms and hands makes the pose look tapered toward the lower edge of the frame. Her arms also cover her tummy, which is often necessary in sitting poses.

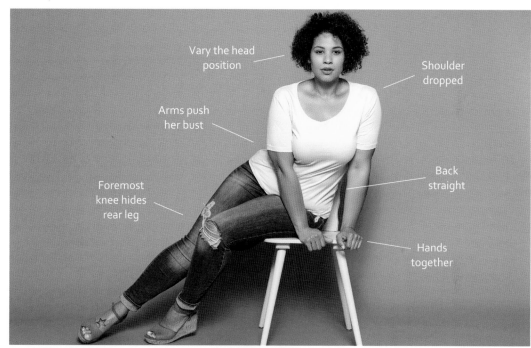

Vary the head position

Shoulder dropped

Arms push her bust

Back straight

Foremost knee hides rear leg

Hands together

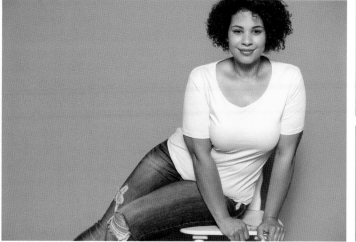

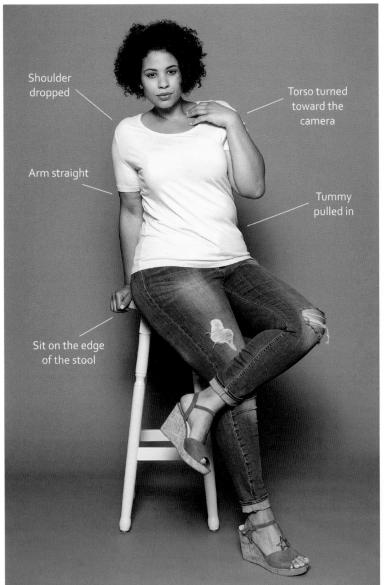

Shoulder dropped

Torso turned toward the camera

Arm straight

Tummy pulled in

Sit on the edge of the stool

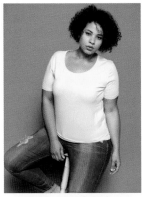

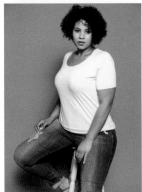

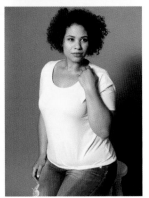

BARSTOOL

Whether your model is perched on a barstool, a window ledge, or the hood of a car, she needs to cross her legs (or at least keep them close together) to keep the pose looking feminine. With her legs slightly apart (see variations #1 and #2), the pose looks more self-assured (see also #001 and #002). The model in this shot can use her hands to hide her tummy or her hips.

085

FRAMING

This page demonstrates a nice portrait pose in which the model uses her hands to draw attention to her face (variation #1). By framing her bust and her face (variation #2), she draws equal attention to her face and cleavage. Once the basic position is right, all the pose variations concentrate purely on the model's face and chest areas.

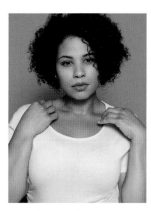

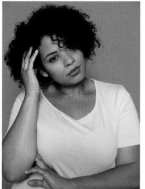

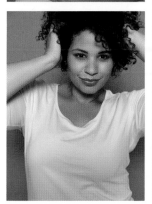

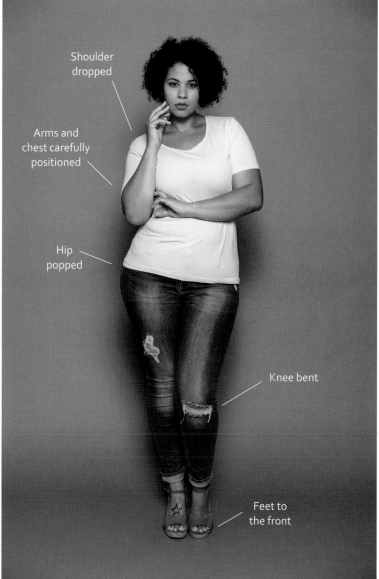

Shoulder dropped

Arms and chest carefully positioned

Hip popped

Knee bent

Feet to the front

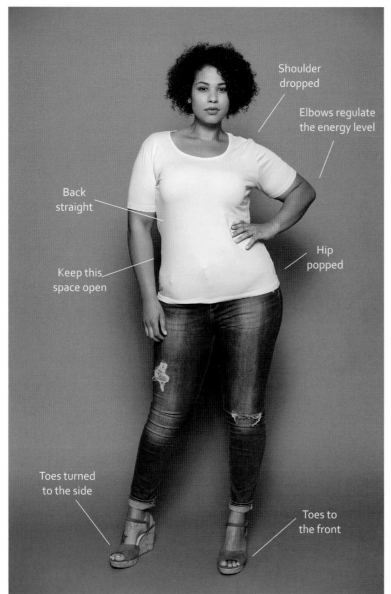

Shoulder
dropped

Elbows regulate
the energy level

Back
straight

Keep this
space open

Hip
popped

Toes turned
to the side

Toes to
the front

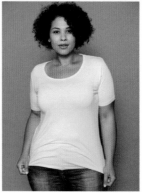

HEAD-ON

Curvy models, too, can be successfully photographed head-on without using any tricks. For the main pose, the model needs to keep her fingers stiff and use them to accentuate her waist. She can then use the elbow of the same arm to create an angle, which injects energy into the pose. Her other arm can simply hang loosely. Combined with the spaces formed by her arms and between her legs, these tricks make the model appear slimmer.

087

SHY GIRL

Don't let concentrating on your model's figure detract from her other attributes, such as her face. Forget tricky poses for a moment and try to captivate the viewer using just your model's facial expression and the emotions it transports. She should position her hands and arms to inconspicuously disguise her tummy and make the pose taper toward the bottom. The main image here illustrates a shy look.

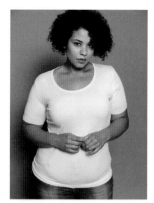

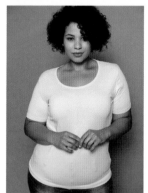

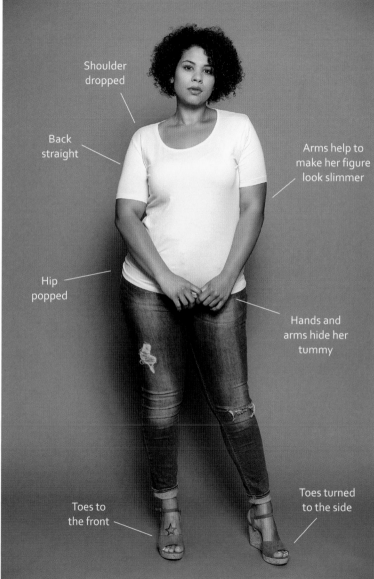

Shoulder dropped

Back straight

Arms help to make her figure look slimmer

Hip popped

Hands and arms hide her tummy

Toes to the front

Toes turned to the side

101

Facial expression
to suit the
overall pose

Shoulder
dropped

Elbows regulate
the energy level

Back
straight

Hands to
accentuate
the waist

Hip
popped

Knee
bent

Feet to
the front

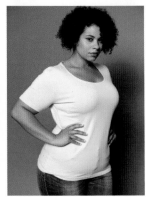

MAKE IT WORK FOR YOU

Sublime is better than self-conscious! Get your model to present her curves proudly to the camera—anything that isn't quite right can be tweaked. Placing hands on hips nicely defines a curvy model's waist (slim models shouldn't do this, as it attracts too much attention to their hands). The important thing here is that your model adopts a strong facial expression that underscores the power of the pose.

#089

LEAN DOWN

Get your model to point one hip way out and drop the shoulder on the same side way down. The increased distance between chin and shoulder produces a cooler, more masculine look. She can let her arms hang loosely or, if required, use them to cover her tummy. Keeping her feet close together adds a slimming appearance.

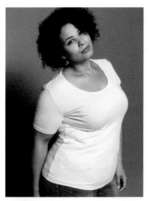

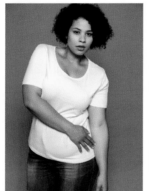

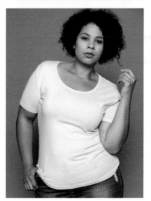

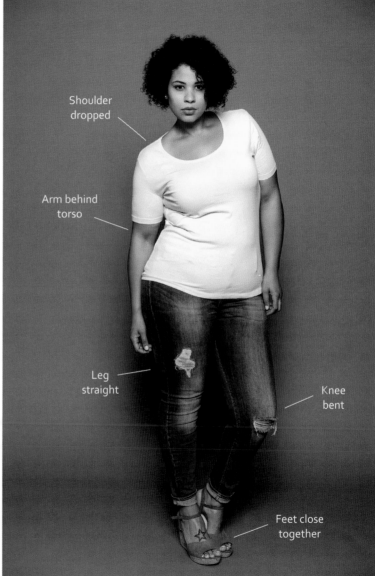

Shoulder dropped

Arm behind torso

Leg straight

Knee bent

Feet close together

Shoulder
dropped

Elbows regulate
the energy level

Free space

Hip
popped

Toes to
the front

LEG UP

Use movements within the pose to show just how nimble the model is. The example here shows what happens when the model raises one leg. Make sure the raised knee doesn't face directly toward the camera, otherwise her leg will look foreshortened and her knee will appear disproportionately large. Experiment with various movements and make sure your model is having fun at the same time.

091

HIGHLIGHTING CURVES

Placing the model's hands on her waist, on her hips, or offset on both nicely highlights her curves. It is important that her palms lay flat on her body to emphasize the line her curves already make. Keep the spaces between her arms and her body open, which prevents the pose from looking too blocky and underscores her curves, too.

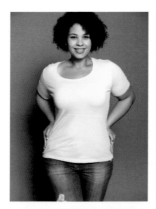

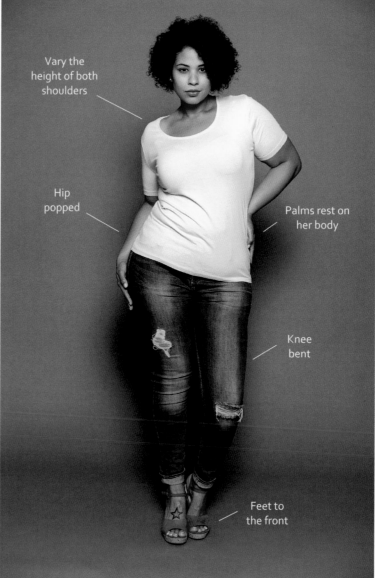

Vary the height of both shoulders

Hip popped

Palms rest on her body

Knee bent

Feet to the front

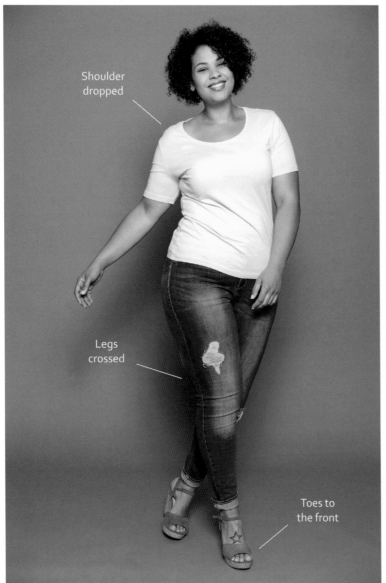

Shoulder
dropped

Legs
crossed

Toes to
the front

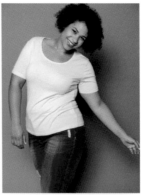

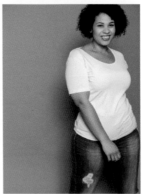

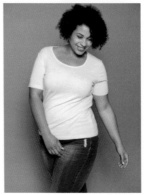

WALK ON BY

 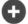

Another way for your model to look nimble is to let her arms hang freely while she takes large strides to the side. She needs to make sure her arms are relaxed so that they swing with her steps. She also needs to drop the shoulder on the side where her hip is closest to the camera. This produces a cool, lively look. If your model is wearing clothes that flow with her movements, this will further enhance the effect.

THE VIEW FROM ABOVE

The poses shown here are all completely different but have the common factor of a raised camera position. This makes the model's face and chest the dominant elements in all these images, while her tummy, hips, and legs fade into the background. In reclining poses shot from above, the model should point her legs away from the camera. Capturing a pose like this with a wide aperture (i.e., shallow depth of field) draws even more attention to the model's face and cleavage. This trick is great for adapting a whole range of poses for curvy models.

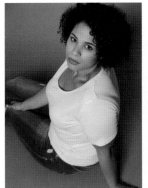

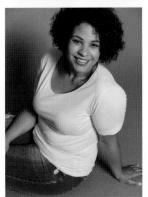

107

CURVY BOUDOIR

Curvy models don't have to be photographed in flowing robes and oversized clothes. There are plenty of poses that make fuller figures look great in scanty clothing.

NOT A CHAIR FOR SITTING ON

Sitting down makes anyone appear shorter and heavier. Virtually every model shows some tummy when sitting, and this is especially true of curvy models wearing lingerie. Don't sit your model down, but instead use the furniture as a prop. The idea is always to maintain great posture that looks as tall and slim as possible. These images will give you some ideas about using a barstool as a prop for achieving exactly that.

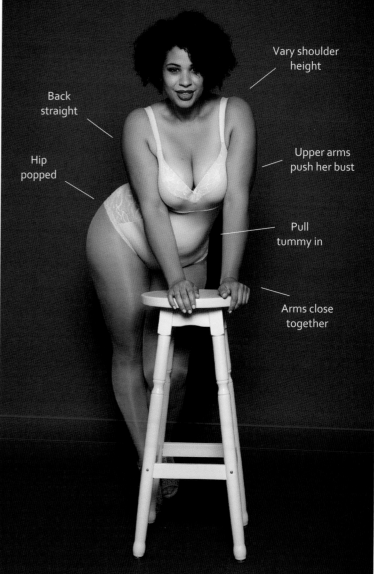

Vary shoulder height

Back straight

Hip popped

Upper arms push her bust

Pull tummy in

Arms close together

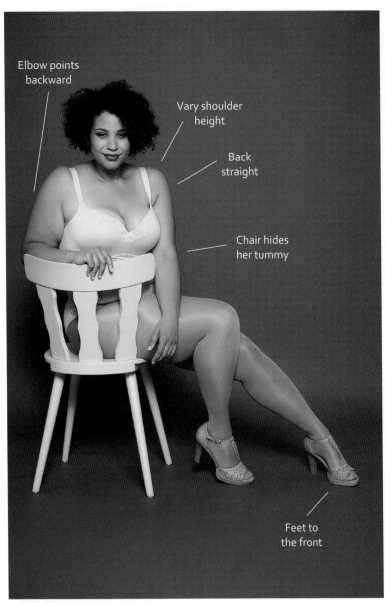

Elbow points backward

Vary shoulder height

Back straight

Chair hides her tummy

Feet to the front

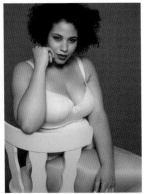

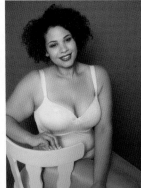

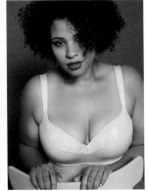

IN HIDING

If you need to get your model to sit, then do it in an unconventional way. The back of a chair is great for hiding details that you don't want the viewer to see. To present a nice, round-looking behind, have the model lean slightly forward and slightly arch her back. If necessary, she can then use her front hand to hide her tummy. Make sure she doesn't lean her head back too far; otherwise she will look as if she is tipping forward.

095

GRAB YOUR SIDES

Placing your model's hand above her hips accentuates the curve of her waist, and she can exert a little pressure to increase the effect. Depending on how full her arms are, you can get her to point her elbow to the side or backward. You need to find the right compromise between foreshortening her arm and having it disappear completely into the background. She can use her other hand to hide her tummy or to steer the viewer's gaze toward her face or chest.

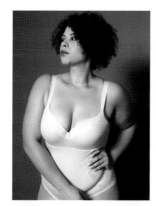

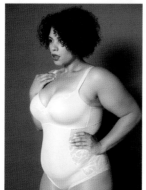

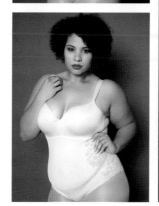

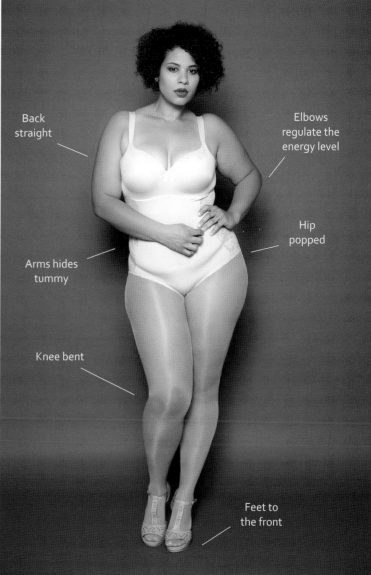

Back straight

Elbows regulate the energy level

Hip popped

Arms hides tummy

Knee bent

Feet to the front

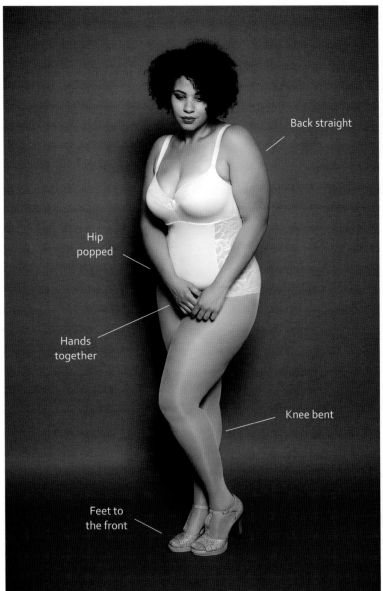

Back straight

Hip popped

Hands together

Knee bent

Feet to the front

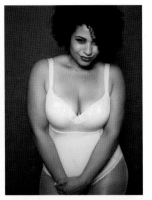

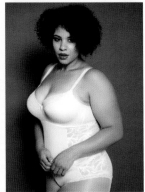

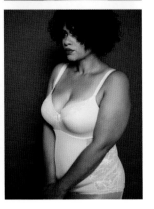

#096

"V" ARMS

Clasped hands can be used to disguise problem zones or simply to give the pose a tapered look. The previous poses in this chapter include a number of variations on these two tricks. Here, the "V" shape our model is making with her hands and arms forms a frame that directs the focus toward her face and chest.

#097

GUIDING FOCUS

Focus on your model's best features. If she has a full bust, get her to guide the viewer's gaze using her hands. She can grab her bra straps or panties, too. Variation #3 shows how varying the camera position can add verve to this type of pose. Try different facial expressions such as playful, smirking, earnest, laughing, and so on. You will both be surprised at how many great images you can produce.

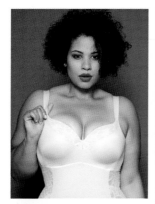

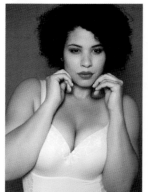

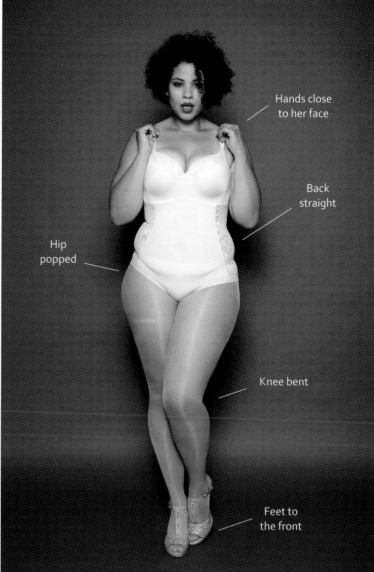

Hands close to her face

Back straight

Hip popped

Knee bent

Feet to the front

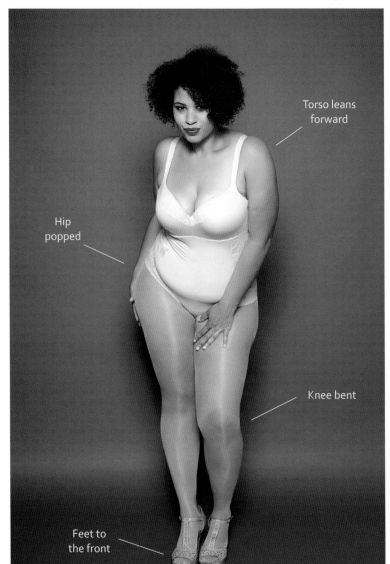

Torso leans
forward

Hip
popped

Knee bent

Feet to
the front

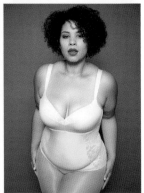

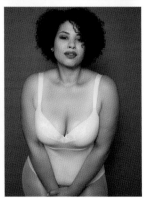

LEAN
FORWARD

If your model has broad hips, positioning her at a slight angle toward the camera will make her hips appear slimmer. To do this, she needs to transfer her weight to her back leg and lean slightly forward. If she leans on her front leg, her hip will move closer to the camera and will look disproportionately large compared to her torso, which is what you are trying to avoid.

#099

BOOBY TRAP

This pose is designed to provide sex appeal. Your model can use her arms to exert pressure on her bust and make it look as firm as possible. She can then use her free hand to support her other arm or hide her hip. If she turns her head away from the camera, the viewer's attention will be steered toward her chest. If she looks directly at the camera, the viewer will be attracted to both her face and chest.

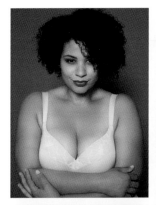

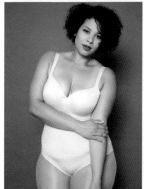

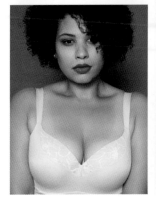

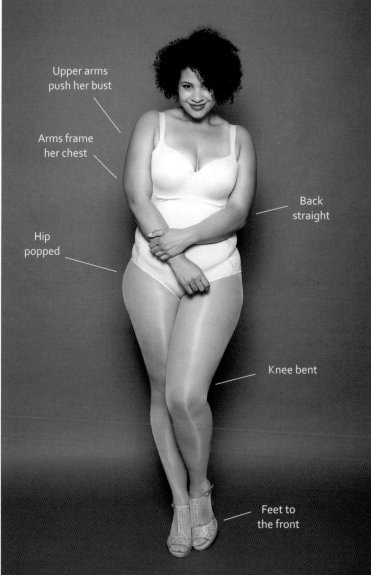

Upper arms push her bust

Arms frame her chest

Hip popped

Back straight

Knee bent

Feet to the front

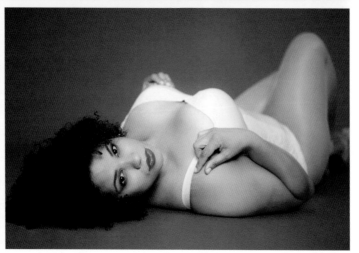

Knees offset

Tummy pulled in

Chin raised

Forehead not wrinkled

Fingers fanned

Elbow points to the side

RECLINING

In this pose, the model's face and chest are the center of attention, while her hips and tummy no longer play a role. As you can see in the variations, a shallow depth of field combined with some subtle repositioning of the arms and hands produces a completely new look. If you want to focus on the model's chest, get her to look away from the camera or place her hands close to her chest.

#101

MERMAID

In this pose, too, clever positioning of your model's arms can help to direct the viewer's gaze or disguise problem zones, thus ensuring that her face and chest are the center of attention. If she supports her weight with just one arm, she can use the other to hide her tummy or her hip.

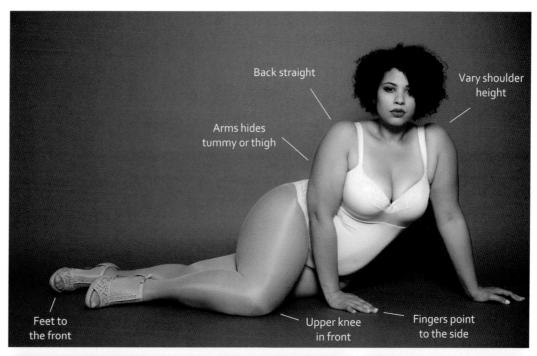

Back straight

Vary shoulder height

Arms hides tummy or thigh

Feet to the front

Upper knee in front

Fingers point to the side

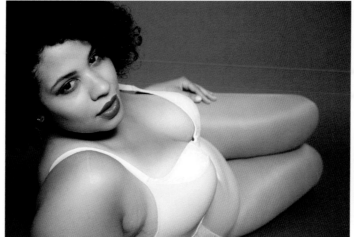

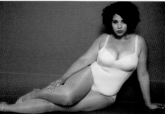

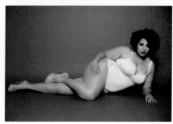

117

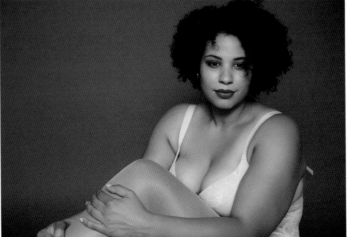

Knee raised

Toes point to
the side

Rear leg
straight

Arm hides
her thigh

Thigh hides
her tummy

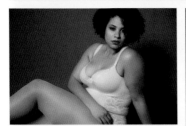

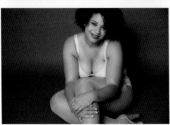

CHILL OUT

Position your model so that her feet are closer to the camera than the rest of her body. Offsetting her legs extends her entire body visually and gives her the opportunity to grab her knee, thus enabling her to simultaneously hide her hip, her tummy, and her calf.

FORE-SHORTENING WELCOMED

Rules need to be questioned and, now and again, their validity checked. One of the unwritten rules of photographing models is that you should avoid fore-shortening effects at all costs. Unlike with slim models, it is not always a good idea to have curvy models point their elbows to the side. Fuller arms positioned to make a 45-degree angle don't always produce the same cool "fashionista" look that slim arms do in the same pose. In this case, the visual benefits of narrowing the overall silhouette at the cost of foreshortening the arms is worth the trade-off.

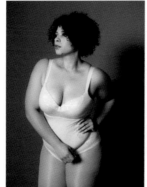

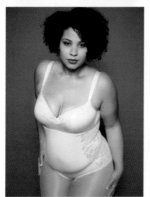

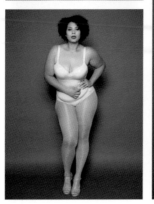

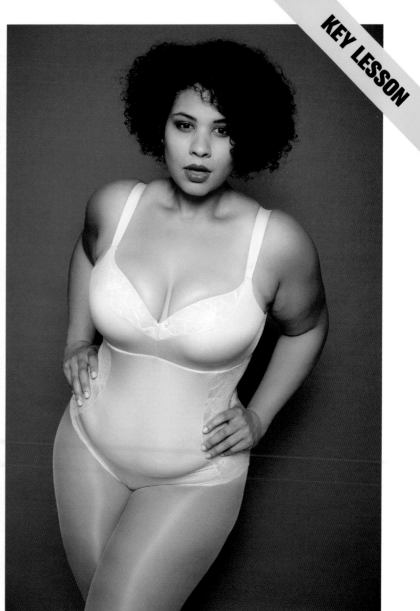

SPORTS

Sporty poses are on an uptrend. This chapter puts less emphasis on specific poses, and instead details the basic techniques involved in capturing a variety of sports and athletic movements.

103

STANDING WARM-UP

On all sports shoots, your model should warm up and pump her muscles before you begin. A nice side effect of a warm-up is that your model will begin to perspire, which underscores the sporty nature of the shoot and implies physical exertion. But don't overdo it—she shouldn't look like she just ran a marathon! As an alternative to real sweat, your model can use body oil to achieve a similar effect.

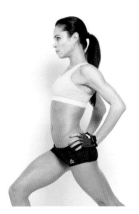

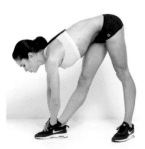

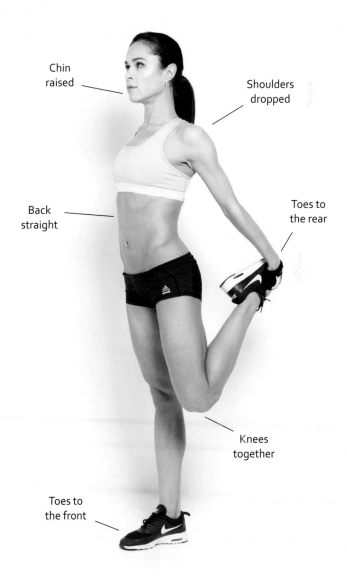

Chin raised

Shoulders dropped

Back straight

Toes to the rear

Knees together

Toes to the front

121

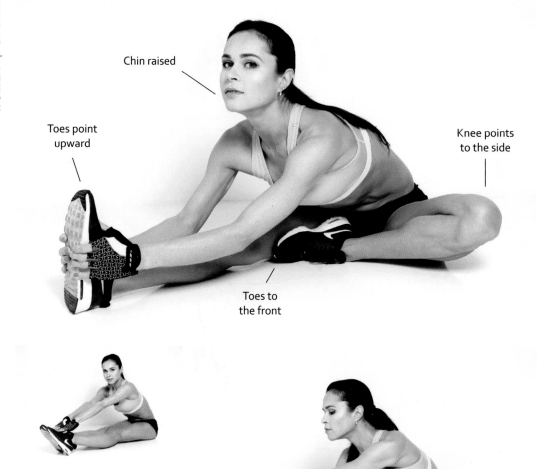

Chin raised

Toes point upward

Knee points to the side

Toes to the front

SITTING WARM-UP

You can make it easier for your model if you get her to do floor-based warm-up exercises. On any kind of shoot, a model usually feels more confident on a chair or on the floor than she does if she is standing in the open in front of the camera. In a sitting position, she knows what she has to do with her body and can concentrate fully on producing the right facial expression.

#105

START SLOWLY

It is often a good idea to discuss the movements you want to capture with your model before you begin shooting. Neither photographer nor model should rely on the other calling the shots. Start with simple exercises, and move on to more complex poses as you both warm up. This approach ensures that you don't lose your way and that you both grow into your own aspect of the job as the shoot develops.

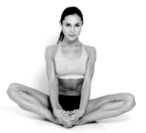

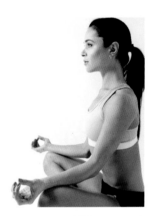

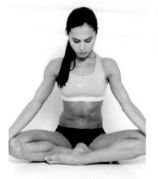

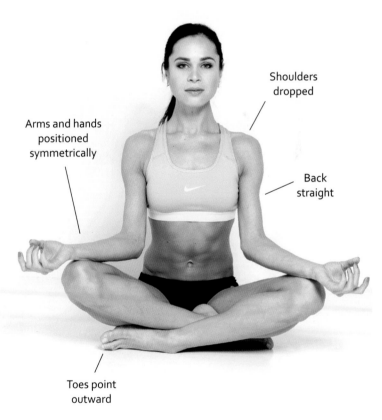

Shoulders dropped

Arms and hands positioned symmetrically

Back straight

Toes point outward

123

Torso facing
the camera

Hand
grabs toes

Arm
straight

Hand balanced
on fingertips

Toes point to
the side

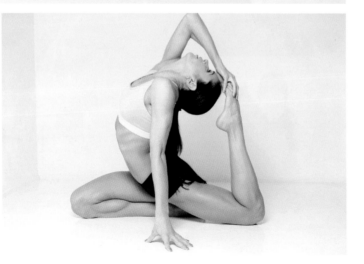

STAGE 2

Once a shoot is flowing, you can raise the bar. Whether you are trying a tricky pose or are simply following a client's instructions, you need to make sure you don't put pressure on your model. Tell her you are going to try an idea together, and that it's no problem if it doesn't work out. Including her in the development process makes the pressure of a shoot much easier to handle for everyone.

107

PACE THE SHOTS

 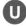

The trick with sports shoots is not to move on too quickly. Especially when you are shooting strenuous poses, you need to let your model take regular breaks so that she doesn't get red in the face or end up with pulsing veins in her head and neck. Don't keep her in any pose for too long. Check your results, and correct any flaws in the next shot.

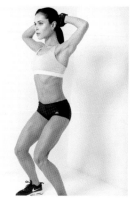

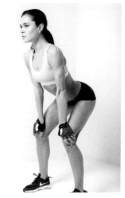

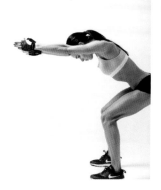

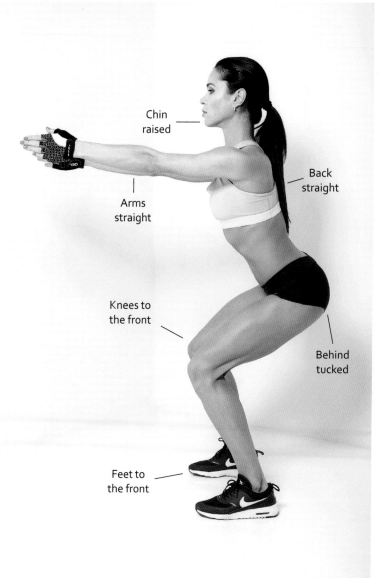

Chin raised

Arms straight

Back straight

Knees to the front

Behind tucked

Feet to the front

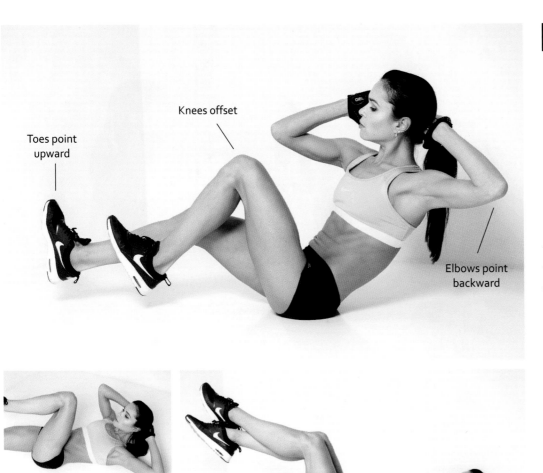

Toes point
upward

Knees offset

Elbows point
backward

WORK THOSE ABS

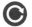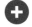

There are just as many ways to photograph sit-ups as there are to perform them. The main image is packed with sharp angles and triangles that add energy to the pose. When choosing your camera angle, make sure the model's elbows don't point toward the camera and that her arms aren't foreshortened. Vary the camera angle and position, and try plenty of different framing options while you work.

PROPS

Your model doesn't actually have to perform any exercise to produce effective sports images. Appropriate clothing and props, such as a basketball under an arm or the variations shown here, make it clear to the viewer that the photo is all about sports.

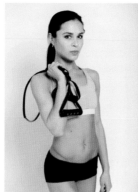

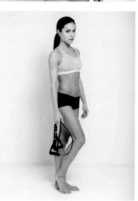

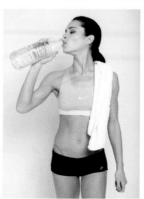

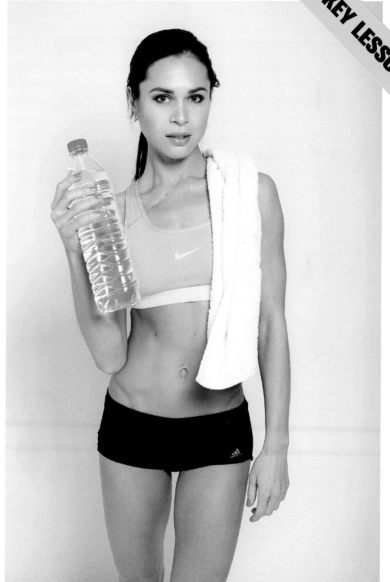

127

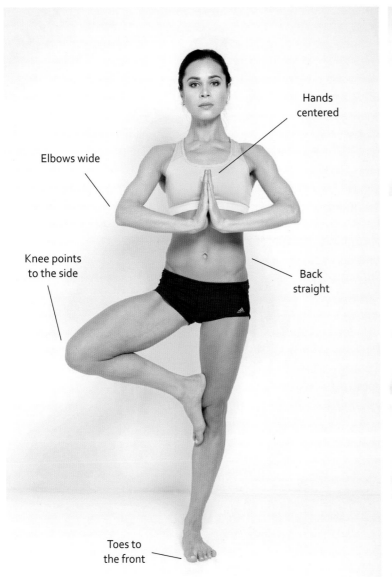

Hands
centered

Elbows wide

Knee points
to the side

Back
straight

Toes to
the front

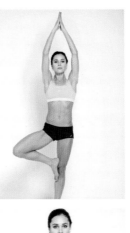

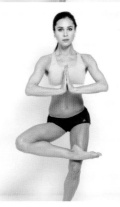

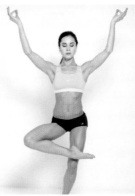

IN BALANCE

One way to effectively capture sporty movements is to get your model to repeat them slowly. If she strikes a pose that you want to capture, simply ask her to stop while you shoot before you let her carry on with her exercise. Don't mess around with the aperture or other settings while she is in a pose, as this will just get her frustrated and spoil the flow. If you need to change settings, do so in advance of the next cycle.

#110

SPIDER WOMAN

The exercises involved in various types of sports offer virtually endless posing variations. You will rarely need to disguise any of your model's features on a sports shoot, but there are still plenty of ways to use her hands and arms to cover up problem zones if required. Always find something for her to do with her hands, and keep experimenting.

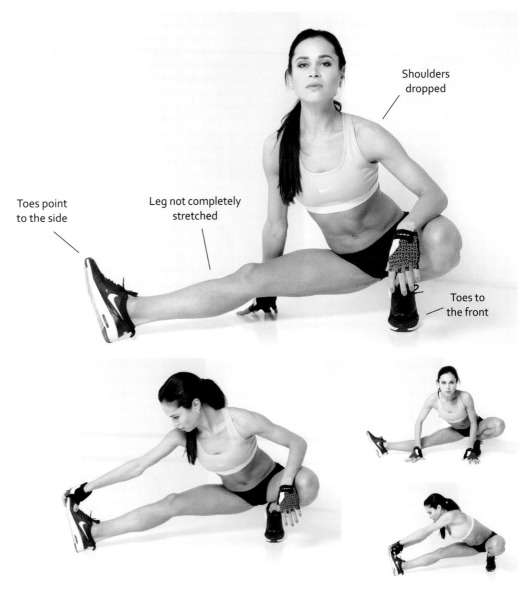

Shoulders dropped

Toes point to the side

Leg not completely stretched

Toes to the front

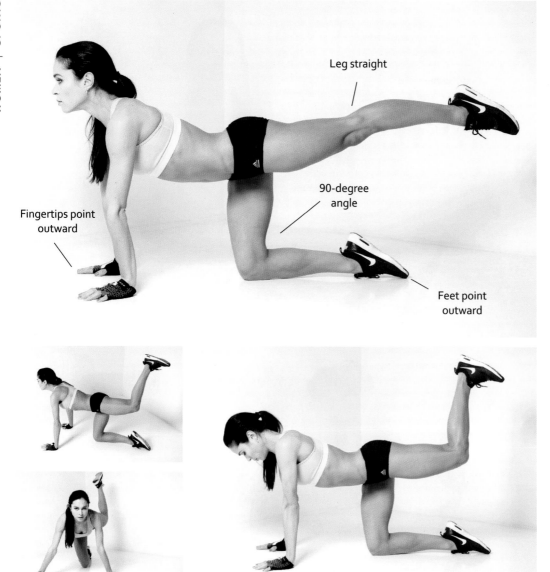

Leg straight

Fingertips point
outward

90-degree
angle

Feet point
outward

#111

LEGS AND BEHIND

The part of your model's body that is central to an image needs to be appropriately emphasized. In this case, the focus is on her behind and her legs, and the exercise she is doing underscores this. Variation #2 at bottom left shows a different viewpoint of the same exercise, but this shot focuses more on the model's face.

112

JUMPING

U

Whether you are capturing large or small movements, you can use a countdown to optimize your timing. For example, agree with your model which pose she is to strike on a count of three. This way, she is prepared for the moment and you won't end up capturing inappropriate facial expressions that result from her exertions. Once you have a couple of shots in the bag, you can correct any flaws in the subsequent attempts. All the while, you can be fine-tuning your shutter-button timing.

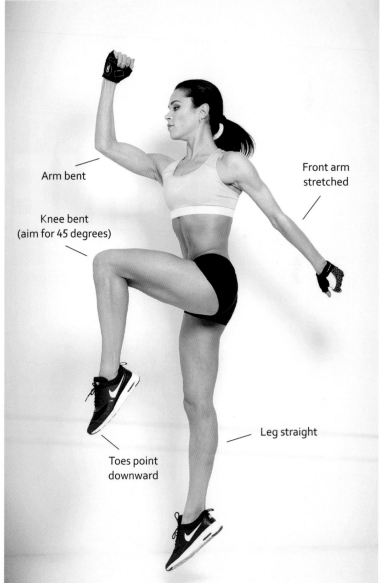

Arm bent

Front arm stretched

Knee bent (aim for 45 degrees)

Leg straight

Toes point downward

BUSINESS

Business situations demand poses that are very different from those we have looked at so far. We are no longer emphasizing physical attributes, and the focus is not on sensuality or fitness. Business poses are all about communicating reliability, competence, and empathy.

#113

SITTING STRAIGHT

Sometimes your model is not meant to appear sexy or dreamy—here she means business! Holding her head high conveys a confident attitude. I didn't plan to include negative examples in this book, but the model's hands in the main image here are an exception. This position is too fidgety-looking and draws the viewer's attention away from the rest of the pose. For business poses, your model should keep her fingers together and lay her hands on top of one another. The hand positions in the variations are much better.

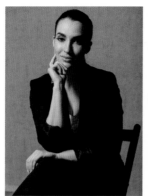

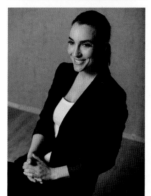

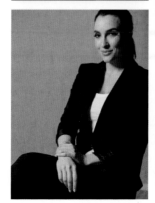

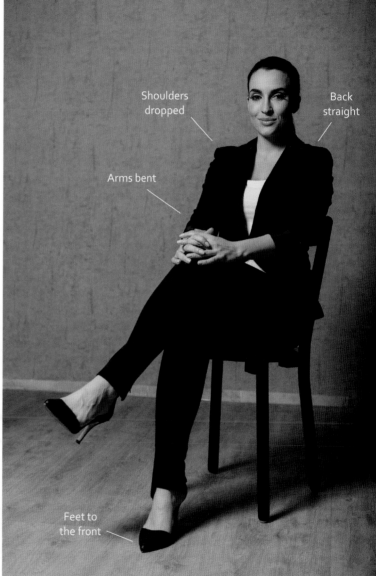

Shoulders dropped

Back straight

Arms bent

Feet to the front

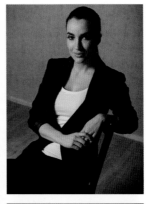

Vary the head position

Torso turned toward the camera

Elbows point to the rear

Grab fingertips with the other hand

Feet to the front

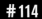

#114

SITTING CASUALLY

A chair back, table, or counter is great for resting your model's arms, but for this to work, she has to sit (or stand) at an angle to the camera. Models often don't know what to do with their hands. To ensure they don't just hang there looking lost, get your model to grasp the fingers of one hand with the other hand.

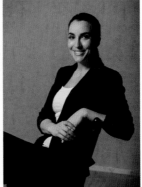

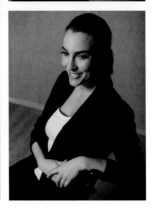

115

A FINE PORTRAIT

A great headshot should immediately grab the attention of a prospective employer or client. Try out a variety of hand positions and facial expressions. Take care if your model rests her arms on her knees, as this might cause her back to slump. Keep an eye on her back at all times!

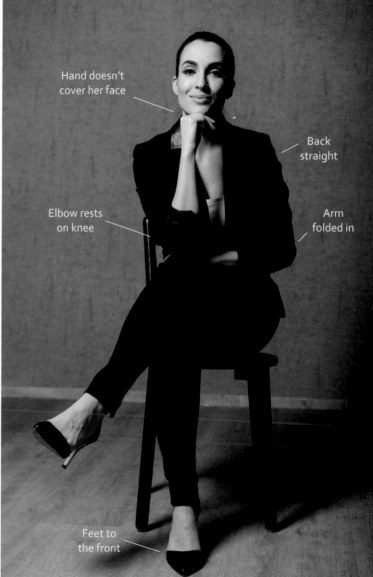

Hand doesn't cover her face

Back straight

Elbow rests on knee

Arm folded in

Feet to the front

135

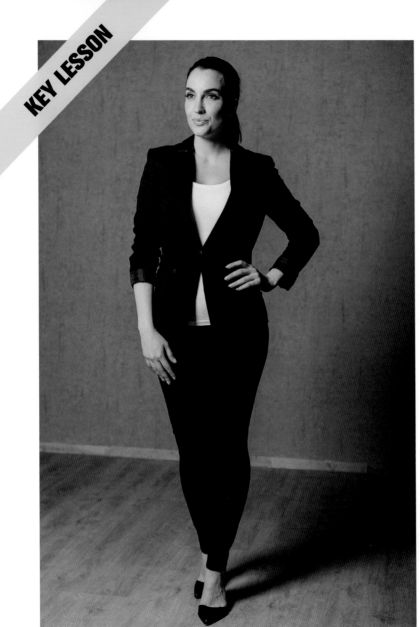

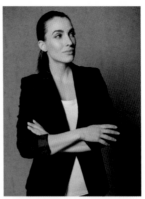

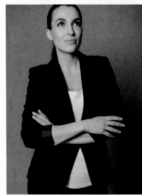

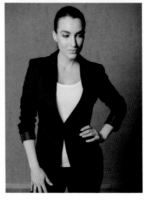

LINE OF SIGHT

The model's line of sight is different in each of these images. Can you read the messages each is sending? Eye contact (or lack thereof) is extremely important in a business context. Looking directly past the viewer toward the horizon communicates determination and a sense of purpose, whereas looking upward infers a cry for help to a higher power. A downward gaze suggests subservience, timidity, or being satisfied with the status quo.

#116

DEFENSIVE

Here, the model covers her torso with her arms, forming a pose that is classified as defensive. This pose is not suitable for someone who works in customer acquisition, but is fine for someone who is perhaps a partner in a renowned law firm. The overall impression is of confidence and strength. In contrast, if you photograph the same pose from above (as in variation #3), it creates a more subservient and obliging impression.

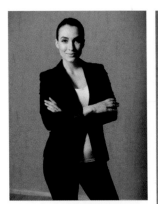

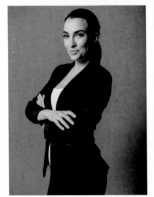

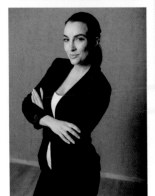

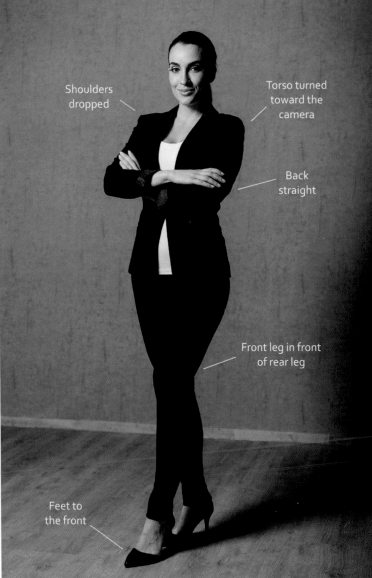

Shoulders dropped

Torso turned toward the camera

Back straight

Front leg in front of rear leg

Feet to the front

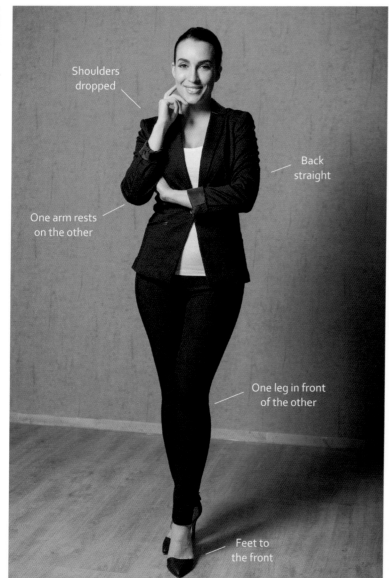

Shoulders dropped

Back straight

One arm rests on the other

One leg in front of the other

Feet to the front

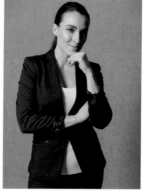

THE THINKER

All it takes is a quick movement of one arm to switch from defensive to pensive. Make sure the raised hand is shown in profile. You can create very different moods simply by getting your model to place a finger on her cheek or her fist beneath her chin. The fist symbolizes strength and resolve, whereas a finger placed on a cheek or temple signals careful consideration.

#118

MERKEL'S RHOMBUS

This is a gesture that has become world famous thanks to its continual use by German chancellor Angela Merkel. Although it is generally a symbol of calm, if it is used at the wrong moment or in front of someone who is agitated, it can appear arrogant, or even plain ridiculous. Grasping the fingers of one hand with the other hand is a much simpler and more modest version of this position.

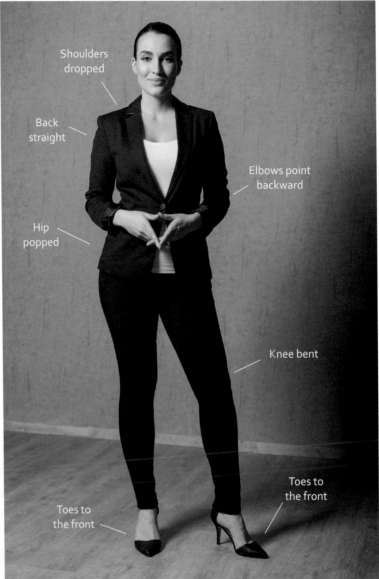

Shoulders dropped

Back straight

Elbows point backward

Hip popped

Knee bent

Toes to the front

Toes to the front

139

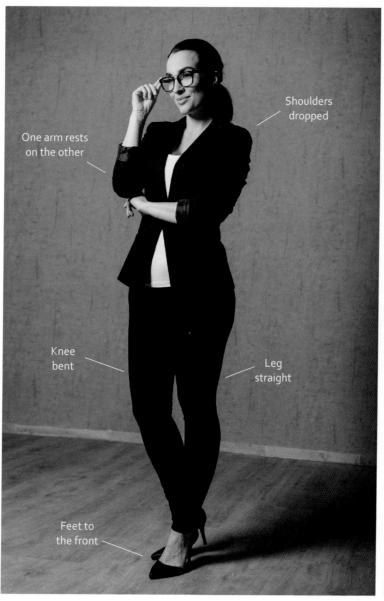

One arm rests
on the other

Shoulders
dropped

Knee
bent

Leg
straight

Feet to
the front

EYEGLASSES

Eyeglasses are very much a part of our everyday lives and they often take on the role of a stylish accessory. However, unwanted reflections can quickly spoil even the best photo. To prevent reflections, you can alter the position of your lights or get your model to lean her head slightly forward (or to the side). Her glasses can be used as an accessory, but should never be used too playfully. Whatever you do, don't let the model put the tip of the temple in her mouth!

#120

CONSULTATION

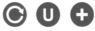 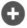

Business photos are often captured in offices or other spaces on a company campus, so it's a no-brainer to use tables, desks, or other business decor to set the scene. This kind of photo is ideal for inclusion in print or online marketing material. In other words, these images are best aimed at end users rather than at people looking to make new contacts. If your model is leaning against an article of furniture, make sure she doesn't emphasize her behind or hips too strongly.

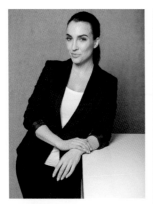

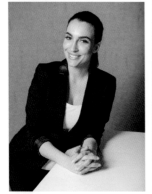

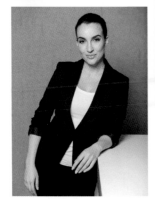

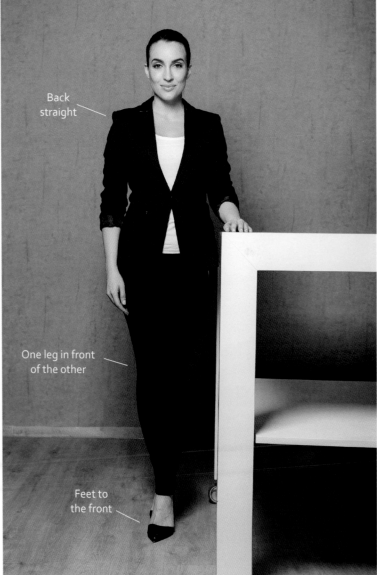

Back straight

One leg in front of the other

Feet to the front

Vary shoulder height

One hand clasps the other

Elbow points to the side

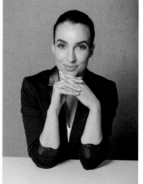

WHO'S THE BOSS?

If your model sits directly facing her desk, her hands and arms are positioned symmetrically and give the impression of someone who is in charge. Interestingly, asymmetrical poses tend to suggest that the person in the picture is a member of a team rather than a team leader. The images here clearly demonstrate this difference.

#122

TA-DA!

To round off this section, here are some poses that you can use when a product photo, an illustration, or text is added to the image later on. The model should always smile (or at least look friendly) in this type of shot. She can look directly at the camera or use her gaze to steer the viewer's attention toward the product.

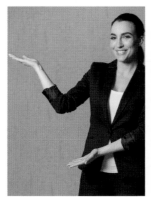

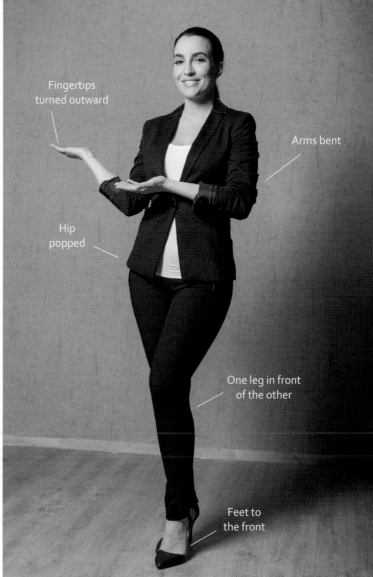

Fingertips turned outward

Arms bent

Hip popped

One leg in front of the other

Feet to the front

WALL

Chairs, tables, and bare floors have thus far formed the stage for our models. Using a wall (or something to lean against) opens up a whole new world of exciting poses!

#123

SIT LIKE
A MAN

What works on chairs and stools works just as well on the floor. The farther your model spreads her legs, the more masculine the pose will appear and the more confident she will look. To avoid unwanted provocations, she can use her hands to casually cover her crotch. If that isn't what the shoot demands, you can look for other ways to position her hands and arms.

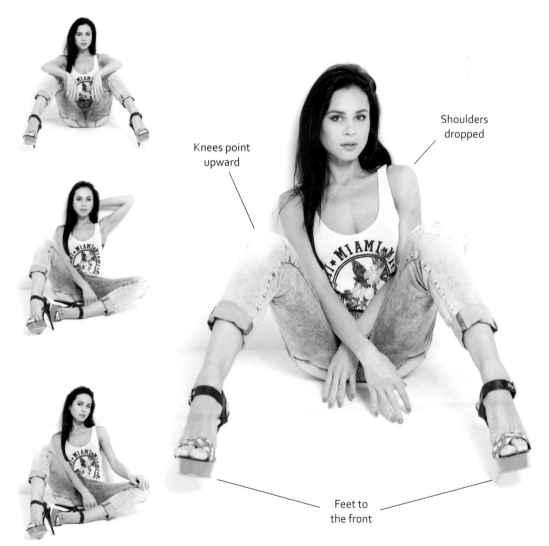

Shoulders dropped

Knees point upward

Feet to the front

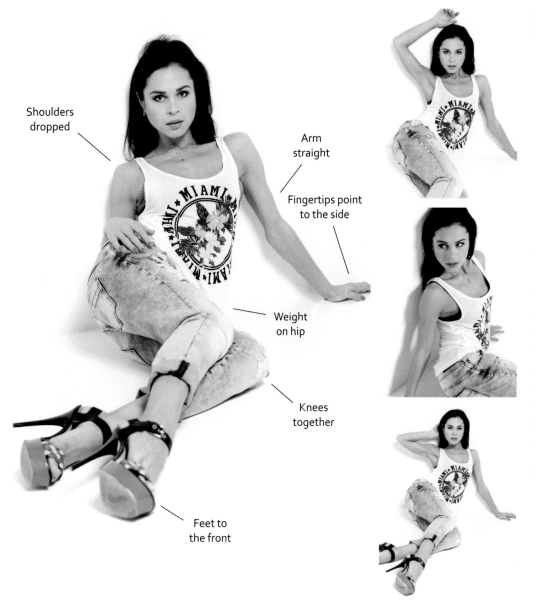

Shoulders dropped

Arm straight

Fingertips point to the side

Weight on hip

Knees together

Feet to the front

SIT LIKE A WOMAN

The moment your model places her legs or knees together, the pose immediately appears softer and more feminine. This approach also emphasizes her curves. By leaning on a wall and crossing her legs, she can create a diagonal line from her torso to her feet that gives this relatively simple pose plenty of extra verve.

#125

LEG DRAWN UP

 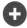

Drawing one leg up gives this pose a more casual look. However, this position requires precision and great body tone on the part of your model. The upper and lower parts of her body are rotated in opposite directions. To make the most of her curves, it is better if she rests her weight on her hip rather than her behind.

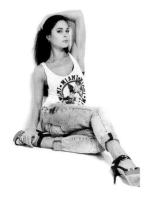

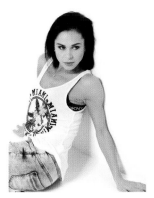

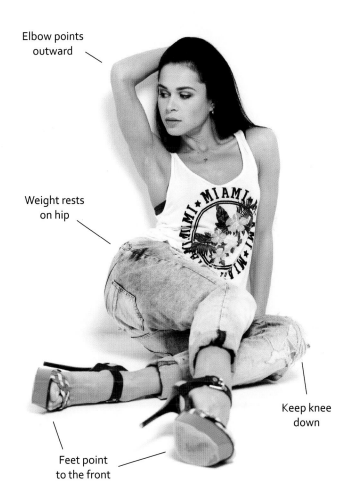

Elbow points outward

Weight rests on hip

Keep knee down

Feet point to the front

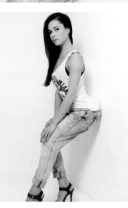

WORK SYSTEM-ATICALLY

Photo teams often put themselves under too much pressure, go into a job without enough preparation, or simply underestimate the variety of poses a single position can produce. Opportunities are often missed, and you end up restricting your own potential.

Posing against a wall can be challenging for both the model and the photographer. It forces you to think in categories and makes you work systematically when looking for new variations, whether the main theme is "profile," "head-on," "back against the wall," or something else. The following series of poses show how to make the most of each position.

SIDE CLOSE TO THE WALL

When you work with a wall, you need to imagine that your model has four "faces" (i.e., front, back, left, and right). Never switch too quickly from one face to another. Here, we see some of the options available when your model leans one shoulder against the wall. You can only find out what works best after you have tried all the possible variations. Here, variation #2 is ideal for hiding the model's tummy.

#126

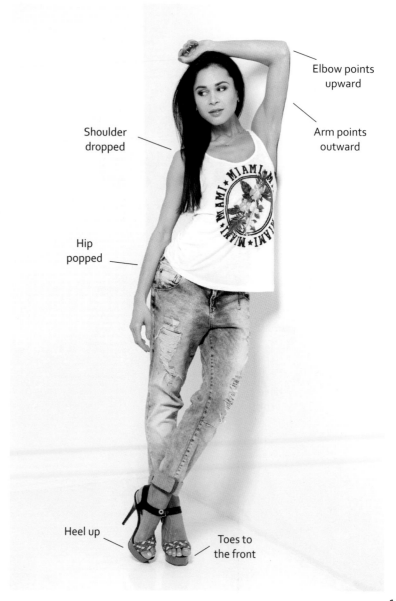

Elbow points upward

Arm points outward

Shoulder dropped

Hip popped

Heel up

Toes to the front

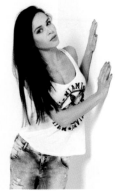

Fingertips
point upward

Shoulders
dropped

Hip
popped

Knee
bent

Feet to
the front

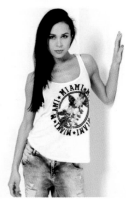

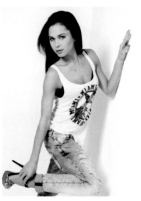

SIDE-ON WITH A GAP

In contrast to #126, this pose has the model lean on her lowered arm or her elbow, thus creating more of a gap between her body and the wall. Her fingertips should point upward to ensure that her arm doesn't look foreshortened. To keep the pose looking relaxed, make sure your model doesn't form a 45-degree angle with her arm.

#128

CLASSIC SIDE-ON

This beauty of a pose embodies a modest approach that is ideal for full-length and fashion shots. Make sure your model pops the hip on the side facing away from the wall; otherwise the pose will look awkward. The model can position her arms just as she would if the wall was not there.

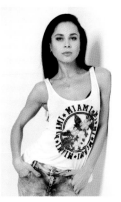

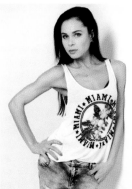

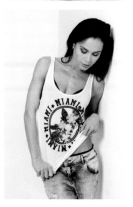

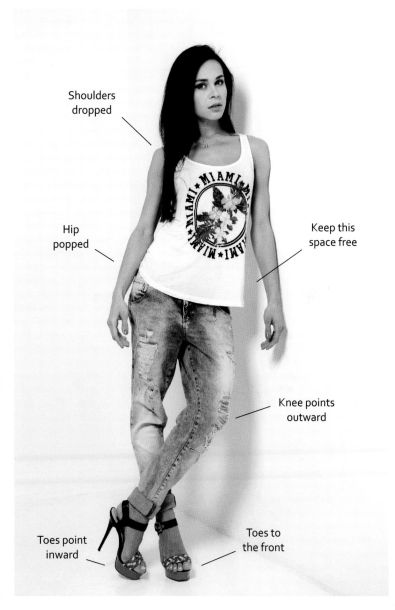

Shoulders dropped

Hip popped

Keep this space free

Knee points outward

Toes point inward

Toes to the front

Shoulders
dropped

Fingertips
point upward

Elbow points
outward

Back
straight

Hip
popped

FRONTAL AND CLOSE

As with the side-on poses demonstrated above, frontal poses can be constructed close to the wall or at a distance. Working with a gap emphasizes the model's curves and gives the pose a sexier look, whereas having her stand right up close to the wall produces a more vulnerable, emotional look. If the pose doesn't work right away, have your model turn her torso slightly toward the camera (as in the main image) or drop her front shoulder more.

#130

WEST SIDE STORY

For this pose, make sure the curve between the model's behind and her lower back is highly visible. Her front arm mustn't cover or interrupt this curve or the space between her arm and her body. Placing her front foot against the wall emphasizes the curve even more.

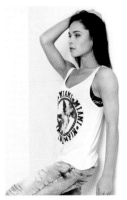

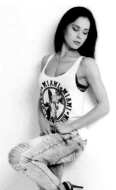

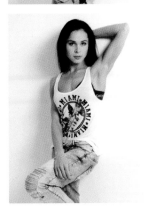

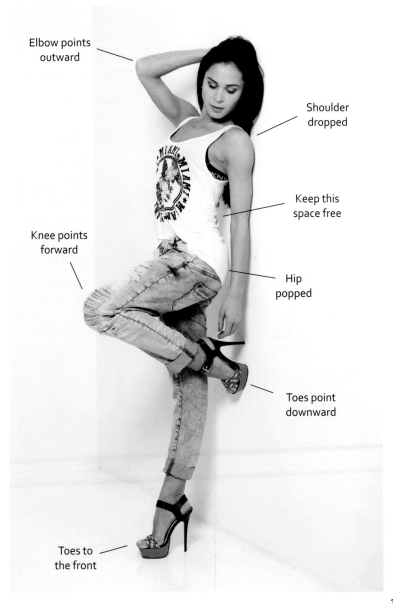

Elbow points outward

Shoulder dropped

Keep this space free

Knee points forward

Hip popped

Toes point downward

Toes to the front

Vary shoulder
height

Back
straight

Hip
popped

One leg in front
of the other

Toes to
the front

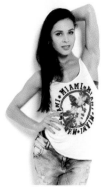
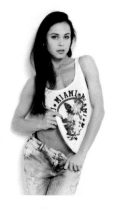
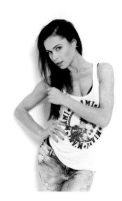

HEAD-ON

When the model poses with her back against the wall, her arms are freed up to do just about anything. Like in the fashion, portrait, and lingerie poses we have already discussed, she can pose her arms any way she likes. Don't be afraid to experiment!

#132

BOOTY LEAN

Although this pose has the model standing with her back to the wall, the only thing actually touching the wall is her behind. Once you have tried some of these variations, try turning the pose around by leaning her shoulder on the wall and moving her behind away from it. In other words, once you are comfortable working with your model's four "faces," you can begin creating sub-categories made up of the different parts of her body.

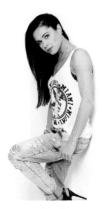

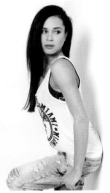

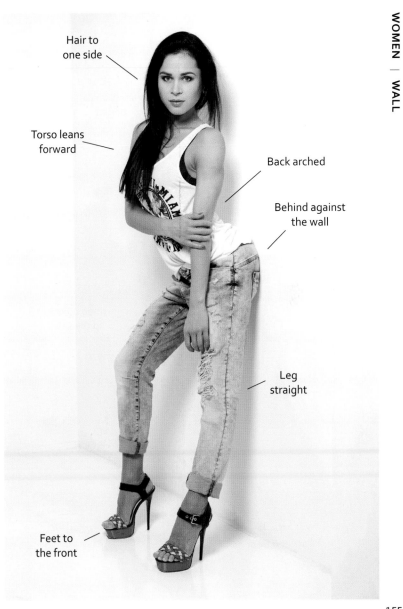

Hair to one side

Torso leans forward

Back arched

Behind against the wall

Leg straight

Feet to the front

Vary shoulder
height

Elbow points
outward

Knee points
to the side

Leg
straight

Toes to
the front

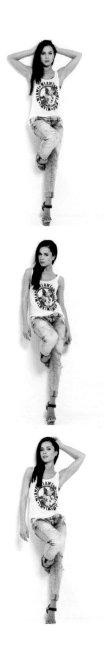

HEAD-ON SIMPLE

You need to approach wall poses just as systematically as any others. Here, for example, the main image and variation #2 show the model's arms hanging loosely while she varies the position of her head. Variation #3 includes one posed arm, and variation #1 uses both arms. Sure, this is a simple set of variations, but it demonstrates clearly what I mean. You can pep up each of these variations using different framing and camera angles, and find out for yourself which combinations you like best.

 #134

HEAD-ON SEXY

As with other sexy poses, sexy wall poses should emphasize your model's curves. Get the model to cross her legs so they create a long diagonal together with her torso. Tricks like this add vitality to a simple pose. If you photograph this pose from the side, make sure your model's behind is touching the wall.

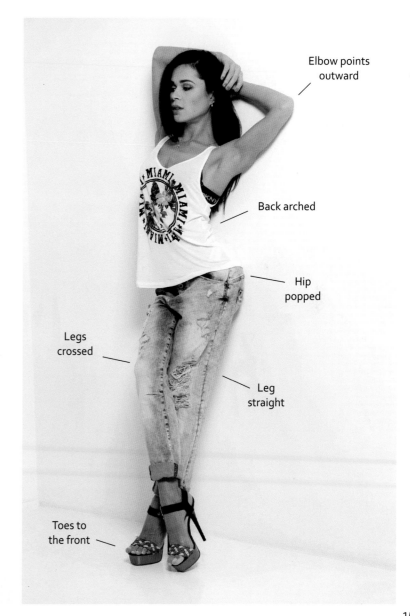

Elbow points outward

Back arched

Hip popped

Legs crossed

Leg straight

Toes to the front

157

MEN

Portraits | Fashion | Implied Nude

Sports | Business | Wall

PORTRAITS

Men often want to give an impression of coolness, strength, mystery, and resolve. This means male poses aren't designed to emphasize curves, but rather strength and character.

135

REVERSED CHAIR

Make it easy for your model by starting with an easy pose. For this one, all he has to do is sit there, while the chair back offers an additional degree of security. Photographically, you can do quite a lot with this pose, and when you have shown your model the first few successful shots, you are sure to win his trust and confidence. Then you can really get going.

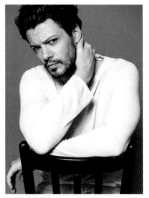

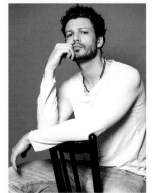

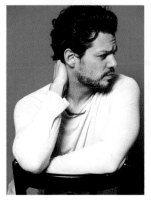

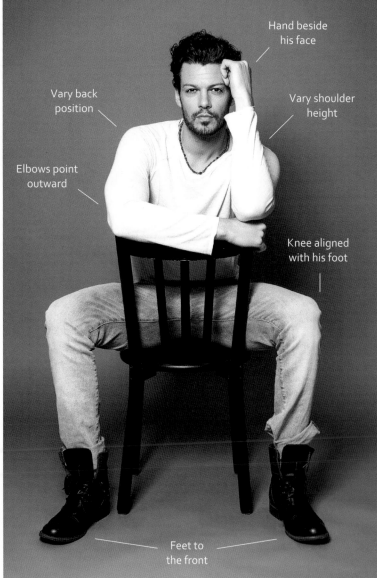

Hand beside his face

Vary back position

Vary shoulder height

Elbows point outward

Knee aligned with his foot

Feet to the front

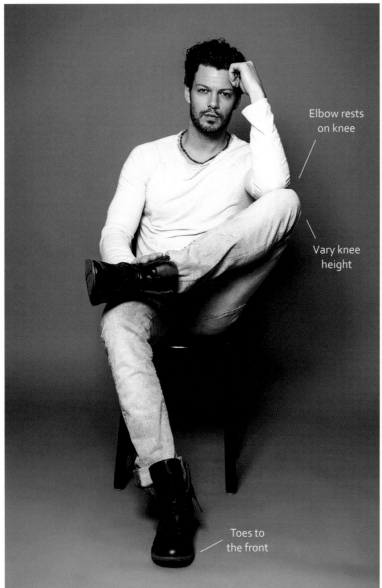

Elbow rests on knee

Vary knee height

Toes to the front

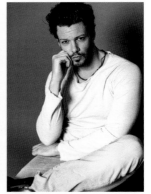

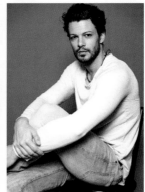

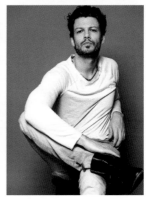

BE COOL

Men often like to see themselves as strong, fit, self-confident, and decisive, rather than cute or dreamy. One way to capture this kind of coolness is to introduce a degree of nonchalance into the pose. Your model needn't look picture perfect from the outset and is definitely allowed to look a little tousled. Facing his gaze and/or his torso slightly away from the camera produces a feeling of detachment between the model and the viewer, which also adds to the coolness portrayed in the image.

#137

THE STANDING THINKER

One way to influence the effect of a pose is to vary how open or closed the model's torso appears. These shots show the different effects folded arms can produce. The spectrum ranges from defensive to cool to unapproachable. Is this good or bad? Neither! You have to know the rules in order to break them, but once you do, you can decide for yourself what you need to turn your photographic ideas into reality.

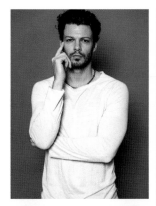

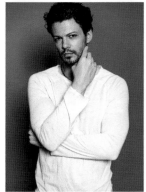

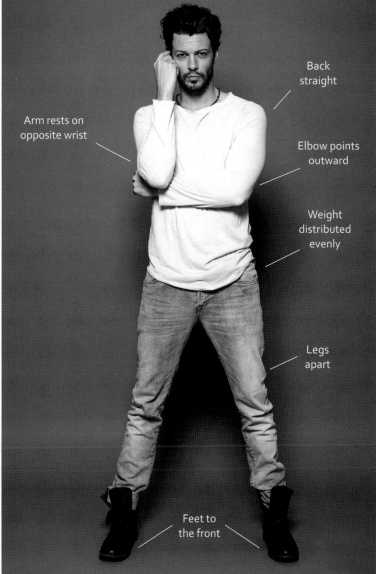

Back straight

Arm rests on opposite wrist

Elbow points outward

Weight distributed evenly

Legs apart

Feet to the front

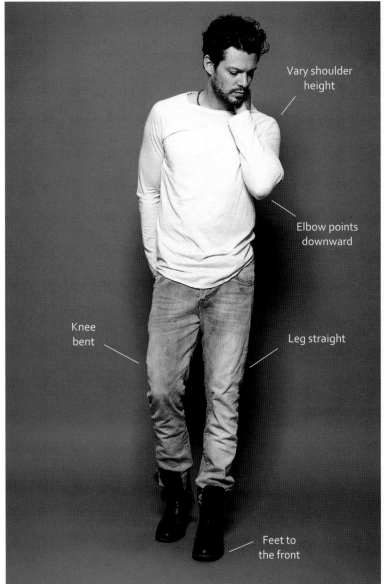

Vary shoulder height

Elbow points downward

Knee bent

Leg straight

Feet to the front

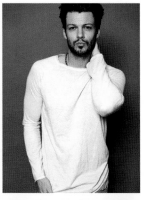

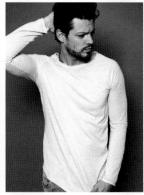

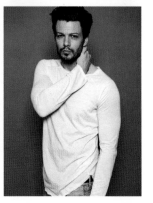

BAD MORNING

Where can we put his hands? Male models often have a hard time deciding what to do with their hands, so it makes sense to pose them as usefully and naturally as possible. Anything that makes the model look awkward and uncomfortable will immediately become visible in the resulting images. Get the model to use his pants pockets, his belt, his hips or his neck, or to simply clasp his hands. Or get him to imagine a hangover or neck pain and use the result as the basis for a sequence of poses.

139

CENTERED

U +

Symmetrical poses give a male model a determined, strong, and decisive look. Despite the inherent symmetry, you can use his hands and arms to influence the overall look of the pose, from strong to pensive or relaxed.

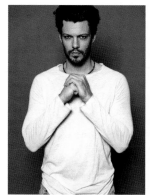

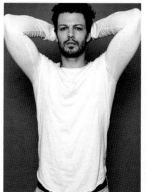

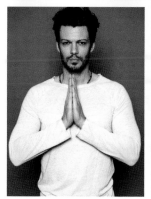

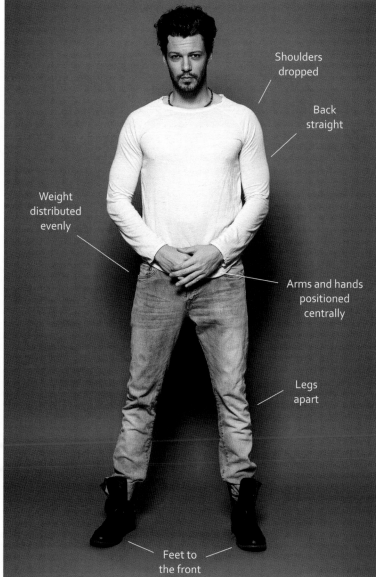

Shoulders dropped

Back straight

Weight distributed evenly

Arms and hands positioned centrally

Legs apart

Feet to the front

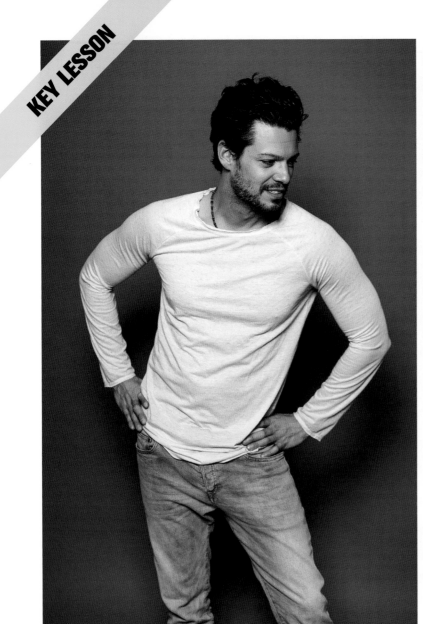

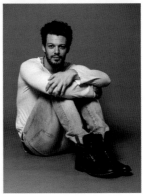

DON'T OVERDO IT

The poses shown here are all completely different but nevertheless they have one thing in common. Can you see what it is? They all stretch the pose beyond its limits and, as a result, they look over the top. This is particularly true of the main image and variation #1. Every model can make mistakes, but—especially with men—you have to make sure your model doesn't push the limits. The same is true for poses that tend toward cute (see variations #2 and #3). Poses that make a woman look exuberant, vulnerable, or adorable are usually a complete no-no for a man.

#140

DISTANCED

Folded arms produce a defensive look, but, thanks to the distanced feel, they can provide a cool, strong undertone. Getting your model to clench his teeth a little underlines the effect. This trick helps to emphasize his jawline and strengthen the masculine feel of the pose. But don't overdo it—otherwise he will look tense or just plain silly.

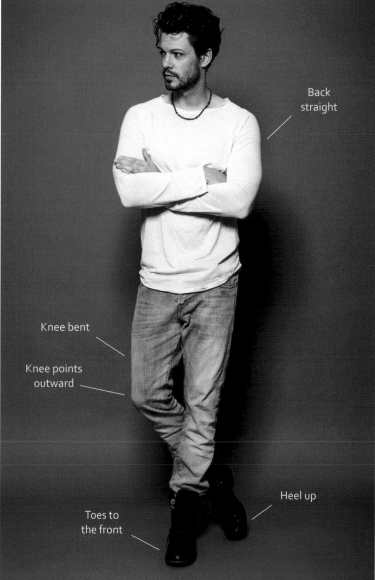

Back straight

Knee bent

Knee points outward

Toes to the front

Heel up

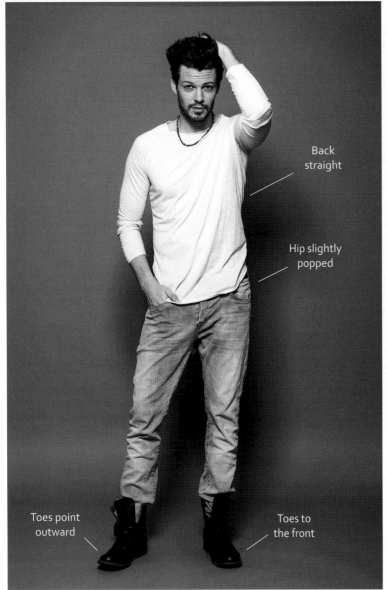

Back straight

Hip slightly popped

Toes point outward

Toes to the front

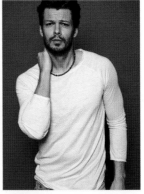

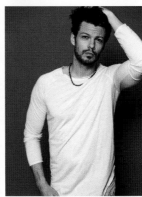

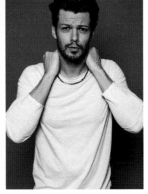

#141

STRESSED OUT

Wide eyes and babydoll looks don't suit men. They make a model look frightened or confused. As opposed to with women, a couple of creases in a man's brow or between his eyebrows don't do any harm, providing they are captured right. Get your model to run his hands through his hair, scratch the back of his head, or position his hands behind his neck.

#142

RELAXED

As you have already seen, men like to appear cool and calm. In this pose, this attitude is underscored by the relaxed position of the model's back, which is the opposite of a lot of other chest-out/tummy-in poses. However, don't let the model slump too much—he is meant to look laid-back, not slack. Depending on the camera angle and your choice of portrait or landscape format, you can position his arms to create a whole range of different-looking images.

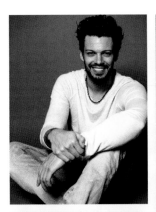
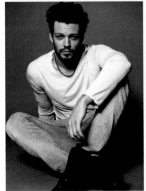

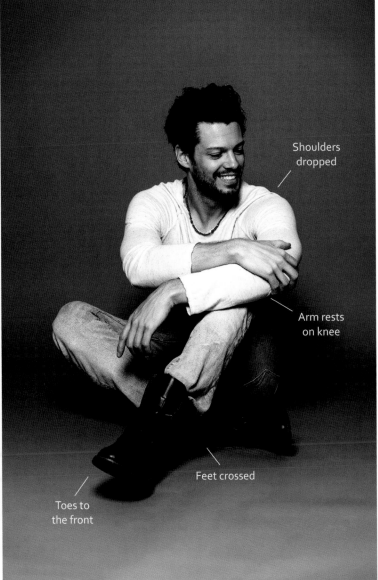

Shoulders dropped

Arm rests on knee

Toes to the front

Feet crossed

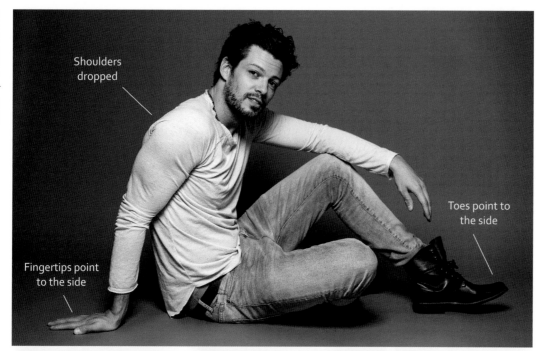

Shoulders dropped

Fingertips point to the side

Toes point to the side

IN PROFILE

To get from the previous pose to this one, all your model has to do is turn a little. This is how posing works—only move on to the next pose when you have fully exhausted all the possibilities of the present one. Trying out all the options helps you to build and subconsciously expand your repertoire. This profile pose shows how important your model's back posture is. Make sure he doesn't straighten his arms too much, as this would spoil the casual nature of the pose.

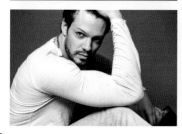

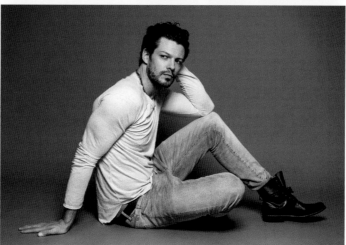

ON HIS BELLY

OK, so men usually want to look strong and casual, but there is an exception to every rule. This is an almost childlike pose that can look good with a markedly masculine model and the right facial expression. There are no limits to what your model can do with his arms and his head, but he needs to look serious for the pose to work.

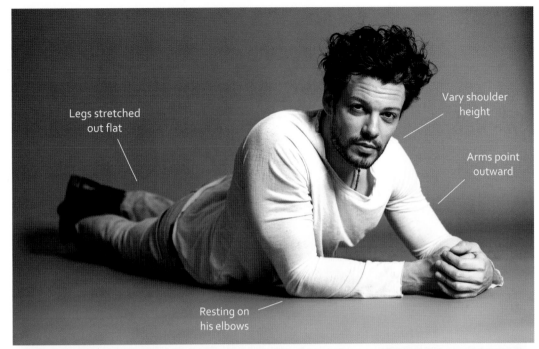

Legs stretched out flat

Vary shoulder height

Arms point outward

Resting on his elbows

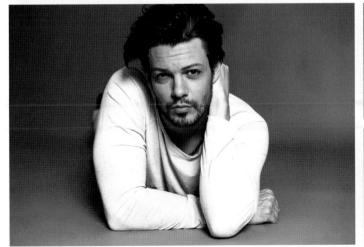

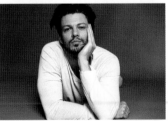

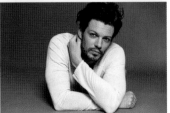

FASHION

Just as in the female fashion world, male fashion is all about the clothes, not the model. The following poses offer a clear view of the model's clothing and often give it an extra visual push.

#149

TALL CHAIR

This pose can be equally well executed using a stool, a table, a window ledge, or a railing. Your model can put his hands in his pockets or fold his arms, and he can alter the position of his legs for each variation. This is a great pose for showcasing pants.

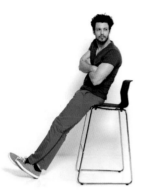

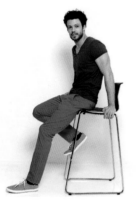

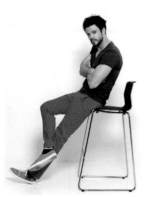

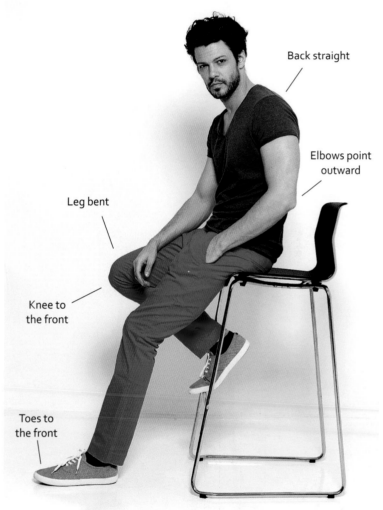

Back straight

Elbows point outward

Leg bent

Knee to the front

Toes to the front

Shoulders dropped

Back straight

Legs offset

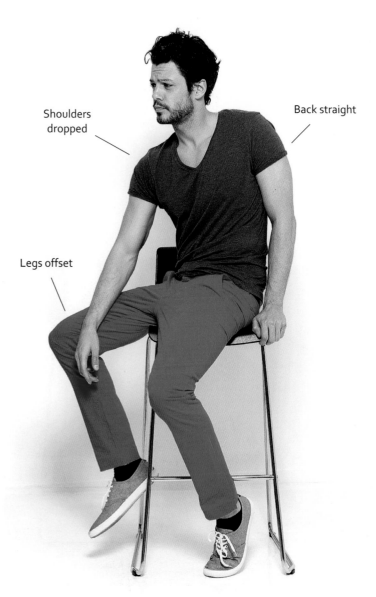

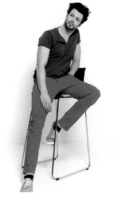

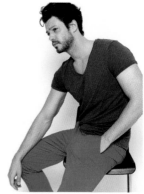

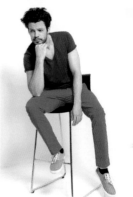

TALL CHAIR II

The main issue in fashion shots is always how to display clothing in the best possible light. Specific poses can be used to underscore the flexibility of a pair of pants, just as careful positioning of the model's feet can be used to simultaneously display shoes from the front and the side. The approach you take will vary from outfit to outfit, so make sure you are clear about what you need to emphasize, and note the differences changes in the pose make to the results.

NO CUTOFFS!

There is something missing in all these images: parts of the model's body. Each pose makes him look as if he's had something amputated. This happens if you shoot from the wrong camera position or your model simply poses incorrectly. As you can tell, you need to avoid this kind of effect at all costs, as it confuses the viewer and spoils the effect of the image.

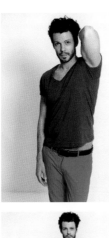

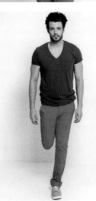

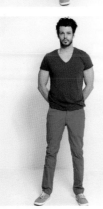

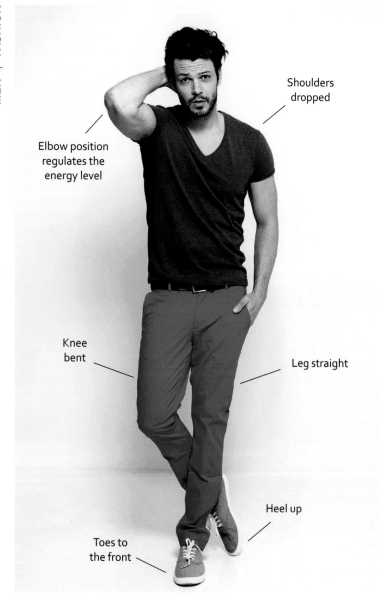

Elbow position regulates the energy level

Shoulders dropped

Knee bent

Leg straight

Heel up

Toes to the front

HAND IN POCKET

Men like to put their hands in their pockets. If your model does this, make sure he doesn't hide his whole hand, as this makes the pose look unnatural. For this particular pose, also make sure he doesn't put too much weight on one leg, as this, too, gives the pose an exaggerated look. After all, you are not trying to produce curves the way you would in a female pose. A casual hand in a pocket and a slight frown (or eyes averted from the camera) give this pose a nice masculine feel.

WALK LEFT, LOOK RIGHT

This simple trick has the model move in one direction while looking toward the opposite direction. This contrast creates tension and gives the image extra vigor. Having the model look away from the camera ensures that the viewer's attention remains on the clothes. If you want to emphasize a shirt, a jacket, a watch, or perhaps a belt, rather than the complete outfit, get your model to grab the fabric of the item in question.

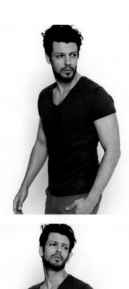

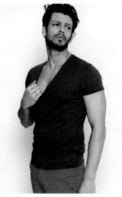

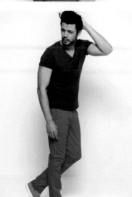

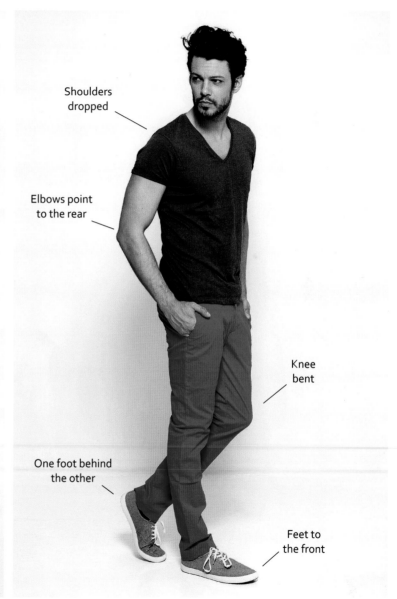

Shoulders dropped

Elbows point to the rear

Knee bent

One foot behind the other

Feet to the front

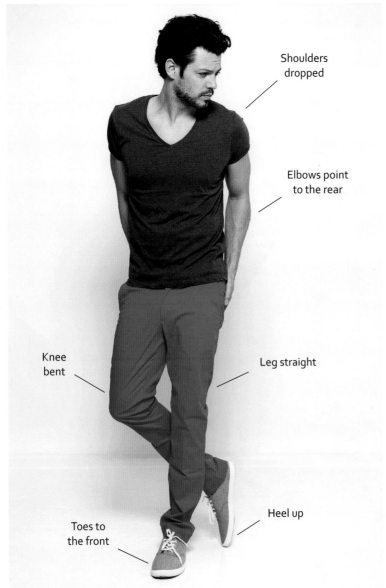

Shoulders
dropped

Elbows point
to the rear

Knee
bent

Leg straight

Toes to
the front

Heel up

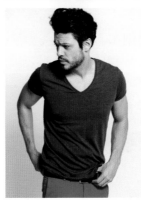

#153

CLEAR VIEW

This pose has a number of advantages for a fashion shot. The model's distracted gaze ensures that the viewer concentrates on the clothes, his arms aren't covering any part of his torso or his outfit, and his hands are discreetly hidden in his hip pockets. In other words— nothing hinders our view of his clothing. His raised foot displays one shoe from the side while his other foot shows the other shoe head-on. His crossed legs also show the pants from the side.

HANGING TO ONE SIDE

U

Varying your model's shoulder height ensures that the movement in #157 looks realistic. However, if you deliberately overdo this effect, it can be used to emphasize the cool look in male poses. Make sure your model doesn't draw his chin and his shoulder together, as this gives the pose a more feminine look. Getting him to stand with his legs apart offers a masculine contrast to the playful look of his shoulder position.

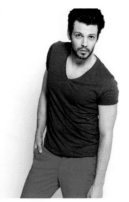

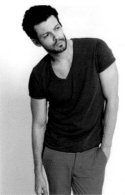

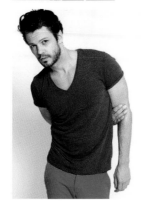

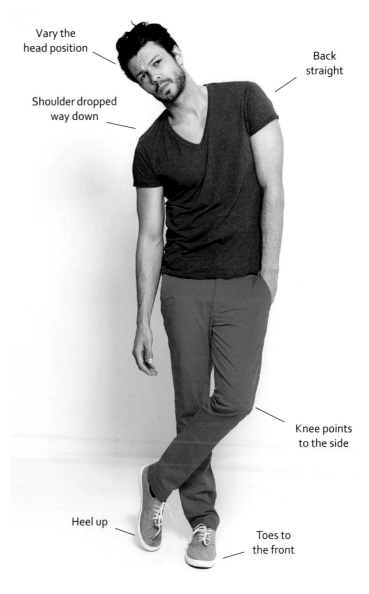

Vary the head position

Shoulder dropped way down

Back straight

Knee points to the side

Heel up

Toes to the front

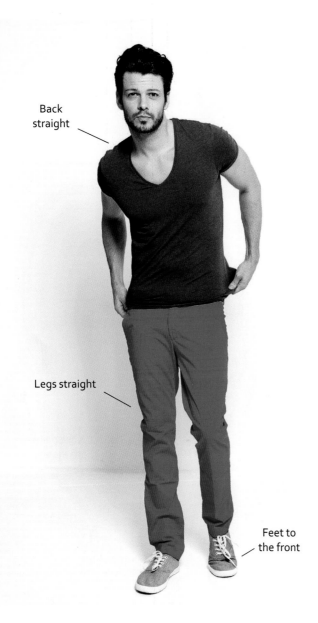

Back
straight

Legs straight

Feet to
the front

CLOTH GRAB

As you have already seen, having your model play with his clothing helps direct the viewer's attention. When you are looking at other fashion photos, check out how many of them include some kind of cloth grab. A great way to remember these poses is to categorize them according to clothing type and to consider how many ways you can get your model to play with a shirt, jacket, or scarf. Once again, a systematic approach will help you memorize poses and structure your shoots.

#156

THE NO-GOOD POSE

Ⓒ Ⓤ

In this pose, your model should press his arms as close to his body as possible and pull his shoulders up. This is a clear exception to the rule that says male poses should emphasize the breadth of the model's shoulders. However, getting him to spread his legs takes up plenty of space and gives the pose a solid, masculine look. This is a great pose for showcasing shirts, and you can vary the coolness factor according to the clothes you are shooting and the location you at.

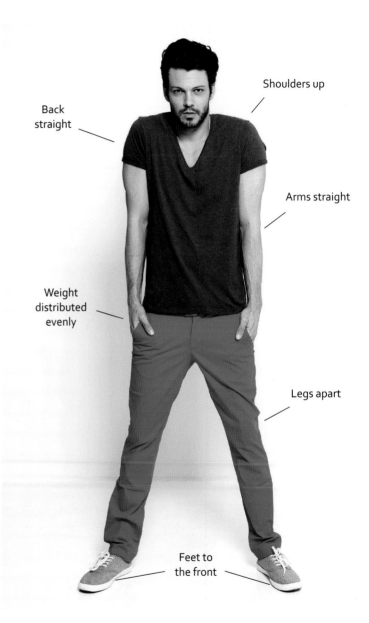

Shoulders up

Back straight

Arms straight

Weight distributed evenly

Legs apart

Feet to the front

185

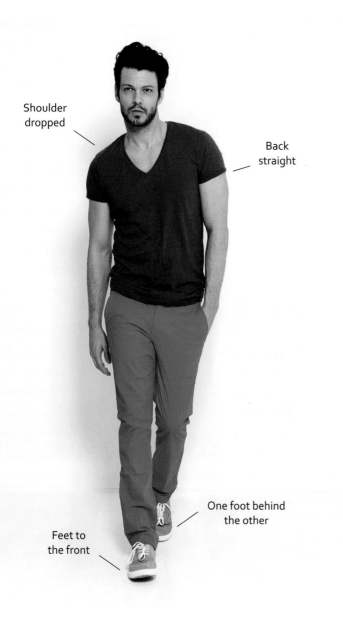

Shoulder dropped

Back straight

Feet to the front

One foot behind the other

WALK THE WALK

If your model takes only a single step, the resulting movement often looks contrived and cramped. If you have enough space, get your model to take several steps when you are shooting this type of pose. Try a regular stride or a swagger, and vary shoulder height to add verve and keep the movement authentic. Shoulder variations are especially important if you don't have enough space to let your model wander. Don't overdo the shoulder drop, however, or your model will wander into #154's territory.

158

GETTING NAKED

Instead of just jumping from clothed to nude, why not build the undressing phase into your shoot? It doesn't matter whether we are talking about a sweater, briefs, or pants—use the options offered by each type of garment to capture plenty of variations.

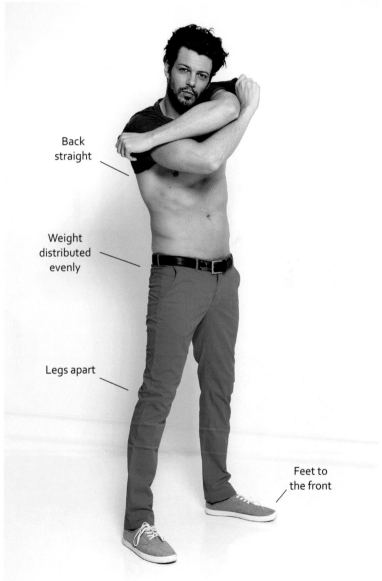

Back straight

Weight distributed evenly

Legs apart

Feet to the front

187

IMPLIED NUDE

Muscles, muscles, muscles. From biceps to six-pack, you only need a couple of tricks to get your model looking strong and sexy. A few light exercises before the shoot will help pump up his muscles, but don't let him overdo it.

#159

EXPECTATION

This seated pose combines a relaxed overall look with tensed abs. To avoid skin folds and to emphasize his muscles, make sure he leans only his upper back on the chair. Whether he is leaning on a chair or a wall, he should move his behind slightly away from its support. This produces a slight bend in his back that further emphasizes his muscles.

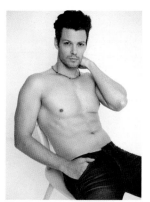

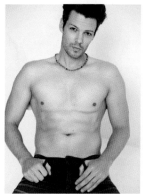

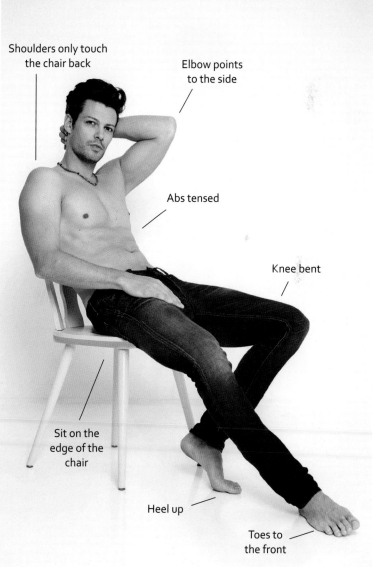

Shoulders only touch the chair back

Elbow points to the side

Abs tensed

Knee bent

Sit on the edge of the chair

Heel up

Toes to the front

189

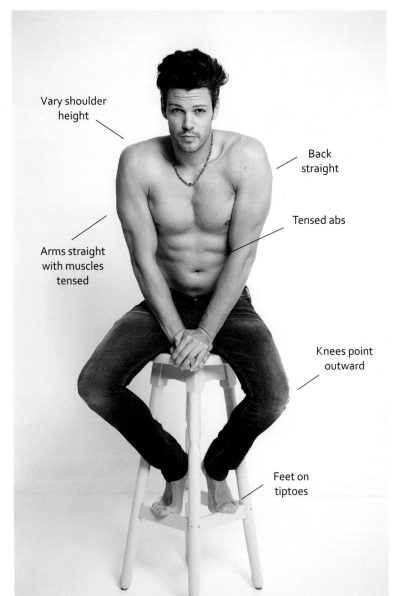

Vary shoulder height

Back straight

Tensed abs

Arms straight with muscles tensed

Knees point outward

Feet on tiptoes

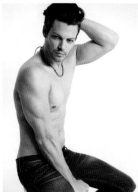

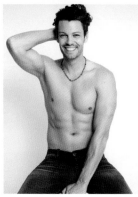

#160

HI THERE!

 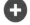

In studio photos, women often lean on their hands to cover the area between their legs, whereas a man does the same to tense his arm muscles. Depending on the effect you are looking for, you can use a stool, a table, a window ledge, or anything similar for this pose. Remember that nude shots are all about emphasizing the aesthetics and the strength of your model's body. Always keep this in mind while you shoot and make everything you do serve this overarching aim.

#161

LAZING

U

In female poses, we make a lot of effort to avoid skin pinching. Contrastingly, in male poses you can utilize the bulges that are caused by leaning positions—perhaps by relaxing the muscles to make an upper or lower arm look broader. However, make sure that the resulting pressure on your model's hand or fingers doesn't produce ugly white knuckles or other blemishes.

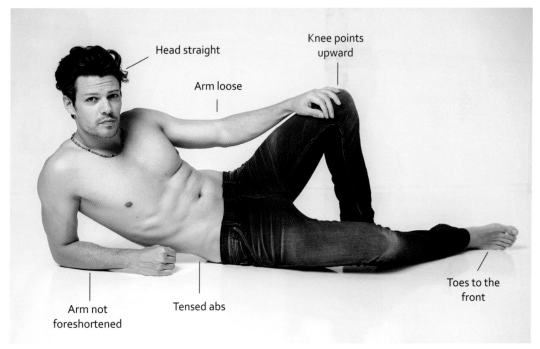

Head straight

Arm loose

Knee points upward

Arm not foreshortened

Tensed abs

Toes to the front

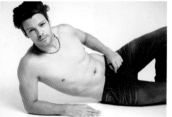

Vary shoulder
height

Back
straight

Vary weight
distribution from
side to side

Feet to
the front

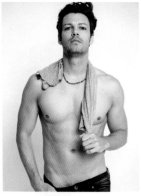

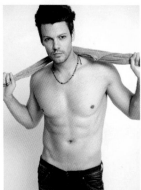

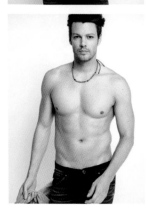

GET
TO WORK

Shooting nude doesn't mean that your model shouldn't work with the clothing he has just shed. This example shows how to utilize a t-shirt to produce a cool, casual look. Furthermore, this gives your model something useful to do with his hands. If he is holding a garment with both hands, he can pull on it to tense his arm muscles.

#163

HMMM

U

This pose appears relaxed but actually requires quite a lot of work from the model. If he runs his hand through his hair, he can tense his arm a little while he does so. The same applies to the hand on his belt or in his pants pocket. This arm, too, should be slightly tensed. Keeping the shoulder position asymmetrical helps to emphasize his abs.

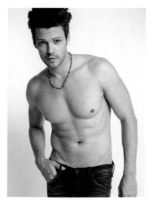

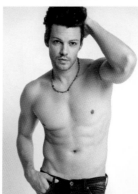

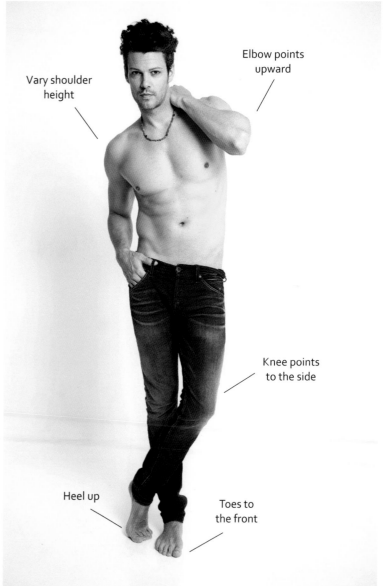

Vary shoulder height

Elbow points upward

Knee points to the side

Heel up

Toes to the front

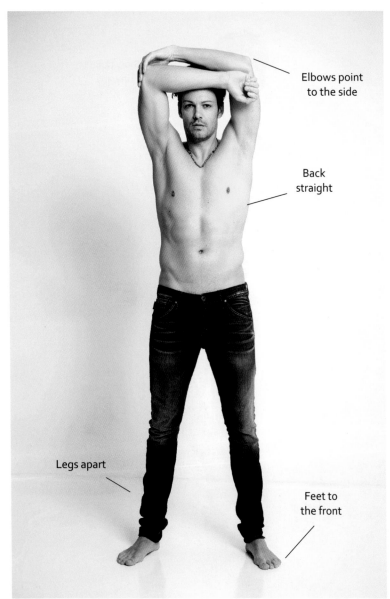

Elbows point to the side

Back straight

Legs apart

Feet to the front

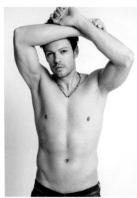

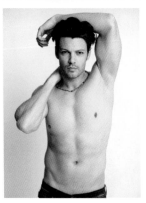

#164

THE "V"

U

A well-formed male torso looks particularly masculine when it creates a "V" shape—in other words, with broad shoulders and a narrow waist. Getting your model to put his hands above, in front of, or behind his head uses his arms to visually underscore the "V" shape.

ALL FOR THE ARMS

Men in nude poses want to look strong and toned, and there are a couple of simple tricks you can use to help his arms look great. They will look broader if his elbows point to the sides rather than forming a line with the optical axis of the camera's lens. This is illustrated by the main image, where the right arm (from our point of view) looks thinner than the other arm, which is pointed to the side. To avoid the feminine look that can result if a man points his elbows outward for no apparent reason, get your model to rest his hands on his thighs or to hold onto something.

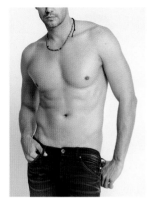

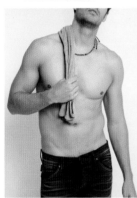

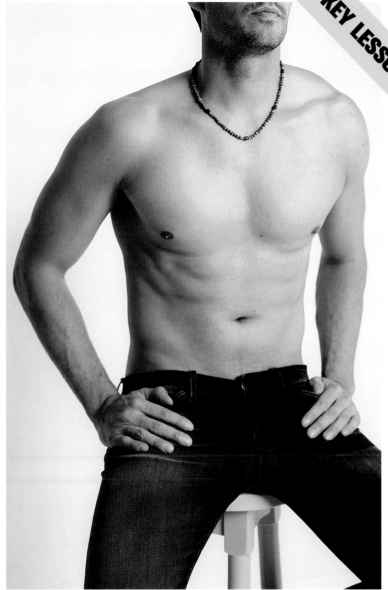

Vary shoulder height

Back straight

Use thumbs to pull clothing

Weight shifts to one leg

Feet to the front

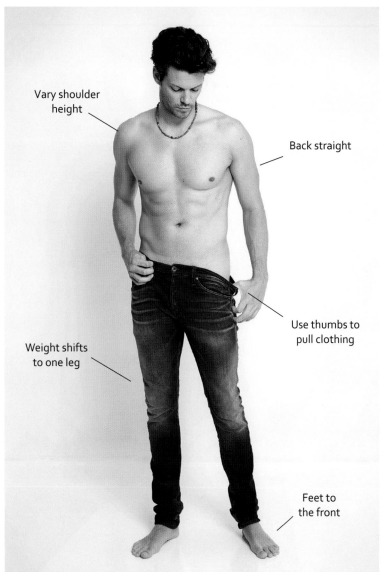

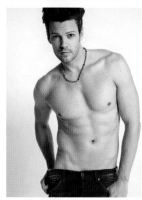

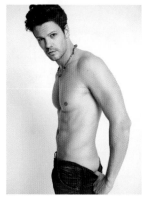

#165

SIX-PACK

If your model has well-defined abdominal muscles, you can accentuate them by getting him to show a hint of skin below his waist. This produces a provocative and distinctly sexy look.

#166

TORSO

Having your model look downward immediately steers the viewer's gaze away from his face and toward his torso. Make sure this position doesn't form a double chin and that his jawline remains visible. If he positions his hands close to his head, make sure his elbows point downward or to the side so that his arms don't appear foreshortened. You can also use his arms to frame his torso and/or his abs. Space between his arms and his sides (see variation #2) emphasizes his waist.

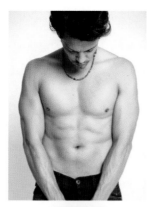

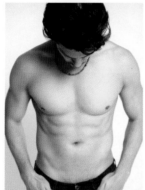

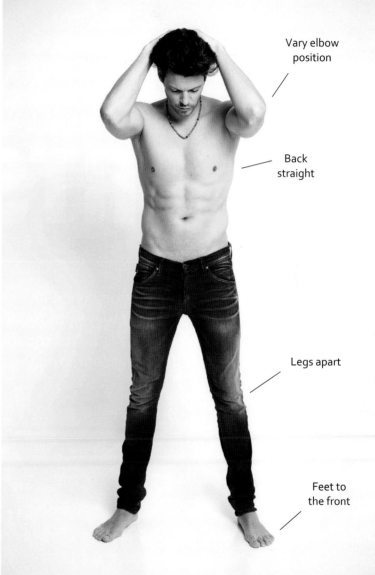

Vary elbow position

Back straight

Legs apart

Feet to the front

SPORTS

The IMPLIED NUDE section concentrates on displaying your model's muscles. However, muscles have to be built up before they can be displayed. This section is about working up a sweat and effectively capturing the physical effort involved.

#167

THE BOXER

Ⓒ Ⓤ ➕

As with portrait and lifestyle scenarios, when it comes to sports shots women like to appear poised and centered (think yoga), while men prefer action poses that convey physical strength. You must find a balance between a movement appearing authentic and making it look good in a photo. For example, your model might need to position his hand lower than he would if he were engaged in a real sporting event. Tell your model why you need him to do something he might feel is unusual, but try both variations.

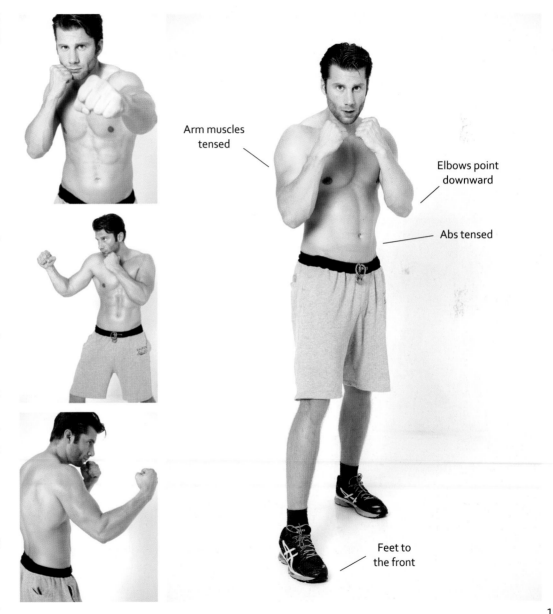

Arm muscles tensed

Elbows point downward

Abs tensed

Feet to the front

199

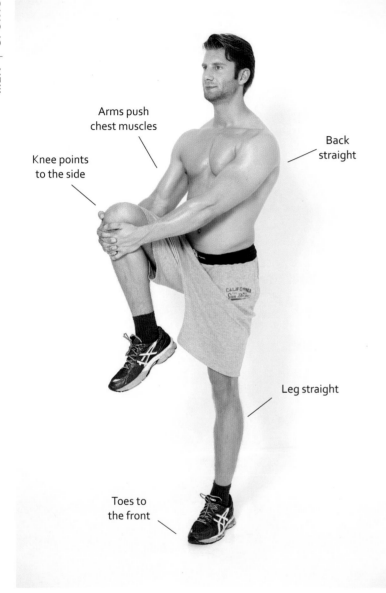

Arms push
chest muscles

Knee points
to the side

Back
straight

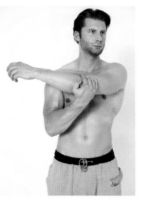

Leg straight

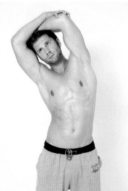

Toes to
the front

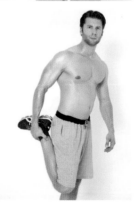

#168

WARMING UP

Don't forget to capture your model's warm-up as part of the shoot. You can use this phase to get him accustomed to the studio lights and get the shoot rolling without putting him under pressure. These might only be test shots, but they are fine for working up a sweat. If your model doesn't perspire, you can achieve a sweat-like effect by having him apply body oil.

PUSH-UPS

This pose is great for accentuating your model's arms, shoulders, neck, and upper chest. Sharp angles not only increase the overall energy level in the image, they also make your model look more striking and muscular, which is what these shots are all about. Stay at less than 90 degrees to the subject when capturing muscle shots. Angles of less than 90 degrees make your model's muscles look more pumped.

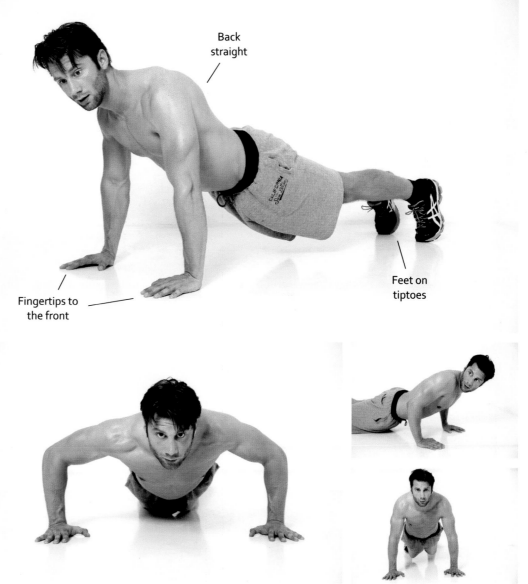

Back straight

Fingertips to the front

Feet on tiptoes

Torso faces
the camera

Knee joint at
90 degrees

Toes point
upward

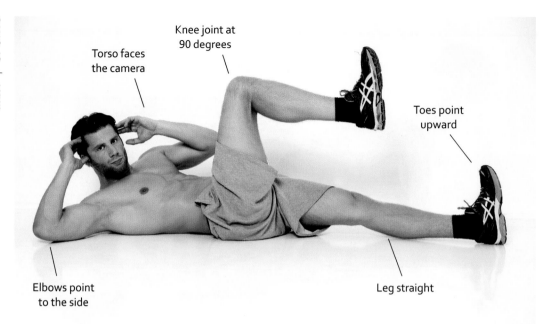

Elbows point
to the side

Leg straight

SIT-UPS

When photographing sit-ups, make sure your model's elbows don't point directly toward the camera. This keeps his arms well defined. In contrast to the female equivalent (#108), you need to get your male model to point his toes upward or toward his body to keep the pose looking masculine. Always have him turn his torso toward the camera so that his "V" is as well defined as possible.

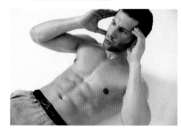

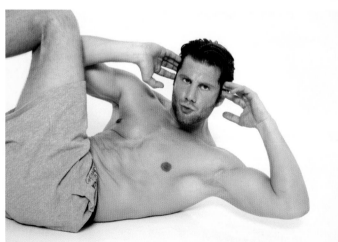

#171

HERCULES

U

To make his back look as broad as possible, get your model to pull his shoulders forward and up. This makes them look rounder and more powerful, while also providing extra definition in his neck. Whether he places his hands on his head or his waist, he needs to keep his arms angled to retain the visual energy of the pose.

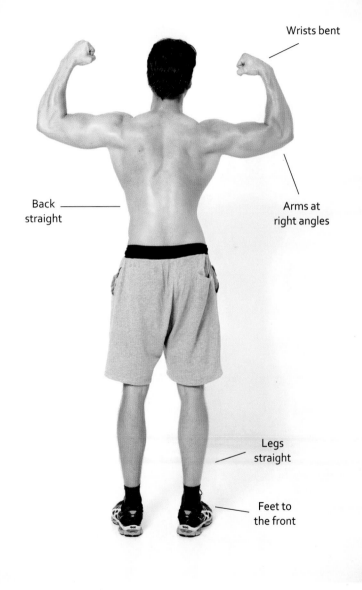

Wrists bent

Back straight

Arms at right angles

Legs straight

Feet to the front

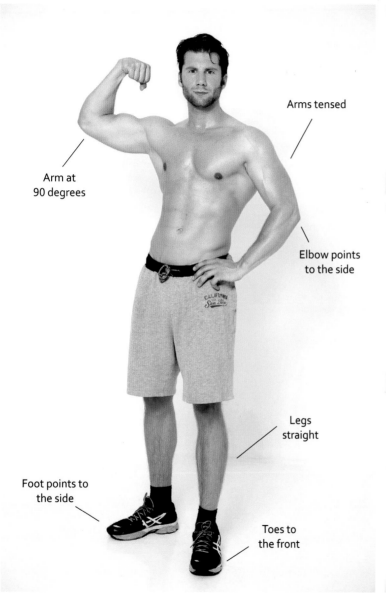

Arms tensed

Arm at
90 degrees

Elbow points
to the side

Legs
straight

Foot points to
the side

Toes to
the front

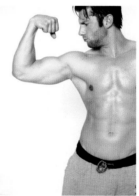

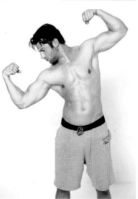

THE HULK

U

Chest out and shoulders back is exactly what body-builders and fitness enthusiasts *don't* want. Moving his arms and shoulders back makes his torso appear smaller, so he needs to pull his shoulders upward and to the front to make him look bulkier. His feet need to be slightly apart and turned slightly outward. Turning his hips slightly away from the camera also helps to add definition to his "V" shape.

#173

THE HULK II

Biceps look broadest when viewed from the side, but they look best if the model's torso is captured head-on. To get your model's rear arm looking nice and broad, too, make sure he points his elbow to the side rather than backward (variation #3). Adding an angle at the elbow makes the rear arm look more muscular, as well. His front arm is positioned lower than his rear arm to provide an unhindered view of his abs. Clenching his fist provides extra tension in his lower arm muscles.

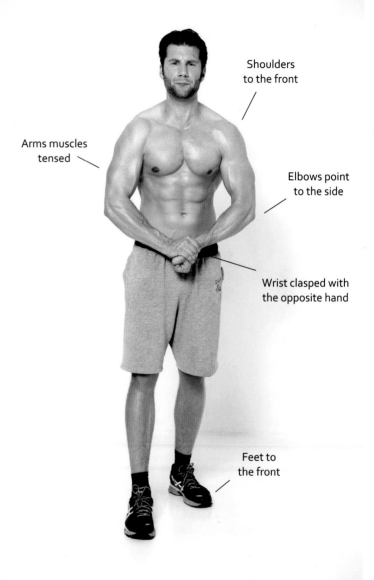

Shoulders to the front

Arms muscles tensed

Elbows point to the side

Wrist clasped with the opposite hand

Feet to the front

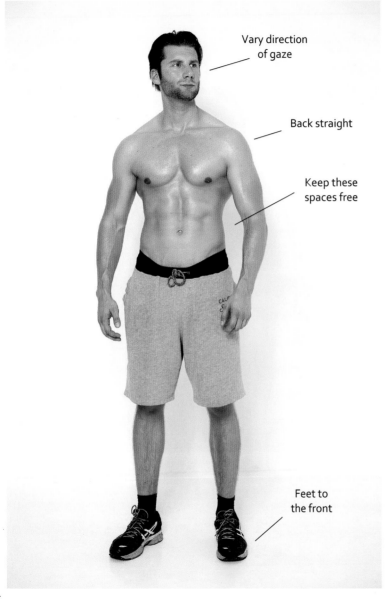

Vary direction of gaze

Back straight

Keep these spaces free

Feet to the front

LAST MAN STANDING

It is always a good idea to photograph sportspeople and body-builders slightly from below, as this makes them appear bulkier and more powerful. Circle your subject and try plenty of different camera positions. You can safely shoot all the poses in this section from below and then decide for yourself which point of view works best.

175

THE ARNOLD

As we have seen in the Key Lesson ALL FOR THE ARMS in the IMPLIED NUDE section, a model's arms look best if they don't form a line with the camera's optical axis. In fashion and nude shots, you need a reason to get your model to point his or her elbows outward, whereas in sports situations, this trick is virtually a given. Your model can clasp his wrist with his opposite hand or ball his fists as much as he likes. Don't forget to take a break periodically so that he doesn't get red in the face.

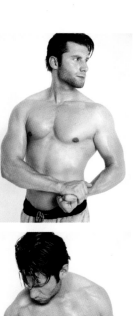

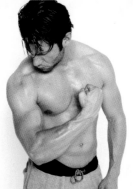

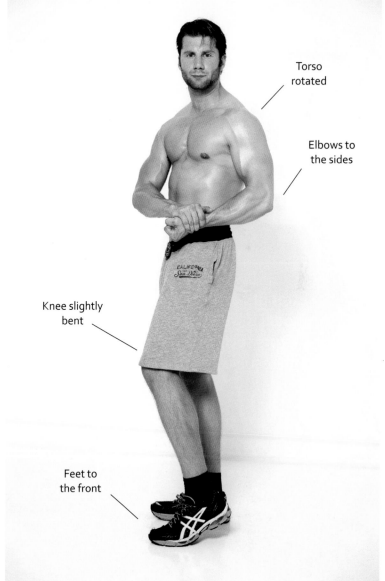

Torso rotated

Elbows to the sides

Knee slightly bent

Feet to the front

BUSINESS

Strength and masculinity still play a role, even when the model is wearing a suit. However, in a business context factors such as competence, single-mindedness, drive, and resolve are more important.

#176

RELAXED BOSS

In business situations, it always helps to know a little about the person you are photographing and the position they hold in the organization. The pose shown here is not suitable for regular workers or salespeople. In fact, it is a very cool pose and is only really suited to photographing a relaxed person in a position of authority.

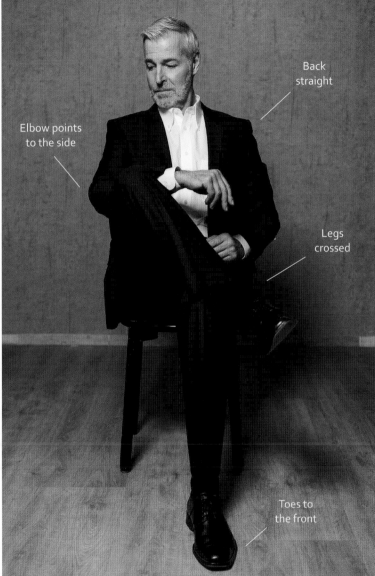

Elbow points to the side

Back straight

Legs crossed

Toes to the front

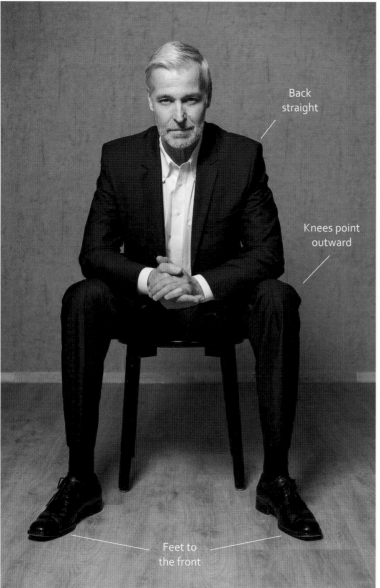

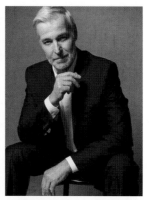

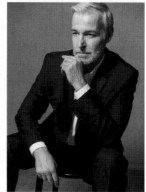

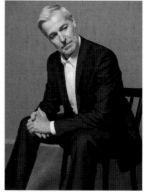

Back
straight

Knees point
outward

Feet to
the front

#177

FOCUSED

This is a useful variation on the previous pose that helps make the subject look less casual. The stability and masculinity provided by the position of the model's legs convey resolve and certainty. The model resting his hands or arms on his legs emphasizes the overall effect. To introduce a little more verve, the model can also lean his torso to the side, as shown in variation #2.

#178

SMOOTH BOSS

This approach is similar to the previous pose, but the crossed legs make it more modest and less forthright. However, to ensure that the model appears assertive, he should keep his hands closed and retain a serious facial expression.

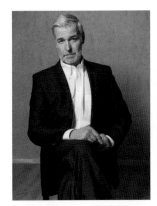

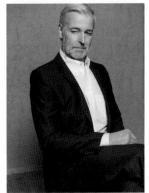

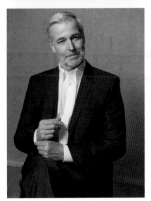

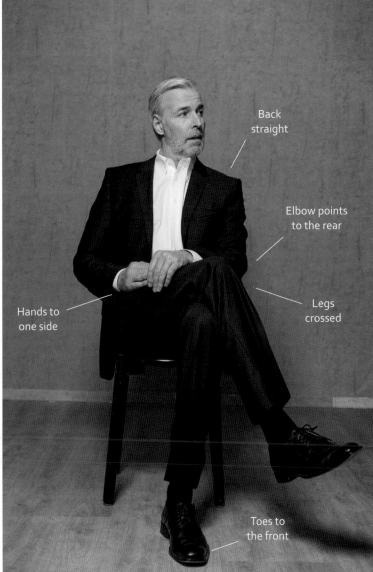

Back straight

Elbow points to the rear

Hands to one side

Legs crossed

Toes to the front

Shoulder drawn back

Shoulder turned to the front

Back straight

Elbow points to the side

Foot to the front

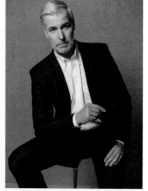

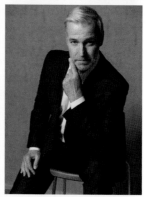

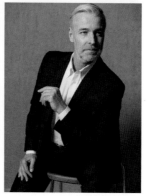

ON A STOOL

You can use the edge of a table instead of a stool if you like. The differing leg positions make this pose a little more playful than its predecessors, and adds a natural, human touch to the otherwise prim and slightly drab world of business images.

#180

LOOKING DOWN

Photographing people from above tends to make them look acquiescent. This pose has precisely the opposite effect. If you want to get a person to look strong and aloof, then photograph them from slightly below. The viewer has to look up to the subject and the model looks down on the viewer. The folded arms in variation #1 add to the feeling of distance by blocking the model's torso. This makes the pose appear defensive.

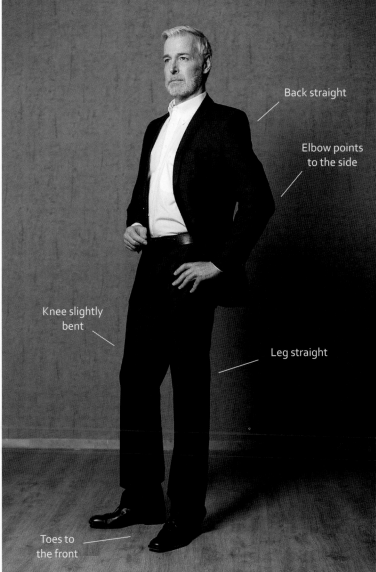

Back straight

Elbow points to the side

Knee slightly bent

Leg straight

Toes to the front

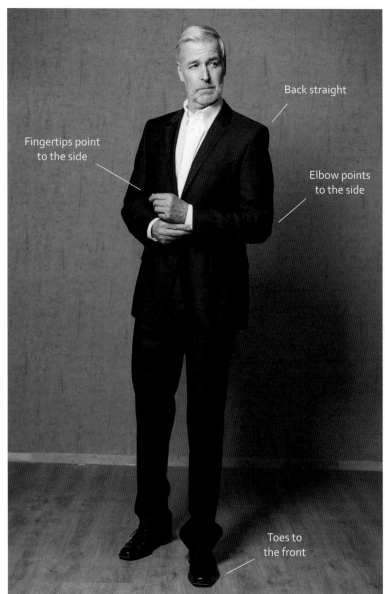

Fingertips point
to the side

Back straight

Elbow points
to the side

Toes to
the front

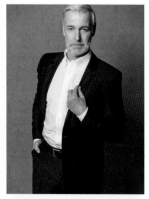

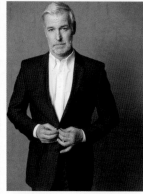

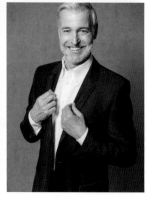

CLOTH GRAB

As in many of the previous situations, business poses also confront the model with the question of what to do with his hands. These images show a number of ways to integrate the model's clothes into the pose. On business shoots, a suit jacket acts as a kind of shield that gives its wearer authority, so you have to consider carefully whether to let your model take his jacket off. Removing his jacket makes the subject appear less distanced and more accessible.

#182

FROM THE SIDE

Photographing your model from the side takes the emphasis away from his clothes and transfers the focus to his face. This is fine in a business context, as the shoot is usually about the person rather than his clothing. Vary your model's arm positions. Gazing into the middle distance gives him a more purposeful look.

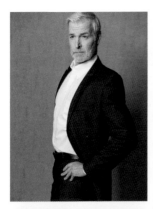

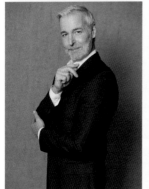

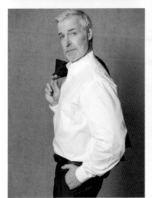

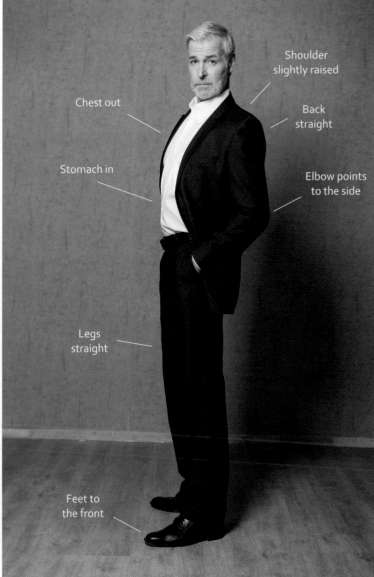

Chest out

Stomach in

Legs straight

Feet to the front

Shoulder slightly raised

Back straight

Elbow points to the side

Vary the direction
of his gaze

Vary the direction
his body points

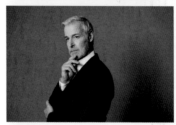

HEADSHOT

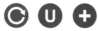

One way to influence the look of a headshot is to vary the angle between your model and the camera. The images on this page demonstrate four torso angles. Get your model to look in different directions and combine these with various facial expressions. He can use his hands, too, if he likes. Playing with his jacket or assuming a "thinker" pose can create great hand variations.

#184

AGAINST THE WALL

 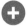

Wall poses represent the casual end of the business photo spectrum. The very act of leaning on a wall exudes a confident, relaxed look. Combine the wall trick with other poses that you know, and get your model to fold his arms or put his hands in his pockets. He can try different cloth grabs too. However, you need to make sure that you don't accidentally "amputate" any of his limbs (see variation #2). A part of each hand should always remain visible.

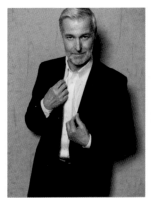

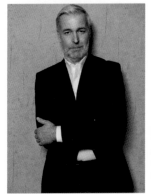

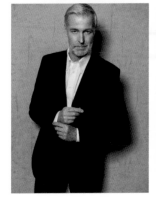

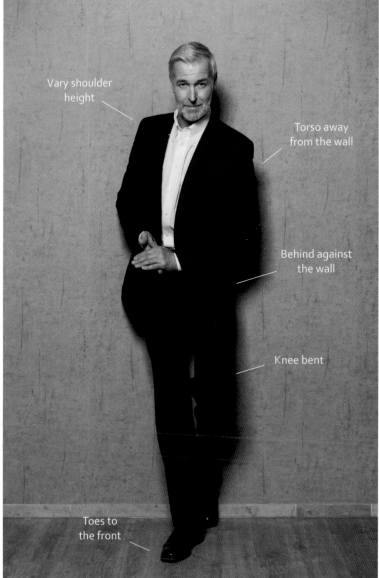

Vary shoulder height

Torso away from the wall

Behind against the wall

Knee bent

Toes to the front

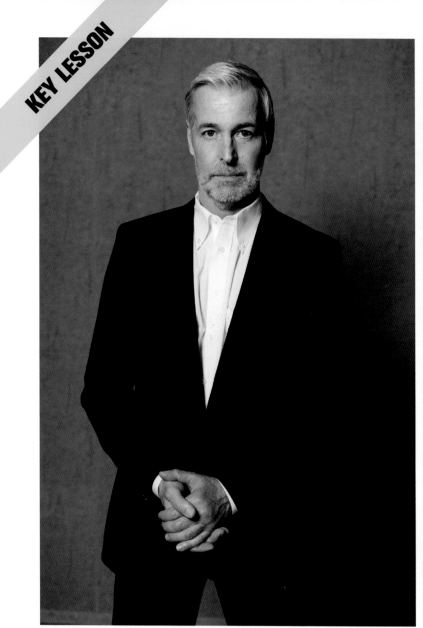

TO SMILE OR NOT TO SMILE

This question is raised regularly on fashion and business shoots, and there isn't always a simple "yes" or "no" answer. The boss doesn't need to smile, while someone who wants to sell something should wear a smile with his mouth slightly open (variation #1 and #2). A consultant can smile with his mouth closed (variation #3). As you can see, a smile can have a number of very different effects, so you need to be clear from the start about whom you are photographing and the effect you want the resulting images to have.

#185

HEADING ONE

Eyeglasses can be used to occupy your model's hands, whether he is wearing them or just using them as a prop (see #186). Glasses combined with a smile are great for portraits, but, with a more serious expression, they are equally suitable for announcing the latest quarterly figures or checking an x-ray. Remember to capture your model's hand from the side to keep it looking slim. Make sure, too, that his fingers look natural. If he is looking cramped, get him to shake his hands and fingers to loosen them up.

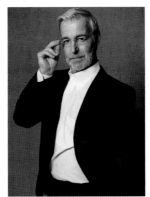

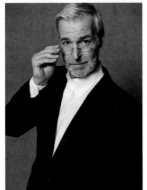

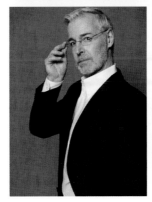

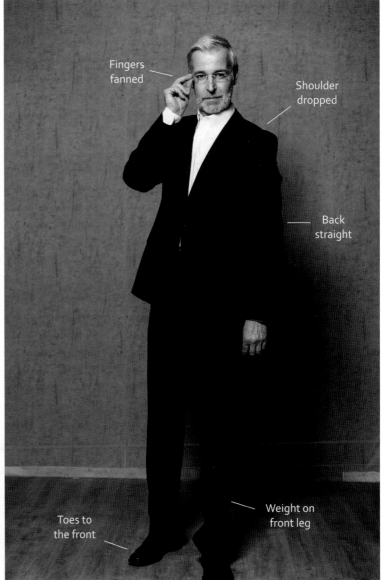

Fingers fanned

Shoulder dropped

Back straight

Toes to the front

Weight on front leg

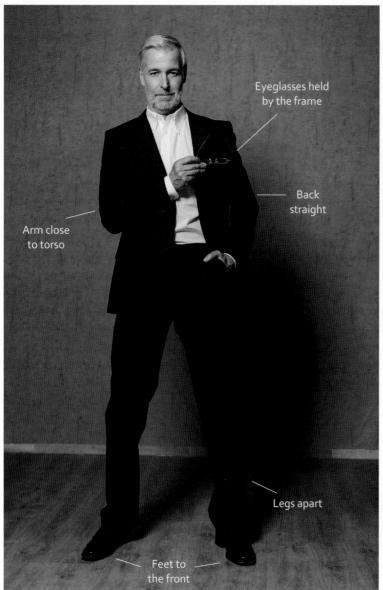

Eyeglasses held
by the frame

Back
straight

Arm close
to torso

Legs apart

Feet to
the front

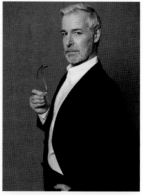

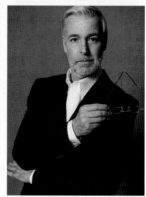

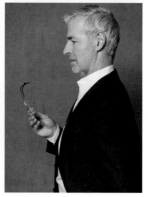

EYEGLASSES AS A PROP

In business situations never let your model put his eyeglasses in or near their mouth. This always creates a sexual undertone, whether you intend it to or not. Get him to hold the temple between his thumb and forefinger. Make sure the eyeglasses are always visible, and avoid reflections from the lenses.

#187

LEAN ON

 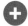

On a business shoot, your model can lean his back or shoulder against a wall. For full-length shots, keep an eye on the distance between the wall and his legs—free space in a photo is always more noticeable than it is in reality. Vary the angles your model produces with his limbs, and move around to find the best camera position and framing.

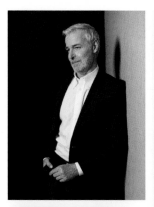

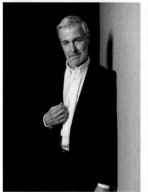

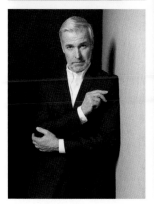

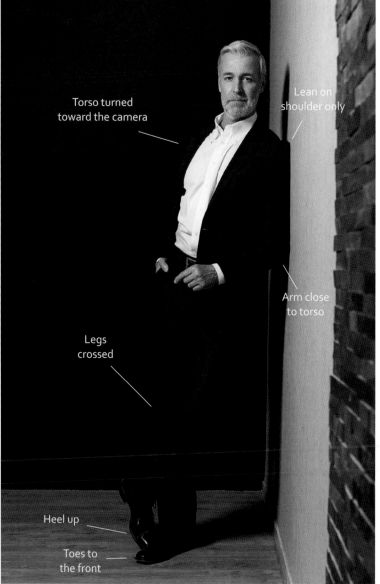

Torso turned toward the camera

Lean on shoulder only

Arm close to torso

Legs crossed

Heel up

Toes to the front

WALL

Male models, too, can interact with a wall to create new and exciting poses. Once again, take a systematic approach, and try out positions that show him from all sides and from a variety of angles.

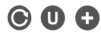

CASUAL WAIT

Ⓒ Ⓤ ➕

Whether your model is simply standing or leaning on some kind of backdrop, you need to take the same systematic approach to the shoot. Begin by choosing the side you want to photograph, and then get him into position. In this example, he is standing with his back to the wall. Once you decide how to position his legs, you can try out some variations with his arms. Note which poses—from the side, head-on, and so on—work best for the job at hand.

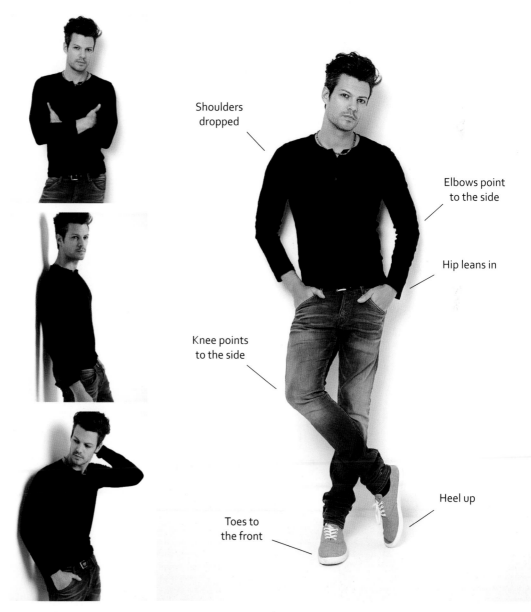

Shoulders dropped

Elbows point to the side

Hip leans in

Knee points to the side

Heel up

Toes to the front

223

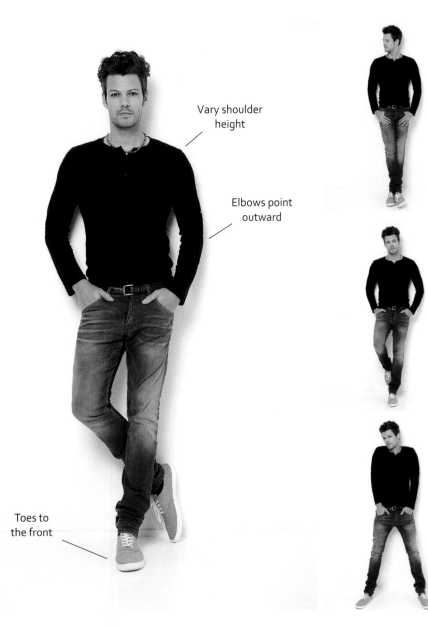

Vary shoulder height

Elbows point outward

Toes to the front

#189

CASUAL WAIT II

C U +

After you decide which side to photograph your model from, the next important issue is the position of his legs and the distance between them and the wall. Even if you don't capture the full length of your model's legs, their position still has a strong influence on the look of the final image, and this is true for virtually any pose. Poses with his legs wide apart (variation #3) always look sturdy and masculine, whereas variation #2 looks much more casual.

#190

CASUAL WAIT III

After you've decided which side of the body to lean on, you also have to decide which part of your model's body should touch the wall: shoulder, elbow, hand, or perhaps something quite different. If you stick to basic poses, you might miss out on a whole bunch of interesting alternatives. For example, if you start with his shoulder, make sure you try out all the available options before you move on to the next category. This approach helps you improve on your favorite poses and expand your repertoire while you work.

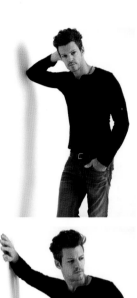

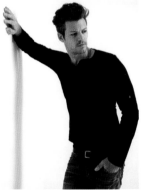

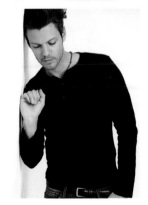

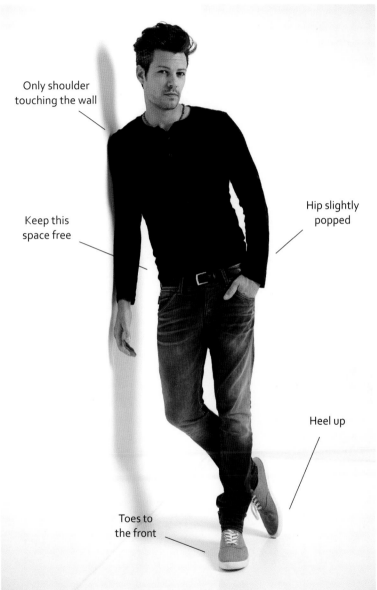

Only shoulder touching the wall

Keep this space free

Hip slightly popped

Heel up

Toes to the front

225

Vary head
position

Arm turned
to the side

Elbow rests
on knee

Knee raised

Toes to
the side

Fingertips point
to the side

Toes to
the front

SITTING

A sitting man should lean only his back against a wall. Leaning on one side while sitting is a highly feminine posture and, therefore, exclusively reserved for females. In this case, the basic pose is a given, so your model has to use his arms and legs to vary the look. Start by varying the position of just one arm or leg and then move on to positions that vary both. Don't forget to vary the angle you shoot from while you work.

192

SITTING II

Moving on from the previous pose, this one has the model resting both elbows on his knees. Here too, you should vary the position of his arms and the angle you shoot from. Develop this pose by starting symmetrically and then work up to include asymmetrical variations. Remember to work systematically, and try out all the variations you can for each position.

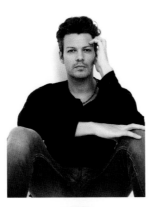

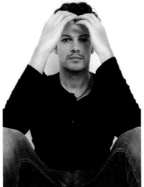

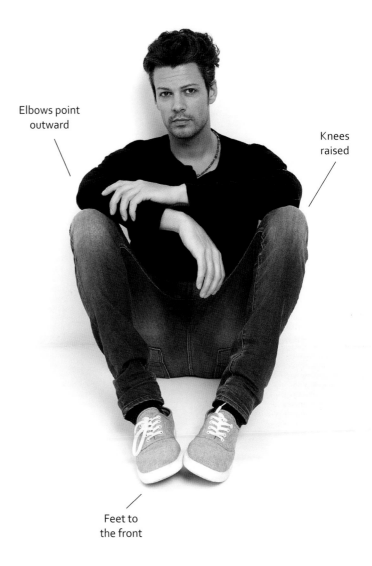

Elbows point
outward

Knees
raised

Feet to
the front

227

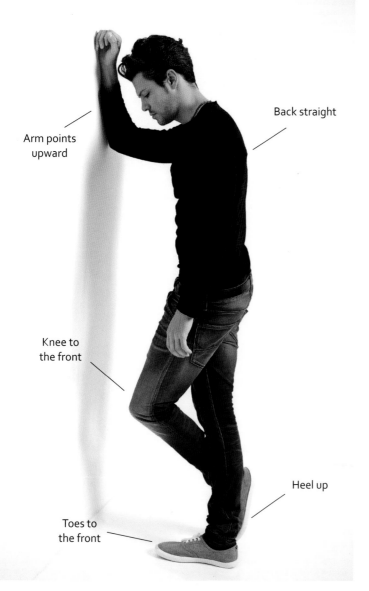

Arm points upward

Back straight

Knee to the front

Heel up

Toes to the front

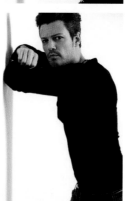

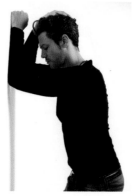

DARN!

U

This type of pose is a favorite with female models, and there are a couple of things you have to watch out for if you want to keep it from looking too feminine when you use it with a male model. Don't let him stretch his back too much, as this produces unwanted curves. Use closed rather than flat hand positions, and avoid dreamy facial expressions. A serious, annoyed, or even bored expression is better for creating a masculine look.

NOT TOO CLOSE

Take care with poses in which the model rests his hands or arms on his knees. His hands (and especially the backs of his hands) mustn't get too close to the camera. If in doubt, get him to bend his elbow and/or his wrists. This isn't about fore-shortening, but rather the fact that the viewer's attention is automatically drawn to whatever is closest to the camera. Hands and arms should be captured close to the camera only if there is a good reason—for instance, when you are photographing a watch or jewelry.

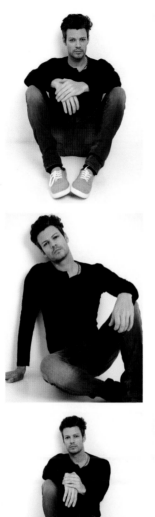

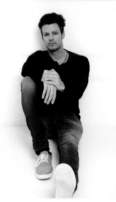

COUPLES

Portraits | Fashion | Implied Nude | Sports

PORTRAITS

Twice the fun! Shooting with two models or a couple means you have to work twice as hard at coordinating and directing them. If the chemistry between your subjects works, you can use the resulting harmony and energy to your advantage during the shoot.

#194

TOGETHER

Begin with some simple, sitting poses to get your models warmed up. Any kind of chair or couch will do to position them one in front of the other. It doesn't matter who sits on the chair or the floor. Check out how both combinations work. The one sitting at the back can put his/her arms around the other to form a frame around both faces.

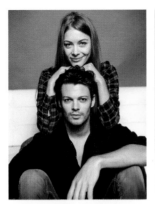

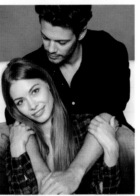

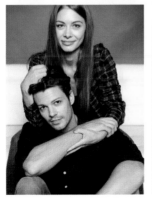

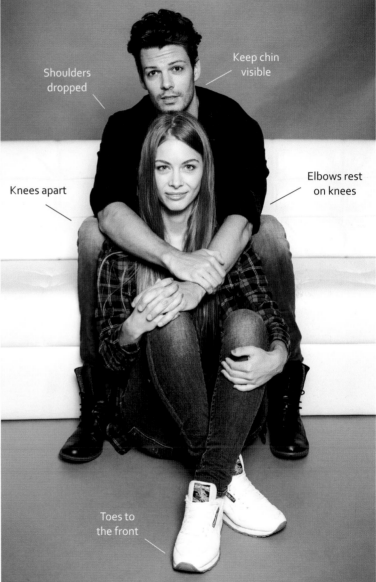

Shoulders dropped

Keep chin visible

Knees apart

Elbows rest on knees

Toes to the front

233

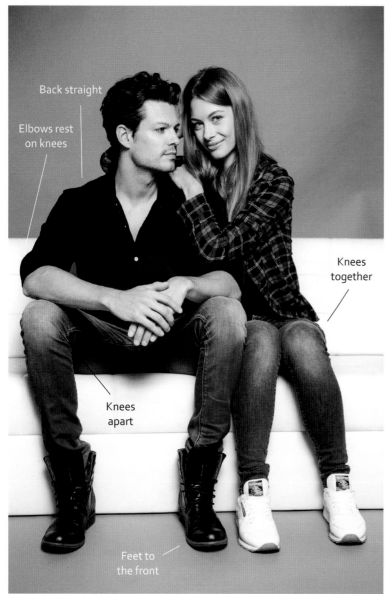

Back straight

Elbows rest
on knees

Knees
together

Knees
apart

Feet to
the front

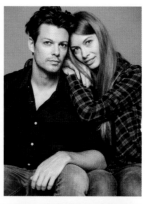

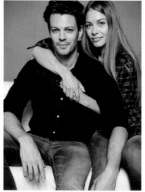

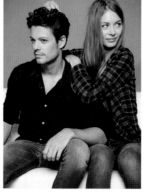

LEAN ON ME

Which woman doesn't occasionally long for a strong shoulder to lean on? For this pose, she can rest her hands, arms, or head on his shoulder. Try serious expressions as well as smiling faces, with mouths open and closed. You can vary the direction each of them looks depending on the idea you are developing.

#196

LET YOURSELF GO

Ⓤ ➕

Not all couples are the same. This pose conveys a fairly intimate mood, but it can work well for mother/daughter pairings, too. Don't follow the positions shown here too rigidly, but instead, consider how to fit the pose to the models and the situation. The sitting partner has to use an arm to raise the other's head. If you look closely, you can see that the male model's right arm isn't actually resting on anything.

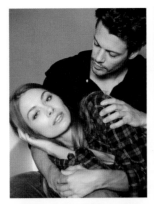

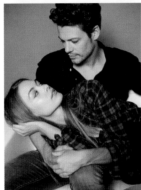

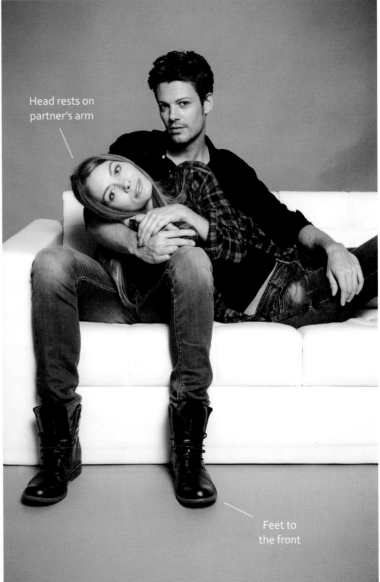

Head rests on partner's arm

Feet to the front

235

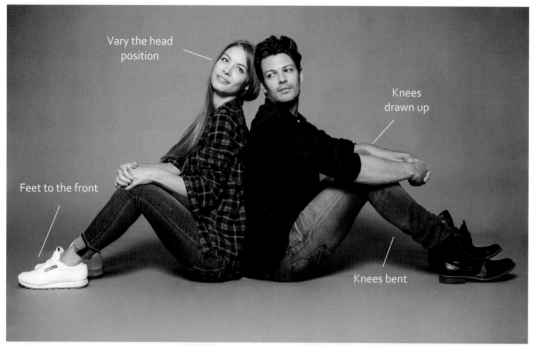

Vary the head position

Knees drawn up

Feet to the front

Knees bent

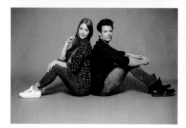

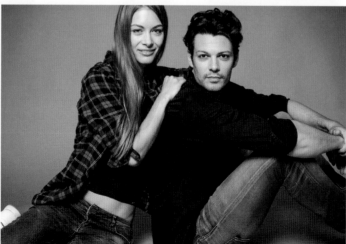

#197

BACK TO BACK

For couples in love, you can start with simple, playful poses that arise virtually automatically from the situation. This particular pose works well not only for lovers, but also for girlfriends, father and son, and other pairings. Begin with a symmetrical view before moving on to other, asymmetrical variations. Leaning side-on against a partner's shoulder is a feminine posture and really works for women only.

#198

OPPOSED SEATED

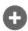

This is a nice pose that produces a strong feeling of balance. It also gives the models plenty of freedom to experiment with their arms and legs. Because female curves are more interesting, the woman should usually sit in front, although like so many rules, this is not set in stone. Get your models to mirror each other's leg and arm positions. This ensures symmetry and keeps the look in the lower portion of the frame simple.

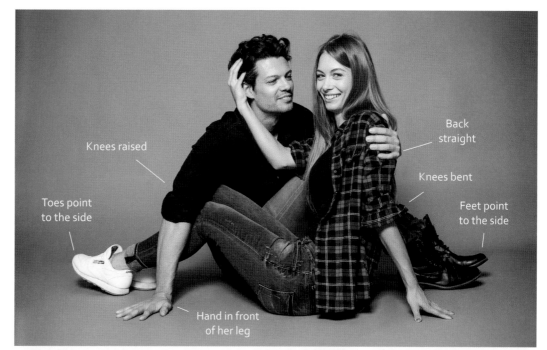

Knees raised

Toes point to the side

Back straight

Knees bent

Feet point to the side

Hand in front of her leg

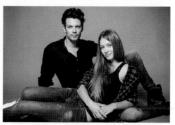

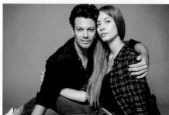

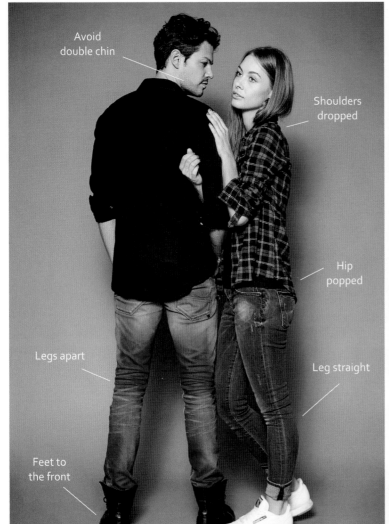

Avoid double chin

Shoulders dropped

Hip popped

Leg straight

Legs apart

Feet to the front

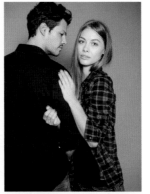

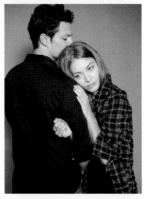

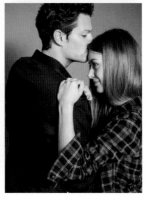

COLD SHOULDER

This pose focuses more on one partner than the other, although the balance is restored if the partner facing away from the camera turns his or her head to face the other. Try it out both ways. If one partner is much taller than the other, get them to spread their legs to compensate.

#200

BEFORE THE KISS

This is an intimate pose that works as a portrait or a full-length shot. Make sure the woman doesn't hide the man's jawline or grab his face too hard. Ideally, she will place her fingers on the back of his head or neck. The facial expressions are the deciding factor for the overall mood: closed eyes convey calm and security, while laughing faces illustrate simple happiness. Like #202, this pose works well with curvy models too.

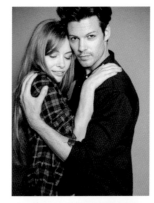

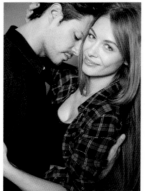

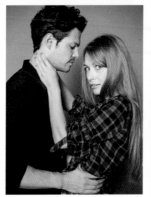

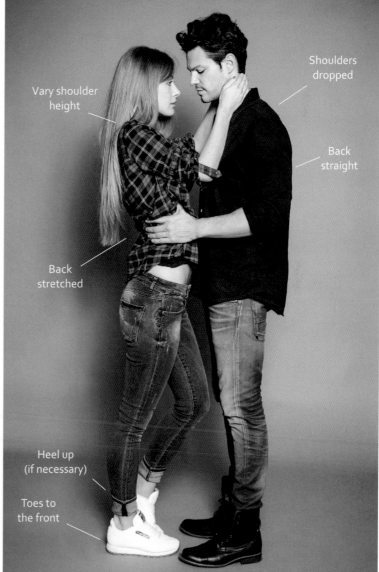

Vary shoulder height

Shoulders dropped

Back straight

Back stretched

Heel up (if necessary)

Toes to the front

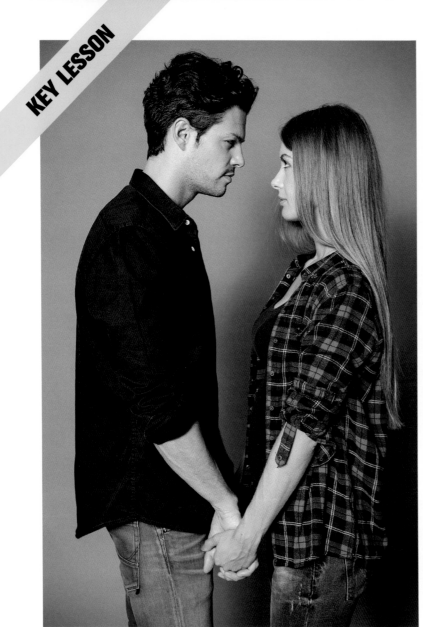

CONNECT!

The big difference between couple shots and business shots involving two people is the connection that exists between the couple. Colleagues don't hold hands or touch foreheads. All the photos on this page involve a physical connection between the models, which is created via their heads, arms, hands, or lips. Their gazes play a role too. The following sections go into more detail on each of these aspects.

#201

BEHIND THE BEAUTY

Holding hands is probably the simplest connection between two models. Although friends might connect using their arms or heads, holding hands definitely conveys more intimacy. It doesn't matter if the models stand next to each other or one in front of the other.

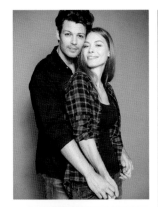

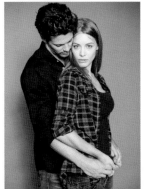

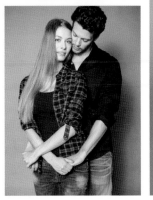

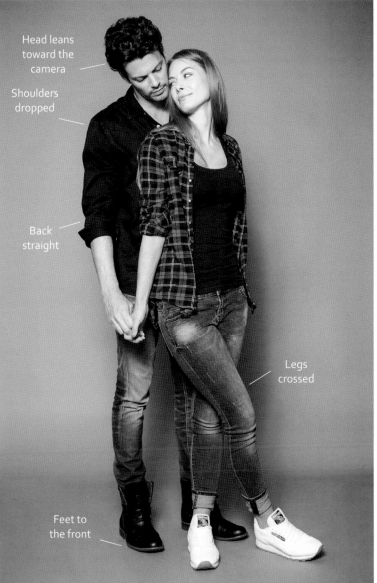

Head leans toward the camera

Shoulders dropped

Back straight

Legs crossed

Feet to the front

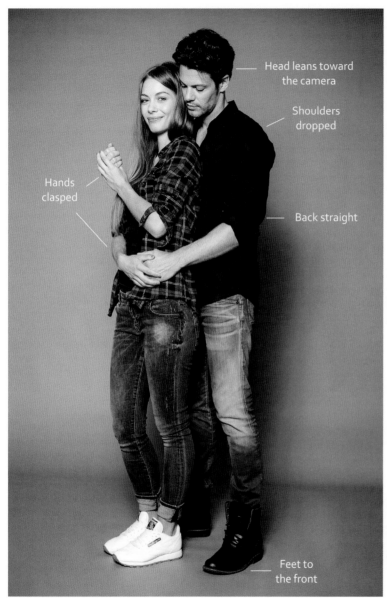

Head leans toward
the camera

Shoulders
dropped

Hands
clasped

Back straight

Feet to
the front

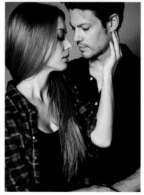

BEHIND THE BEAUTY II

The partner who is the focus of the shot needs to be in front. Once you have decided who is more important, you can try out various ways to make the connection: head to head, holding hands, a kiss, and so on. The closer the crop, the more intimate the end result will be. Because this pose doesn't emphasize the woman's tummy and legs, it is well suited for use with curvy models, too.

#203

HEARTFELT

Contact between the partners' heads is another way to symbolize intimacy. Sure, couples like to look at each other, but it can be quite tiring to do so from so close up. Closing their eyes can make the pose look even more affectionate. Kisses can be strategically placed on noses, lips, or foreheads, or just hinted at.

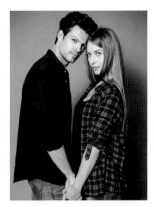

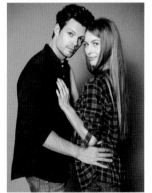

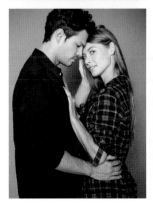

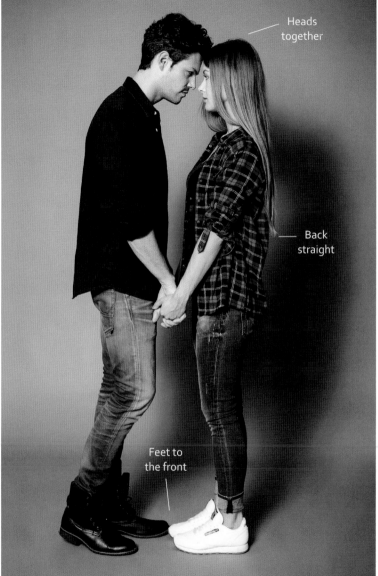

Heads together

Back straight

Feet to the front

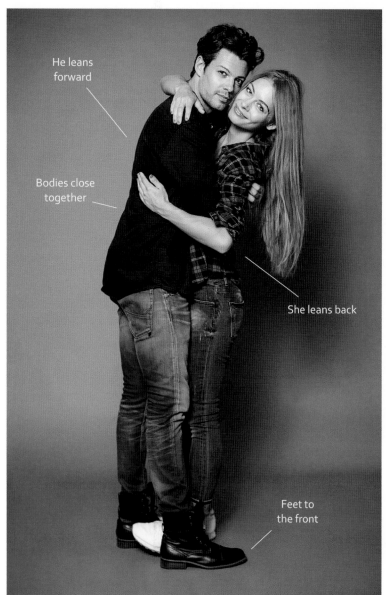

He leans forward

Bodies close together

She leans back

Feet to the front

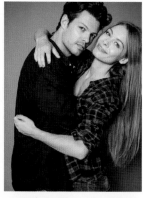

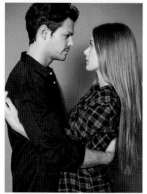

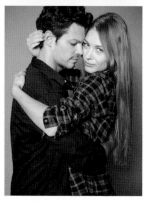

#204

IN YOUR ARMS

Arms are great for connecting, too. A warm embrace forms a close bond without appearing too intimate. The tricky part is finding a way for your models to embrace that appears natural to both. One approach is to let them find out for themselves what works best.

#208

THE DANCE

U

This pose is ideal for showcasing jeans or a slit skirt. The female model's drawn up leg makes both her legs look longer, while the angle this creates adds energy to the image and ensures that it grabs the viewer's attention.

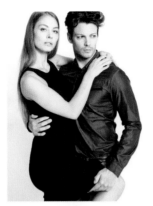

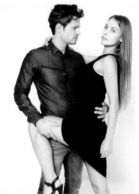

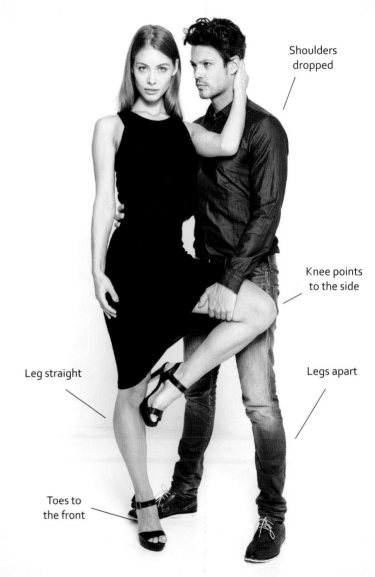

Shoulders dropped

Knee points to the side

Legs apart

Leg straight

Toes to the front

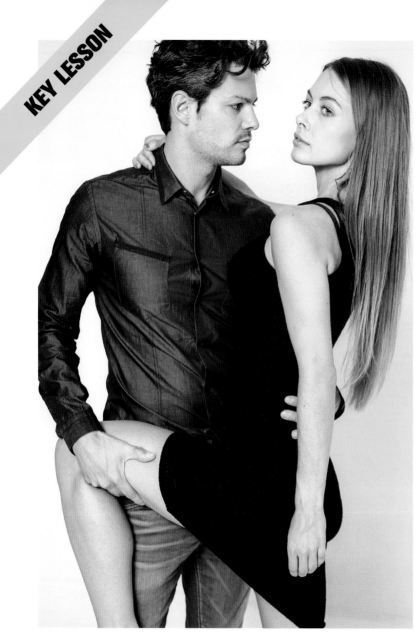

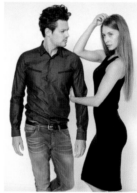

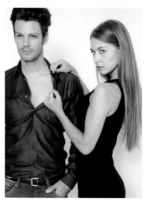

SEX SELLS

Take a closer look at some fashion shots—on TV, the internet, or billboards. You are sure to find a lot of poses that could just as easily be categorized as "sexy" or "nude." Whatever your personal opinion, the reason for this is quite simple: Sex sells.

#209

STANDING OFFSET

You should aim to have both your models take up equal amounts of space within the frame. If both face the camera directly, they will crowd the image. If the breadth of the man's body threatens to dominate the image, you can vary the pose so that one model is standing head-on while the other shows a profile. This trick evens out the weighting of the two bodies and produces a more balanced image.

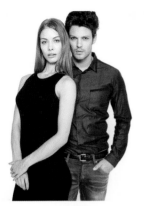

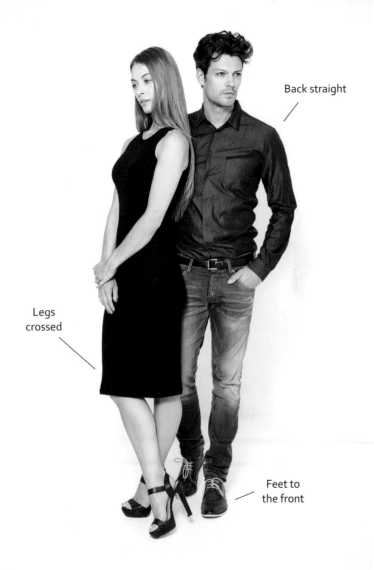

Back straight

Legs crossed

Feet to the front

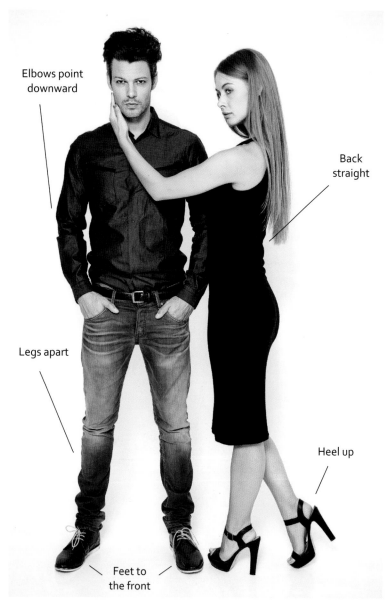

Elbows point downward

Back straight

Legs apart

Heel up

Feet to the front

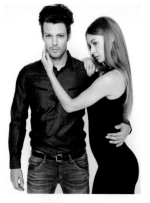

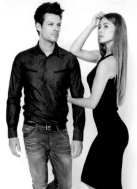

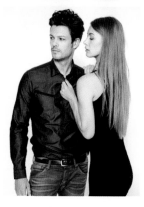

#210

YOUR SHOW

If the focus of a shot is on just one outfit, the model wearing it should face front. The second model can then show a profile to attract less attention. However, you can also turn this pose around to display a backless dress or a top with a feature on the back. This draws focus to the model displaying her profile.

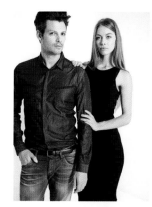

#211

ONE BEHIND THE OTHER

Another way to emphasize one of the outfits more than the other is to position your models one behind the other. If the foremost model establishes eye contact with the camera, this attracts more attention to the clothes that model is wearing. You can boost this effect by having the second model look at the first model's clothes. If neither of them looks directly at the camera, the viewer will assume both outfits are of equal significance.

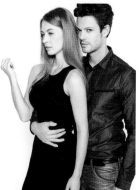

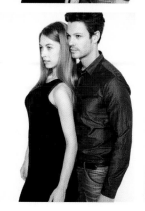

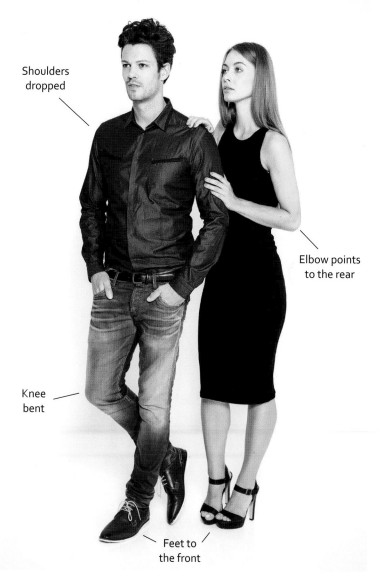

Shoulders dropped

Elbow points to the rear

Knee bent

Feet to the front

253

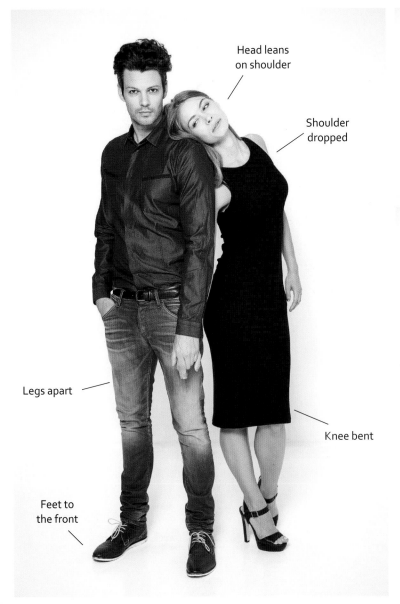

Head leans
on shoulder

Shoulder
dropped

Legs apart

Knee bent

Feet to
the front

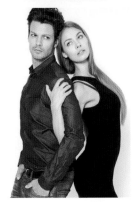

#212

BACK
TO BACK

U

You have to cheat a little to get back-to-back fashion poses right. To display the clothes adequately you need to create more of a shoulder-to-shoulder pose in which both models turn slightly toward the camera. If they are holding hands at the front, they can use their eyes, the other arm, or the position of their heads to vary the pose (see variation #2).

#213

PASSIONATE

There are various reasons for a model to touch his or her own clothes, but when one model starts touching the other's clothes, it is guaranteed to add excitement and passion to the shot. The model doing the touching can use just one finger or an entire hand to achieve the desired effect, and the results can be anything from vaguely erotic to full-on sexy.

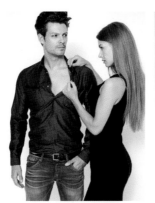

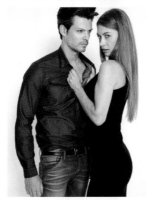

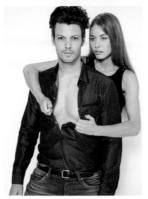

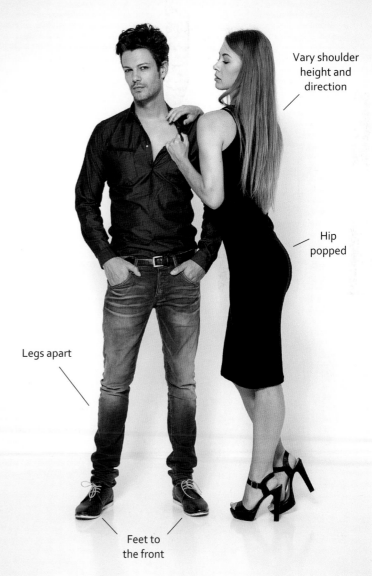

Vary shoulder height and direction

Hip popped

Legs apart

Feet to the front

255

IMPLIED NUDE

Little clothing but plenty of emotion. Let things run their course and keep shooting while they do. Nude sessions are about capturing genuine feelings, and the following poses explain how to ensure that's exactly what happens.

#218

SHOW YOUR BACK

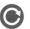 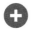

A well-proportioned back is always nice to look at, whether male or female. Make sure both your models stand up straight for this pose.

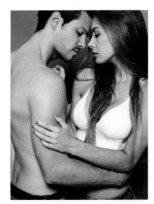

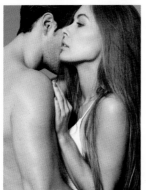

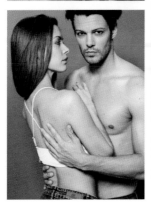

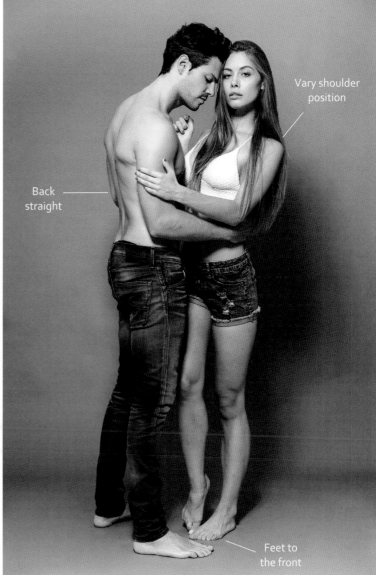

Vary shoulder position

Back straight

Feet to the front

261

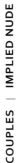

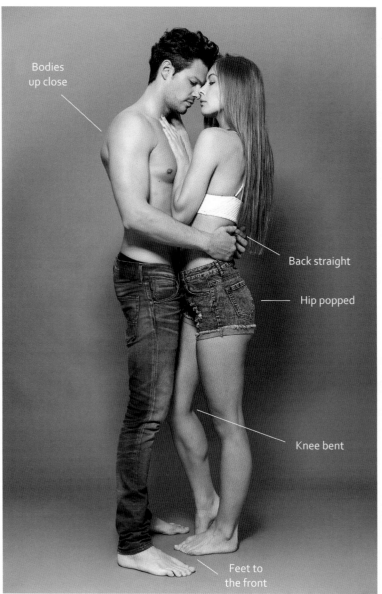

Bodies up close

Back straight

Hip popped

Knee bent

Feet to the front

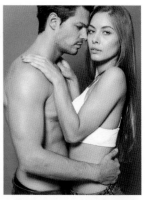

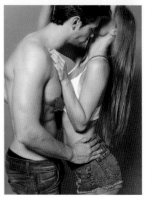

#219

INTIMACY

Having your models snuggle up close produces a really intimate atmosphere. Get them to alternate which of them looks at the camera. The main image shows them concentrating on each other, while the smaller images show some of the other possible variations. These include the man looking at the camera, the woman looking at the camera, and both just doing their thing.

#220

ON TOP OF EACH OTHER

Whoever is on top has to make sure they don't obscure the other's face or jawline. Make sure, too, that they don't hold each other's hands too tightly. A passionate grab of a partner's wrist is fine. Try as many variations as you can to keep things flowing.

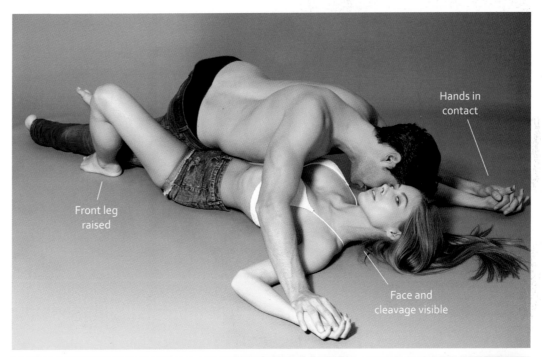

Hands in contact

Front leg raised

Face and cleavage visible

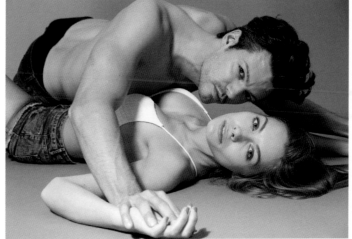

263

SPORTS

Couples can take part in sports together, or they can help each other perform specific exercises. These poses are designed to illustrate sports in an aesthetically pleasing way, while simultaneously showcasing the models' clothes.

221

IN SYNC

Position your models in front of one another and slightly offset to one side. This shot is more about a visually pleasing setup than a specific pose. It doesn't matter if they are doing yoga, warm-up exercises, or fitness training—the offset is ideal for presenting any kind of sports performed as a duo.

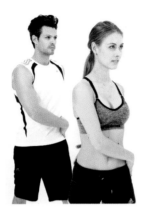

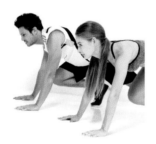

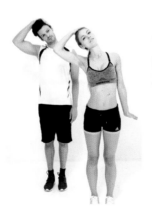

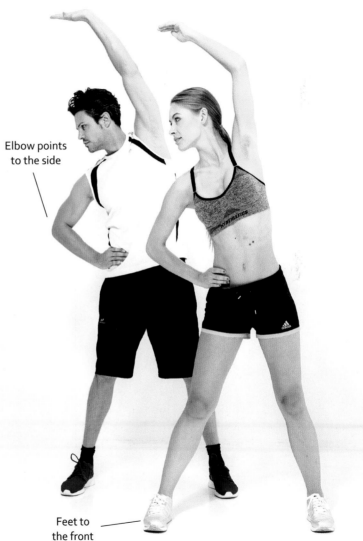

Elbow points to the side

Feet to the front

265

Back-to-back

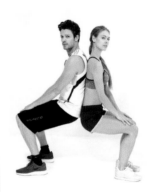
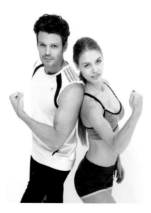

Toes to
the front

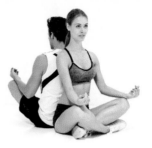

#222

BACK TO BACK

Performing back-to-back exercises is a great way to put both models center stage. Decide whether you want them to strike symmetrical or asymmetrical poses, and then concentrate on details such as the direction they look or where their feet are pointing.

#223

FOOLING AROUND

Who is the stronger of the two? Try getting your models to play "human weights" to illustrate the point. Whoever carries the most weight needs to keep their lower back tensed. And who says it has to be the man who is in the stronger position? Let your models have fun experimenting, and keep shooting while they find out what's possible.

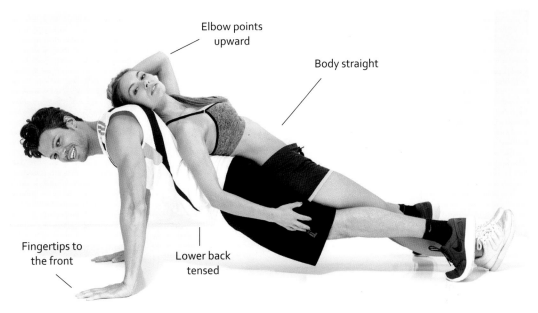

Elbow points upward

Body straight

Fingertips to the front

Lower back tensed

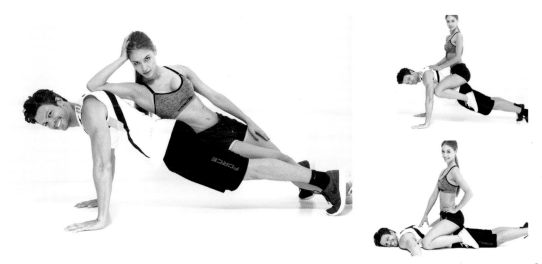

#224

Body straight

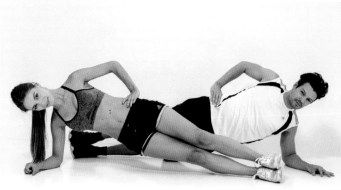

Fingertips to
the front

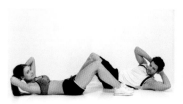

LEFT / RIGHT

In addition to the *Synchronized* and *Back to Back* poses (#221 and #222), this is another great way to get your models to perform simultaneously. Get one of your models into position and then ask the other to mirror the action but face in the opposite direction. As you can see, this works really well for a variety of exercises. Remember to alter the point where their bodies overlap to suit the exercise they are doing. The overlap is near their butts for the push-ups and around their knees for the sit-ups.

#225

THE MOTIVATOR

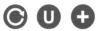

Get one of your models to play the helping hand or motivator for the other. Again, this is less of a pose and more of a general way to illustrate sports for couples. Keep an eye on your models' facial expressions—a concentrated look emphasizes the intensity of the exercise, whereas a smile indicates that your models are having fun.

Elbow faces the camera

Elbow points forward

Knees raised

269

Knee raised

Back straight

Knee at
90 degrees

Toes to
the front

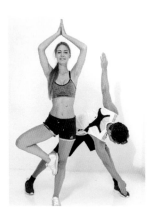

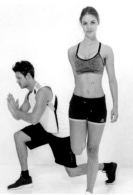

NON-SYNCHRONIZED

We have already looked at a number of synchronized exercises, but couples don't have to participate in sports this way. If you get your models to do different things, you need to work harder to create a balanced image, but the reward is more freedom when it comes to creating new positions. Like the synchronized poses, it helps to get your models to stand one in front of the other and slightly offset. The exercises themselves need to suit one another as well.

WORK SYSTEM-ATICALLY

As you are sure to have noticed, in the sports poses the aesthetics of capturing sporting couples is more important than the pose itself. The techniques involved include positioning your models back to back, offset one in front of the other, facing in opposite directions, or helping each other exercise. Once again, the trick is to think in categories and try out all the variations you can before switching to a new category. There are plenty of variations for every sport, every pose, and every posture.

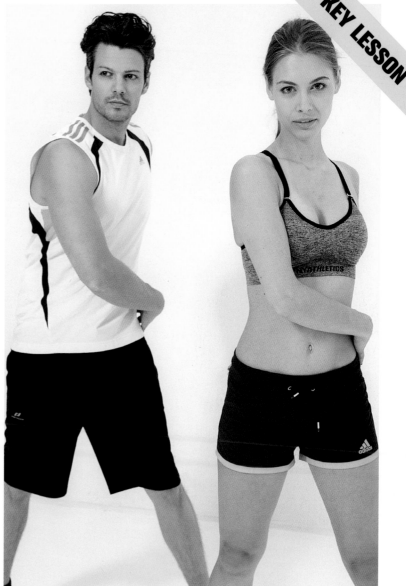

EXPECTING

Baby Belly Single | Baby Belly Couple

BABY BELLY SINGLE

Pregnancy is a very special time in the life of a woman, and it is worth taking some trouble to capture the experience photographically. The goal is to capture aesthetically pleasing and natural-looking images. The best time to do this is between eight and four weeks prior to the birth.

#227

THE FLOWER

A model doesn't have to be naked to show her baby belly. It is easier for the photographer to see that it is clearly visible than it is for the model. The position of her legs is key, and it is important to make sure there is no pinched or folded skin visible where her thighs meet her calves. One way to do this is have her sit with her legs slightly splayed, as shown in variation #1. If necessary, she can also use her hands to hide any problem zones.

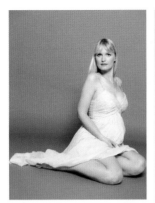

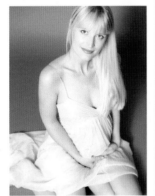

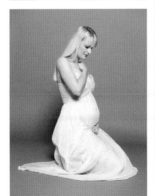

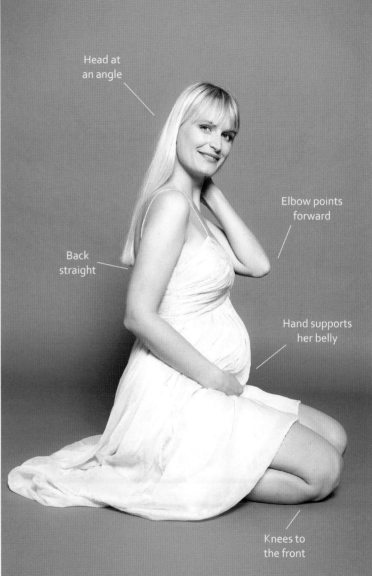

Head at an angle

Back straight

Elbow points forward

Hand supports her belly

Knees to the front

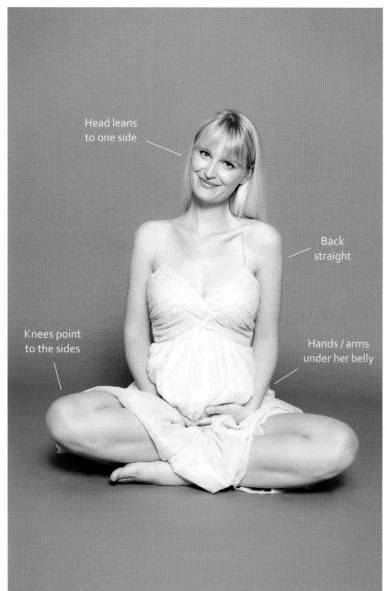

Head leans
to one side

Back
straight

Knees point
to the sides

Hands / arms
under her belly

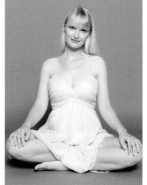

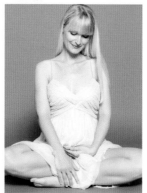

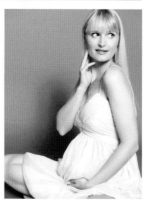

#228

BUDDHA

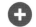

This innocent-looking, play-ful pose is great for pregnant women, as it incorporates a childish element. It works even better if her baby belly isn't cov-ered, but she can still accentuate it using her hands or by posing side-on to the camera.

229

SEMI-RECLINING

U **+**

Pregnant and sexy is no contradiction. This side-on pose beautifully displays your model's baby belly while creating a nice curve between her back and her behind. If there is space, she can further accentuate her curves by positioning one arm behind her head. Make sure these curves are not interrupted by her elbows or her hair.

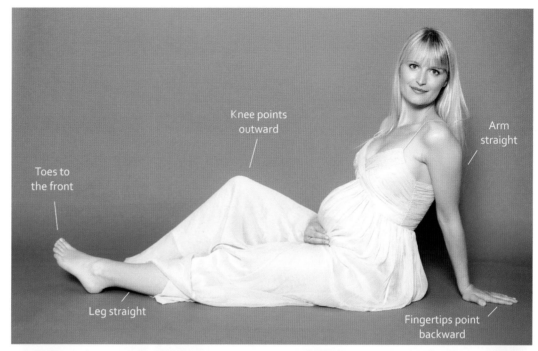

Knee points outward

Arm straight

Toes to the front

Leg straight

Fingertips point backward

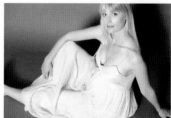

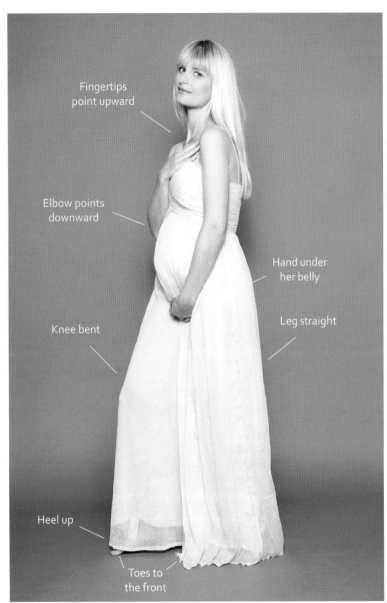

Fingertips
point upward

Elbow points
downward

Hand under
her belly

Knee bent

Leg straight

Heel up

Toes to
the front

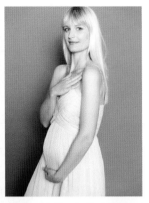

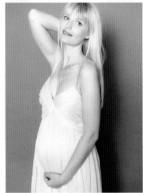

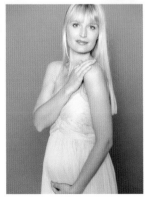

#230

IN
PROFILE

While displaying your model's baby belly, this pose also forms a nice curve between your model's back and her behind in a similar way to #229. Her left hand steers the viewer's gaze to her belly, while positioning her right hand with its palm turned inward creates a sensitive, almost vulnerable look. The position of her arm in variation #2 produces a completely different, more self-confident look.

#231

IN PROFILE II

Images shot in profile are great for displaying a baby belly, whether your model is standing or sitting. It is crucial here that your model rests her weight on her arm rather than leaning back against the chair. This creates a pleasing geometric shape that keeps the image looking balanced. Positioning her feet one in front of the other and on tiptoes adds a graceful note.

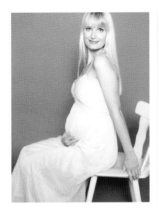

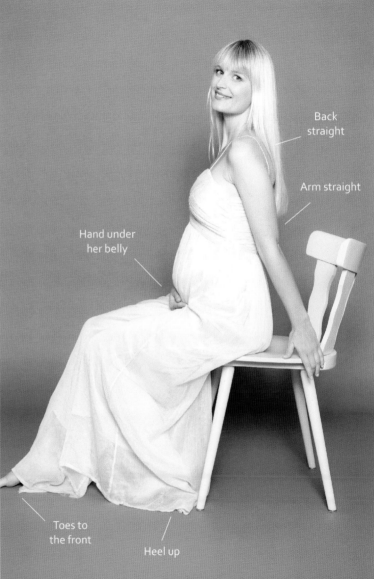

Back straight

Arm straight

Hand under her belly

Toes to the front

Heel up

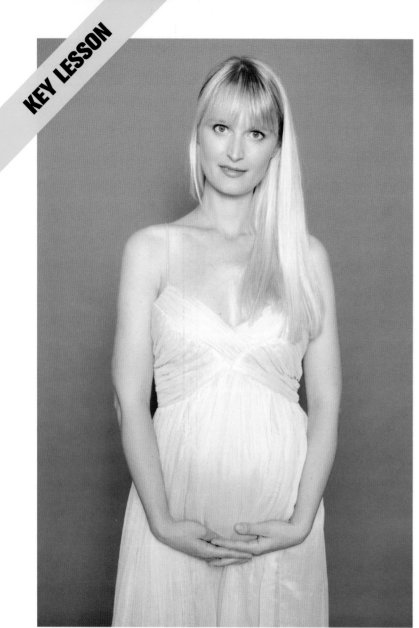

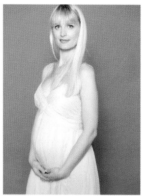

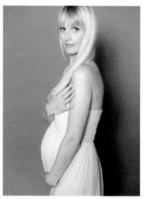

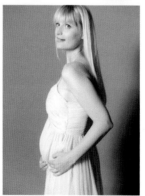

45-DEGREE ANGLES

A great rule to apply when capturing a baby belly is to have your model turn toward the camera in 45-degree increments (or walk around her in 45-degree increments). This way, you can capture the roundness of her belly from a variety of viewpoints. Baby bellies seem to disappear if you shoot them head-on, especially if your model is wearing black. Light clothing such as a crop top or an empire-style dress (as shown here) are ideal for this type of shot.

FEELING SEXY

Not all women feel sexy when they are pregnant. Pregnancy changes a woman's body and her life. Paying her compliments will help your model to feel good about herself. Positive reinforcement will motivate your model and will form the basis for attractive-looking poses.

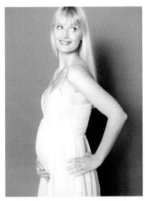

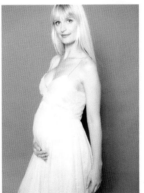

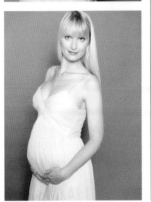

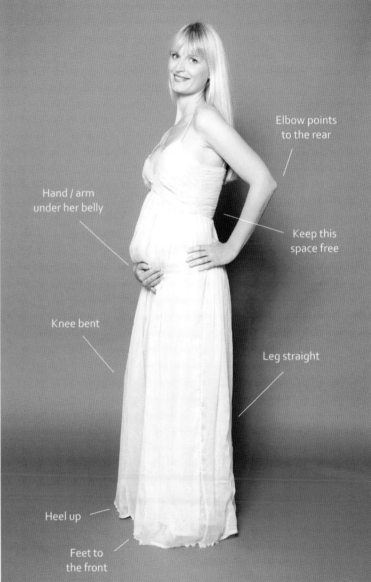

Elbow points to the rear

Hand / arm under her belly

Keep this space free

Knee bent

Leg straight

Heel up

Feet to the front

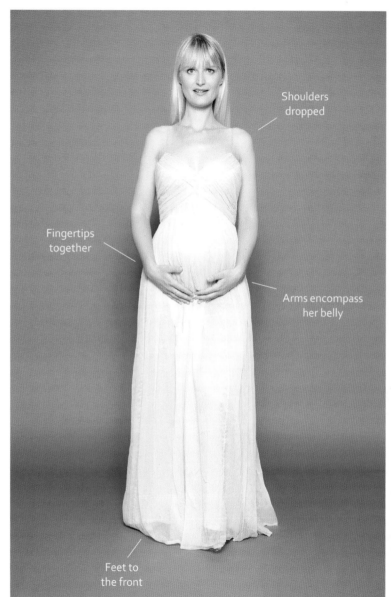

Shoulders dropped

Fingertips together

Arms encompass her belly

Feet to the front

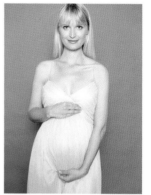

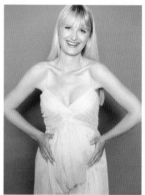

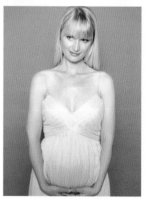

#233

HEAD-ON

Listen to your model, and note where she thinks her problem zones are. If she says she has fat arms, stretch marks, or other blemishes, work around them instead of accentuating them. This pose focuses strongly on your model's midriff, while (if unclothed) she can hide any stretch marks with her hands.

#234

GENTLE

As you already know, turning the palms of her hands toward her body gives your model a more sensitive, feminine look. The same trick works, too, if she touches her chest, her face, or her belly. To simultaneously emphasize her baby belly, get her to turn 45 or 90 degrees away from the camera. Generally speaking, expecting models look best in the 45-degree position.

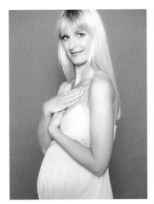

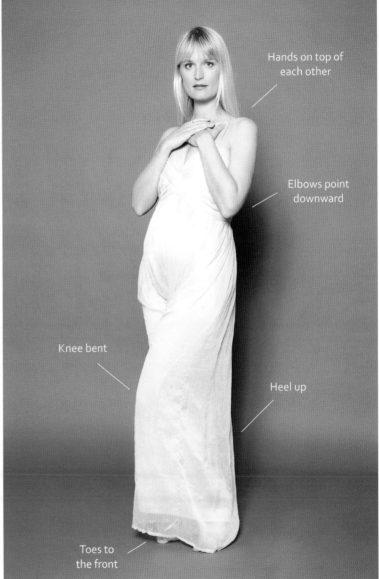

Hands on top of each other

Elbows point downward

Knee bent

Heel up

Toes to the front

BABY BELLY COUPLE

It takes two to make a pregnancy, so it's only natural to include the father in the photos. There are lots of ways to capture the anticipation, pride, and protective instincts shown by a father-to-be.

#235

HANDS ON BELLY

(U) (+)

It is completely natural for parents-to-be to touch and feel the mother's belly. This is also an easy way to attract the viewer's attention. This pose is very natural and automatically provides a place for the couple to put their hands. Try different variations with both partners' hands clasped or in different positions.

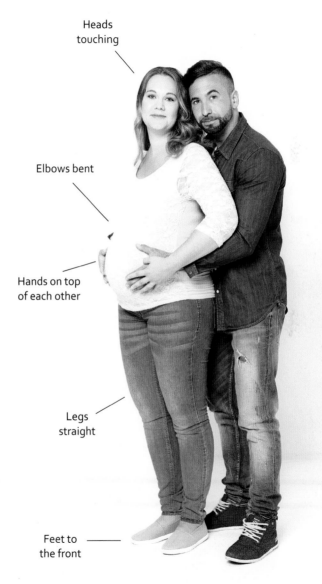

Heads touching

Elbows bent

Hands on top of each other

Legs straight

Feet to the front

285

Heads together

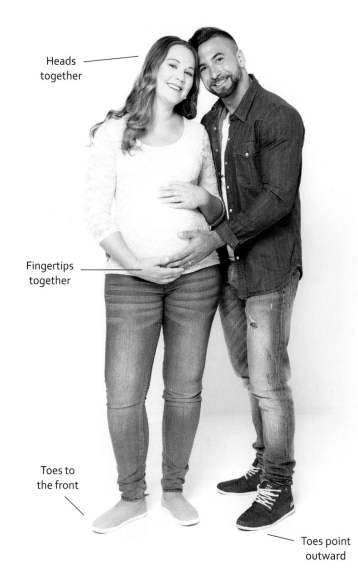

Fingertips together

Toes to the front

Toes point outward

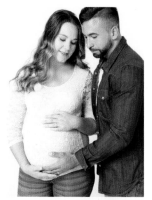

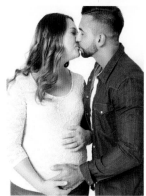

AVOID A DOUBLE CHIN

Nobody likes to see a photo of themselves with a double chin, even toward the end of a pregnancy. If your female model looks down at her belly, make sure she doesn't move her head back. This often looks strange and almost guarantees a double chin. If you find the position of her head looks awkward, get her to look at a point in front of her feet rather than directly at her belly (variation #1).

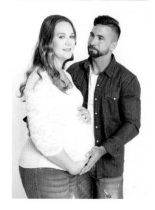

#237

FRONT TO FRONT

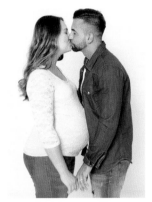

Even in a pose as interesting as this, the viewer's attention should be steered toward the woman's belly. Shooting from hip height ensures that her belly is the center of attention. You can create a connection between your models by having their heads, hands, or arms touch each other, or with a simple kiss.

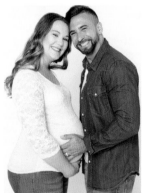

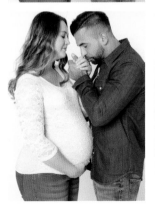

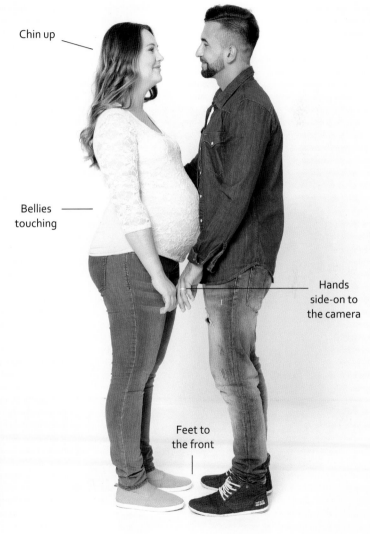

Chin up

Bellies touching

Hands side-on to the camera

Feet to the front

Vary head
positions

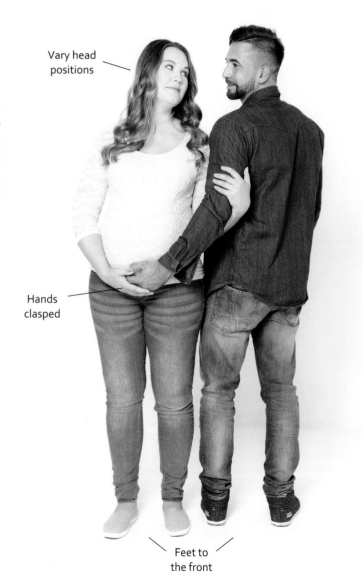

Hands
clasped

Feet to
the front

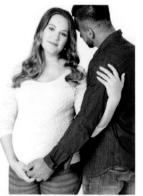

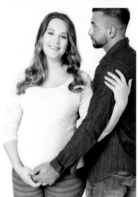

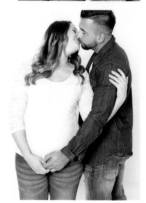

#238

PASSING BY

This is a great pose for putting the mother-to-be center stage. There are plenty of ways for both models to vary their facial expressions and head positions. They can look directly at each other, glance past each other, or touch heads. The hand beneath her belly automatically directs the viewer's gaze and turns this portrait pose into a baby-belly pose.

#239

RECLINING

This pose requires the man to support the woman's back with his knee. She needs to position herself so she can raise her rear leg. The pose itself is quite rigid, so it is up to the photographer to vary the look using different camera angles.

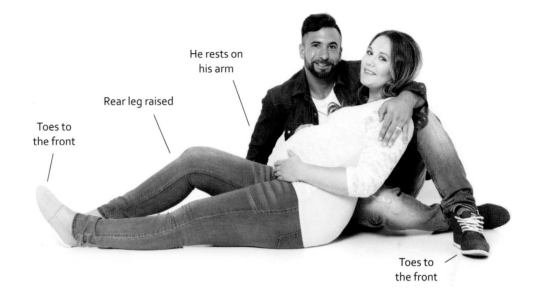

He rests on his arm

Rear leg raised

Toes to the front

Toes to the front

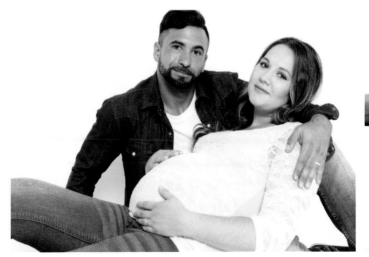

Hair to
the back

Hands
hide hips

Feet to
the front

Feet on
tiptoes

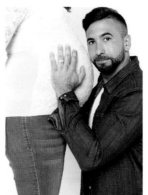

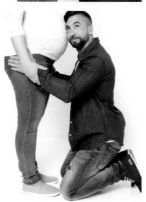

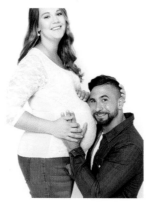

#240

BABY
WORSHIP

Here, the kneeling father-to-be can hold his partner's hips, touch her belly, hold her hands, or simply listen to the baby. Get him to vary his facial expression for each variation. Don't shoot from too high up. In fact, you can get down low with your model and alter your framing while you work. The images here show just some of the possible variations.

#241

HEART TO HEART

If you use your models' hands or fingers as part of the pose, make sure they don't look too fidgety. This can happen easily if they intertwine their fingers. Ideally, they will place their hands on top of each other and keep their fingers together.

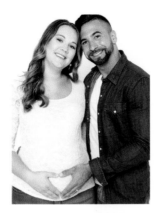

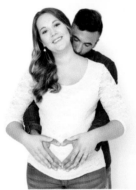

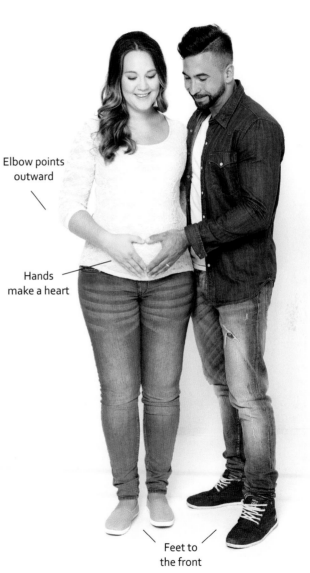

Elbow points outward

Hands make a heart

Feet to the front

FAMILIES

Mom, Dad, and Baby | New Family | Children

MOM, DAD, and BABY

Photographing a baby requires you to improvise. A baby can't pose, even if the parents can. These images concentrate on the interaction between baby and parent.

#242

START SAFE

The baby's safety is the number one priority, so begin with some seated poses. The mom or dad should hold the baby in folded arms or let one partner hand the other the baby once they are seated. The parents can then alter their arm positions after everything is in place. If you need to begin again or radically alter the pose, hand the baby to someone else first.

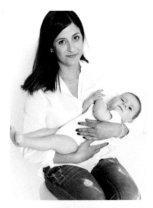

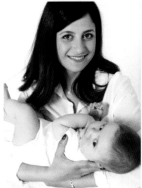

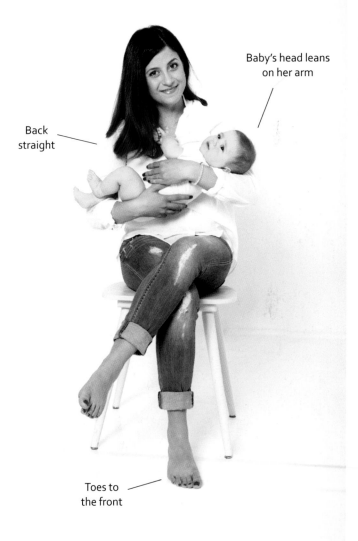

Back straight

Baby's head leans on her arm

Toes to the front

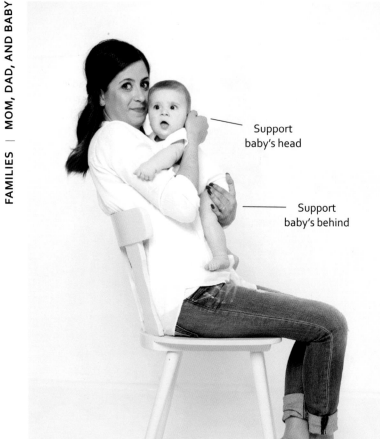

Support baby's head

Support baby's behind

Ankles crossed

Heel up

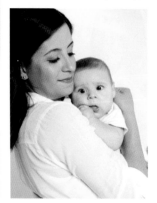

#243

HEADS TOGETHER

A baby's head is often very close to its parent's head, or the parent will look downward to communicate with the child. Both situations tend to produce a double chin that is not usually there. When you are giving instructions to your model, check that she doesn't unintentionally create a double chin. Pushing her chin forward a little helps, but not too far to avoid looking forced and awkward.

#244

THE UNIVERSAL BABY POSE

Ⓤ ➕

Babies either sleep or they don't, and you need to watch out for the critical phase during a shoot. A crying baby means irritated parents, and that doesn't make for great results. This pose works for babies who are asleep or awake. The only prerequisite is pointing the (sleeping) baby's head in the right direction or getting the (alert) baby to look at the camera.

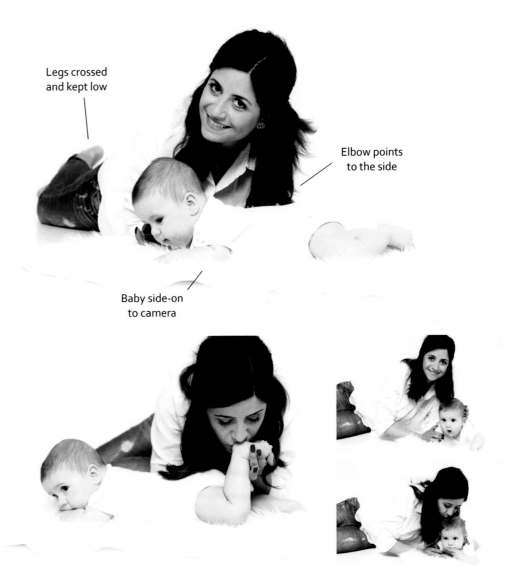

Legs crossed and kept low

Elbow points to the side

Baby side-on to camera

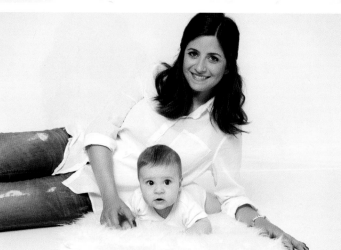

Knees bent

Arm straight

Toes point
outward

Fingertips point
outward

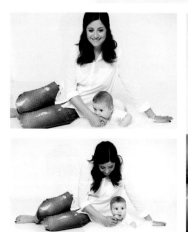

IN
FOCUS

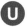 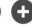

This pose develops smoothly from the previous one, but here the focus is squarely on the baby who is placed looking directly into the camera. The parent is positioned behind the baby while you work. Use a wide aperture. At this kind of distance, the adult won't end up completely defocused, and there are plenty of ways to vary the basic position.

IN DAD'S ARMS

U **+**

Dads love to be photographed with their babies. This is a classic pose that shows a strong dad cradling his vulnerable child. You can almost hear him saying, "You are safe with me." The angle of his arms should be slightly less than 90 degrees; anything greater will look unnatural and will add too much energy to this calm pose. The aim of this pose is to create an emotional, natural-looking shot with the baby nice and close to the father (compare variations #1 and #2). Make sure the dad doesn't make a double chin while he looks at his child.

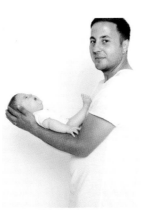

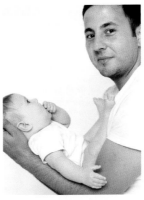

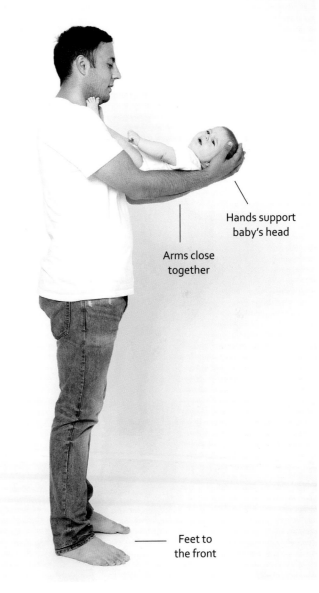

Hands support baby's head

Arms close together

Feet to the front

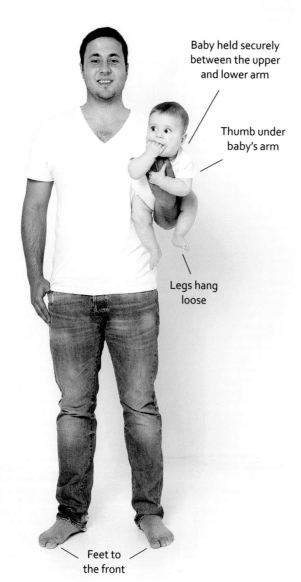

Baby held securely between the upper and lower arm

Thumb under baby's arm

Legs hang loose

Feet to the front

THE PARCEL

Safety first! For this pose, the father should have plenty of practice holding his child this way to ensure safety. This pose supports the baby by its chest in a way so the baby won't to slip sideways. Nevertheless, you have to assume that babies and small children are going to make sudden, unexpected movements. Bending his arm gives the baby additional security. Once your model has struck this kind of pose, he should stand still while you move around to find new angles and alter the framing.

#248

FLYING HIGH

Lifting (but not throwing) an alert baby up high is a great way to get it to smile. Mom and dad can do this from a standing or a sitting position, so it's a great way to vary a shoot. You can use this trick at regular intervals between a variety of other standing or sitting poses.

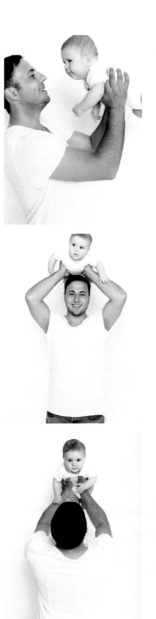

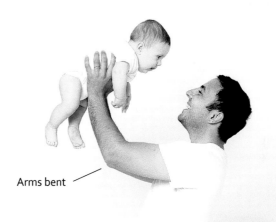

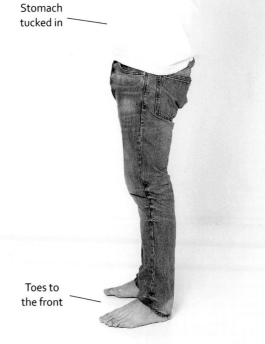

Arms bent

Stomach tucked in

Toes to the front

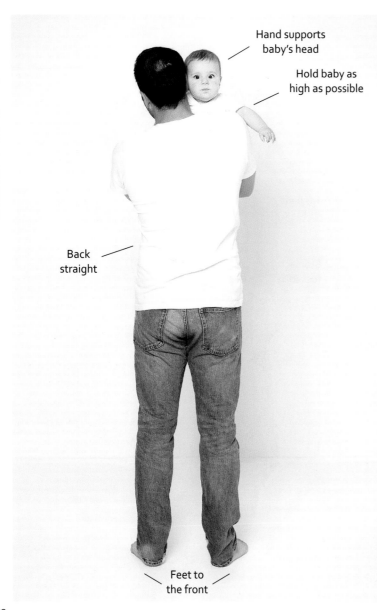

Hand supports baby's head

Hold baby as high as possible

Back straight

Feet to the front

SHOULDER TIME

This pose is great whether the baby is asleep, awake, crying, or tired. Make sure there are no ugly creases in the skin of the parent's chin or neck and that there aren't any hairs in the baby's face. Use the baby's favorite toy or make a noise to grab its attention. Alternatively, you can get the other parent to talk to it. Whichever trick you use, place the source of interest behind the camera and close to the lens.

#250

SAFE AND SOUND

This pose stems from the fact that a baby's head always needs support. All the mom or dad has to do is hold the child and lay its head in their hands. You can get the parent to lean forward or hold the baby at various heights to get it comfortable and to create the perfect pose.

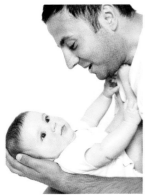

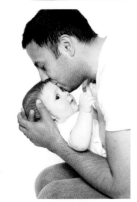

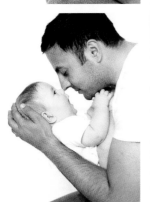

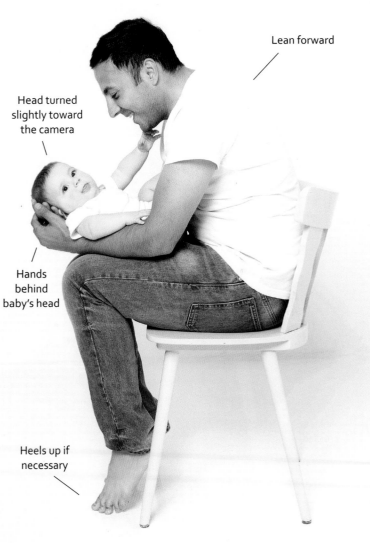

Lean forward

Head turned slightly toward the camera

Hands behind baby's head

Heels up if necessary

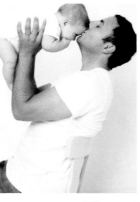

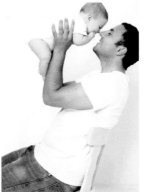

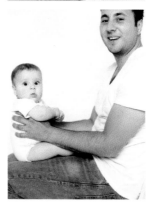

Elbows point downward

Lean back

Ankles crossed

Heels up

UP AND DOWN

The mom or dad grabs the baby, making sure the spaces between their fingers aren't too wide. Fanned fingers make the resulting image look too fussy. They can now hold the baby at different heights. The most important part of this pose is the parent's facial expression. Closed eyes convey a feeling of intimacy and security.

AVOIDING DOUBLE CHINS

There is often a risk of capturing an unwanted double chin when you photograph parents with their child. This is because parents automatically either draw their heads back to look at their child, or lean forward to look down at it. Always mention this phenomenon at the start of a parent/child shoot to make the parents aware. You will be surprised by how often you have to repeat your instructions in this regard.

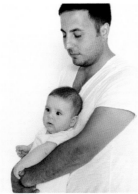

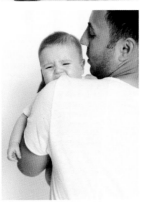

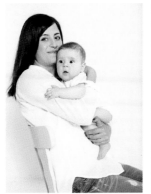

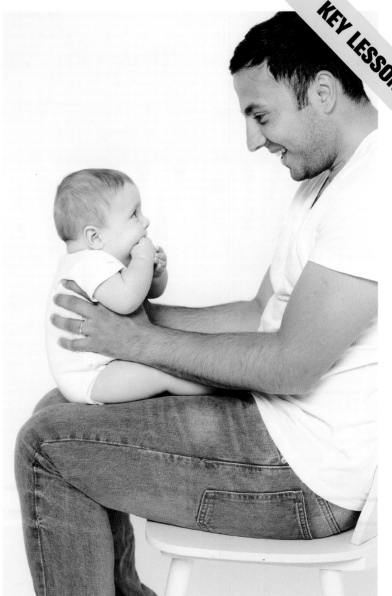

NEW FAMILY

The same is true here with both parents as it is for shots with a baby and a single parent: The baby cannot pose but the adults can. Photographing both parents provides plenty of opportunities to vary the structure of the image, but you have to be clear from the start about who is going to hold the baby.

#252

BABY SANDWICH

Position the parents opposite each other with the baby in the middle. Use their heads to vary the pose, but decide in advance who is going to securely hold the child and who is simply posing their hands. There must be no doubt whatsoever who is in charge when the models break the pose.

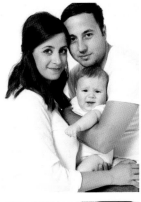

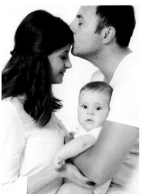

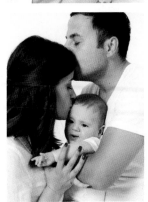

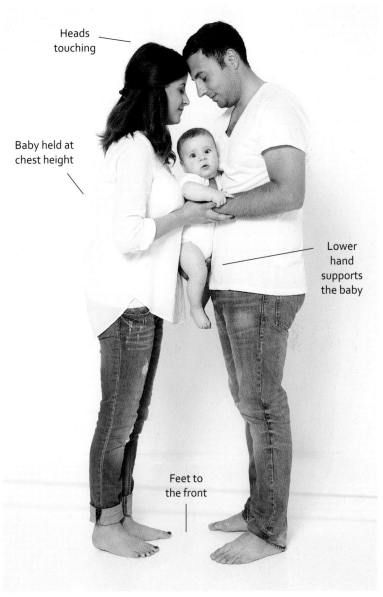

Heads touching

Baby held at chest height

Lower hand supports the baby

Feet to the front

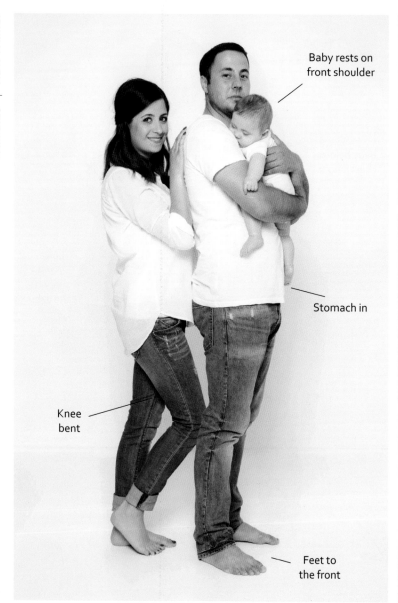

Baby rests on
front shoulder

Stomach in

Knee
bent

Feet to
the front

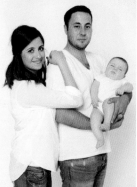

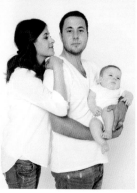

BABY
SANDWICH II

Altering the sequence of your
models is a great way to vary
this pose. You can use it with
small children as well as babies.
If your models are about the
same height and are positioned
behind one another, it is a good
idea to get them to lean their
heads in opposite directions so
that neither ends up hiding parts
of the other's head.

#254

THREE LITTLE SOLDIERS

Position the members of the family in a row, one behind the other. Dad stands at the back with his arms around Mom, who holds her baby in front. The parents can look at the camera, turn their heads toward each other, or play with their baby together. Once they are in position, move around and try out various camera angles.

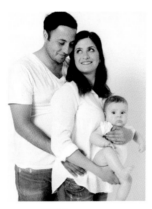

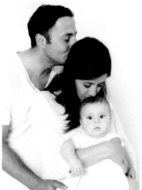

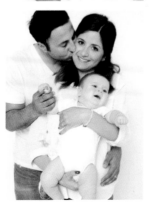

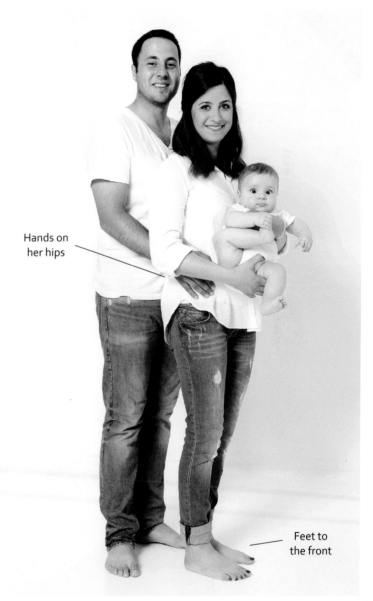

Hands on her hips

Feet to the front

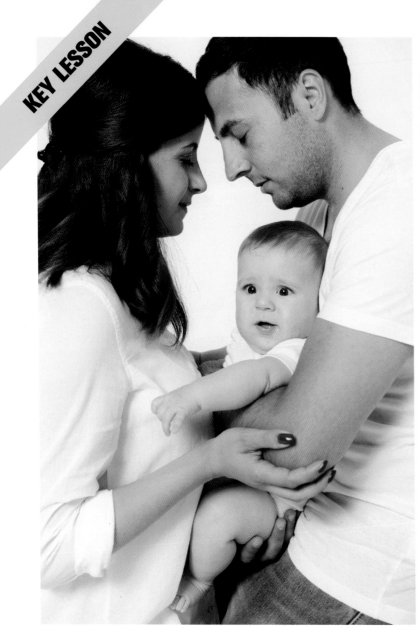

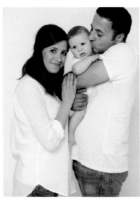

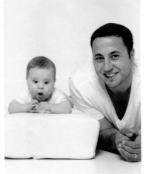

SAFETY FIRST

The most important factor of all when photographing babies and children is safety. Loose wires can easily become tripping hazards, and sudden movements made in the heat of the moment can quickly make a flash head tip over. Always keep your studio tidy, and minimize the risks wherever possible. In shots that include both parents and a child, agree in advance who is going to hold the child and stick to your decision. Don't pose a child on tables or pedestals. It is too easy to get distracted and accidents can happen faster than you think.

#255

FAMILY TIME

The way the father holds the baby in this pose gives him virtually no freedom of movement. In other words, it's the woman's job to introduce variations that keep the pose interesting. Keep moving while you shoot, and use various camera positions and framing to fine-tune the image.

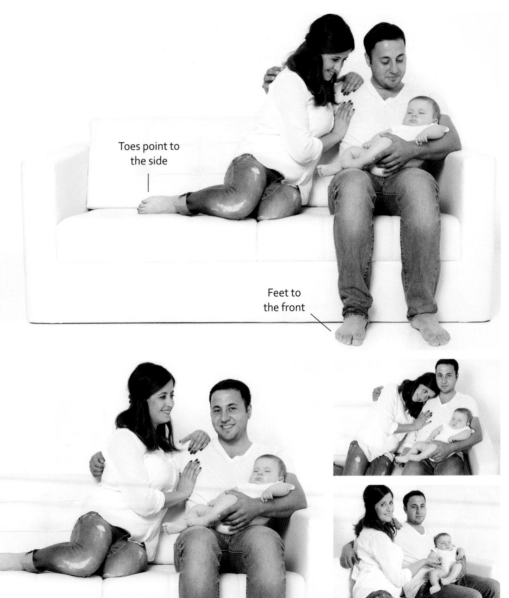

Toes point to the side

Feet to the front

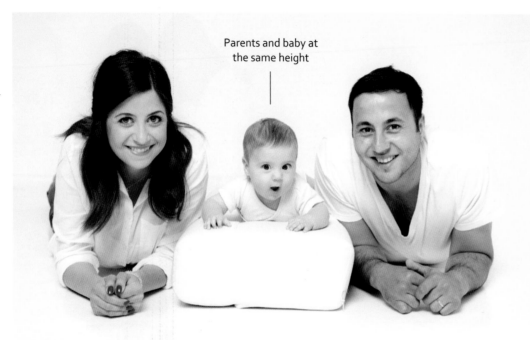

Parents and baby at the same height

KING OF THE WORLD

The life of a fresh-baked family revolves around the baby for quite a while, so why not make this situation the subject of a pose? This cute pose is great for placing the baby center stage. Having both parents give their baby a gentle kiss or a cuddle emphasizes the baby's cheeks. Make sure that neither adult squishes their baby's face by pressing too hard. To prevent their noses getting squashed against their baby's cheeks, get them both to turn their heads slightly toward the camera.

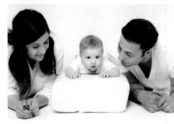

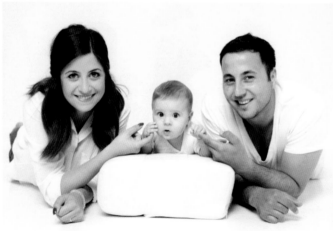

#257

ON THE STEPS

U **+**

This is another great way to vary the sequence of your models, and it works well on a staircase, too. Depending on how old the child is, it can remain in its parents' arms, sit on someone's lap, or sit on a step of its own. You can set up the pose according to the abilities presented by the child. Mom definitely does not have to be in front. Try as many variations as possible.

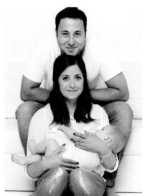

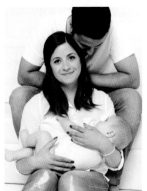

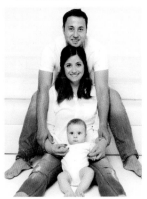

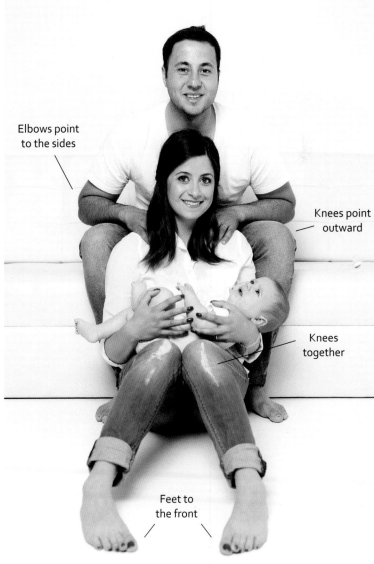

Elbows point to the sides

Knees point outward

Knees together

Feet to the front

CHILDREN

You have to be prepared to improvise when you photograph children. There will always be mood swings or shots that simply don't work. On the other hand, if you manage to get things flowing, working with children can be a lot of fun and the results are often quite surprising.

#258

WAITING ROOM

Children more than adults tend to rest on their hands in a way that produces maximum squish. Kids simply like to be comfy and will often position their fingers in ways that don't fit with the accepted rules of photographic posing. However, this is all natural behavior for a kid, so go ahead and capture everything your young model does. Make sure you shoot plenty of spontaneous, imperfect poses before you begin to make any corrections—if you make any corrections at all.

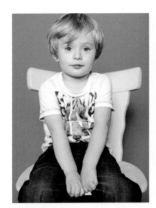

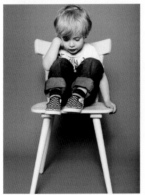

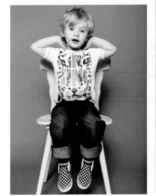

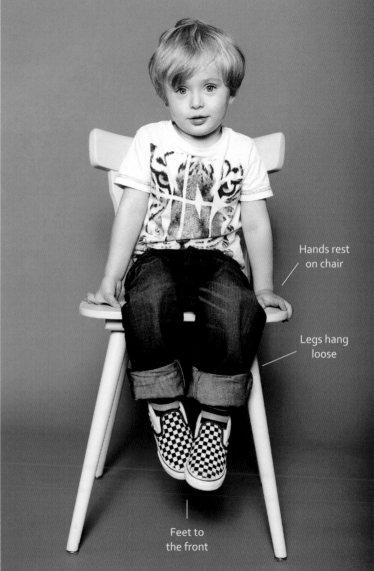

Hands rest on chair

Legs hang loose

Feet to the front

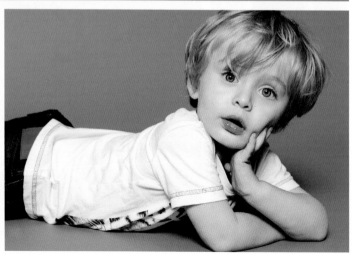

Feet raised

Child photographed
from the side

THINK ABOUT IT

Photographing kids doesn't always mean capturing cheesy smiles. Try to capture your subject looking surprised, serious, bored, or thoughtful. Try asking questions like, "What do you want to be when you are grown up?" "What's your favorite food?" or "Who is your best friend?" Asking questions helps when you are photographing adults too—you just have to adjust the questions to suit the subject.

#260

WELL NOW

Young children are much more likely to follow instructions given by their own parents than ones coming from a photographer they have never met before. Get the parents to nudge their child in the right direction, but make sure there aren't too many people giving instructions at the same time; otherwise the child might lose interest.

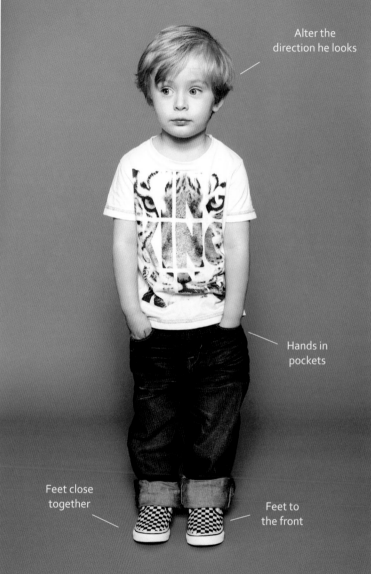

Alter the direction he looks

Hands in pockets

Feet close together

Feet to the front

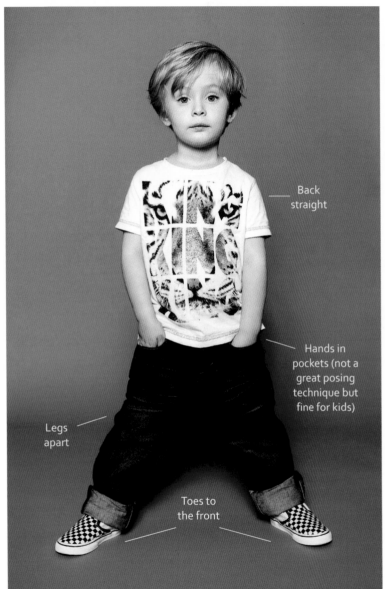

Back straight

Hands in pockets (not a great posing technique but fine for kids)

Legs apart

Toes to the front

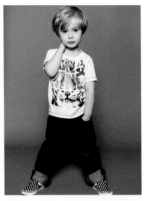

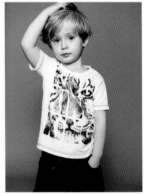

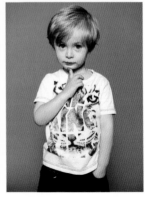

WHAT'S UP?

U +

Kids love to stand with their legs wide apart. This is a simple pose that gives the child a feeling of stability and security, and makes him look relaxed (or even cool). Don't try to give instructions about where to point their feet or how to distribute their weight. For this pose, you only have to concentrate on the hands and arms.

WHAT'S UP? II

In answer to the question of which poses are suitable for children, the answer is, "All of them!" (Except, of course, anything that is remotely sexual.) Try out plenty of adult poses, and see what a child makes of them—this is a great way to develop new ideas.

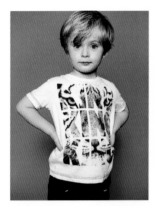

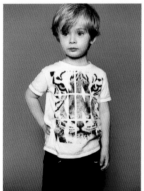

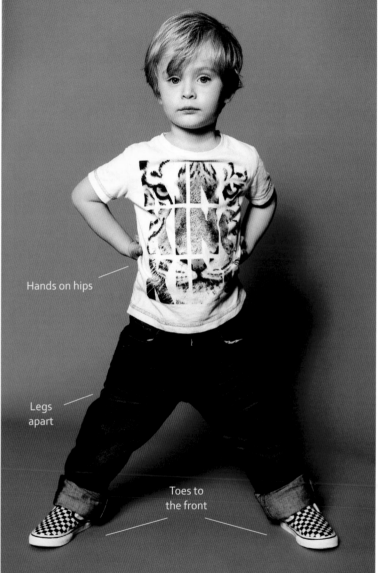

Hands on hips

Legs apart

Toes to the front

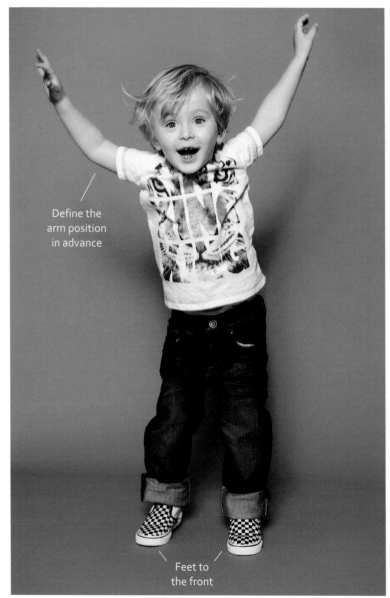

Define the
arm position
in advance

Feet to
the front

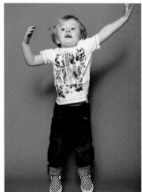

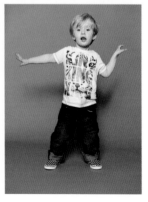

LET'S DANCE

Set a short exposure time and, if necessary, increase the ISO setting to ensure successfully capturing fast-moving poses. Children in action make unique and spectacular photographic subjects if you (and your camera) are fast enough. Keep shooting, and don't become distracted by the captured images on your screen.

#264

TAKE A BREAK

Mirroring is a great technique for getting kids (especially shy kids) to strike cool poses. All you have to do is show your model what you want them to do and get them to copy your movements. You will probably only have to make a few slight corrections, if any at all. This approach works with adults too. One you have positioned your model, move around to find just the right camera angle.

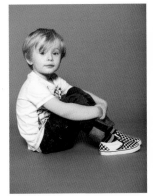

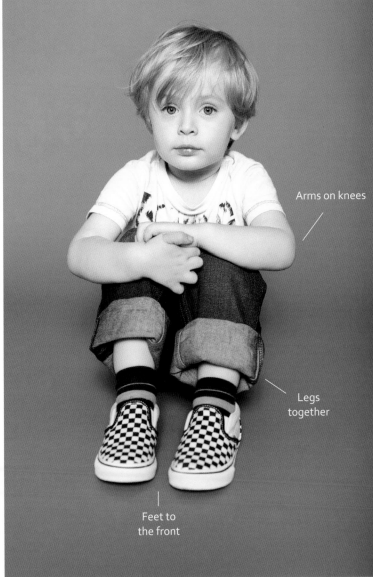

Arms on knees

Legs together

Feet to the front

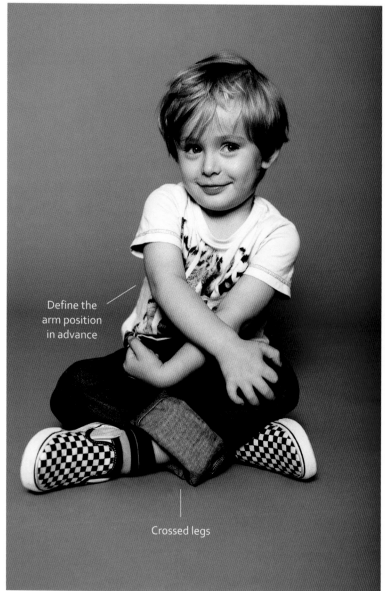

Define the
arm position
in advance

Crossed legs

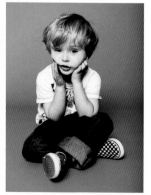

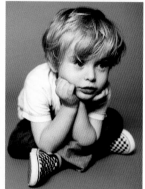

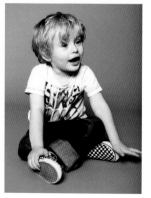

FROM HAPPY TO SAD

Kids are unpredictable, so you have to be prepared for a whole range of moods with plenty of bored looks and disinterested postures along the way. Don't be afraid to keep on shooting and, instead of waiting for the perfect pose, simply capture everything that happens in front of the lens.

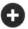

#266

WAS THAT IT?

Few children are instinctively good at posing. If you want to capture natural-looking shots, you need to create a relaxed, secure atmosphere in which kids can behave freely. This increases your chances of capturing carefree moments without annoying your model or having too many adults issue instructions at the same time.

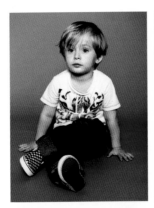

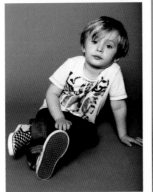

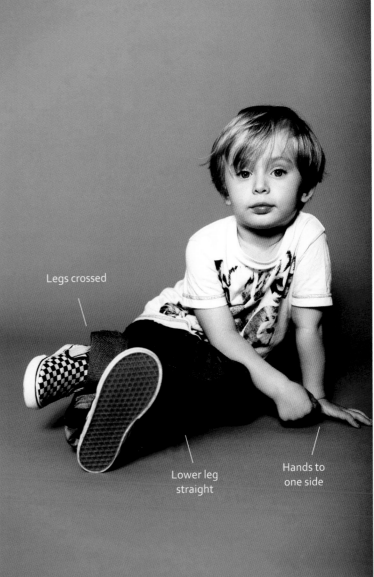

Legs crossed

Lower leg straight

Hands to one side

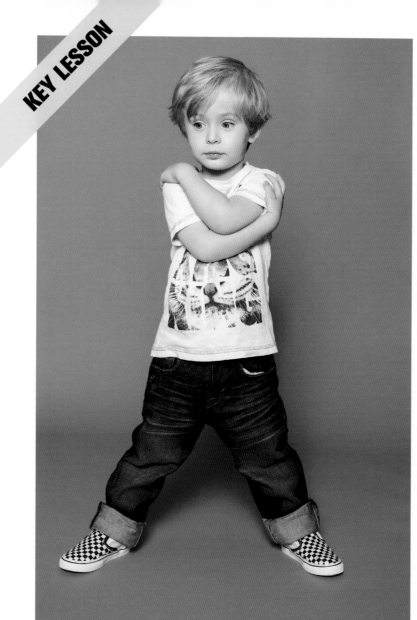

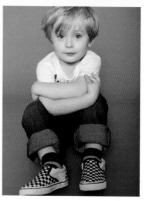

BAD ACTING

Kids often overact when they copy adult poses. The movements they make would look ridiculous if it were an adult in the picture, but kids simply look cute. Don't worry if your model doesn't do exactly what you say. Relax, and let the child interpret things his way. But don't forget to press the shutter-button because you are laughing too much!

#267

ZOOM IN

Ⓒ Ⓤ ➕

Just one more thing: Don't photograph youngsters from above, but instead, get down to kid height. Try getting right up close, especially if your model is finding it tricky to get into a pose. Zooming in or using tight framing helps to make the most of a situation.

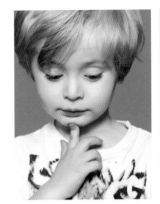

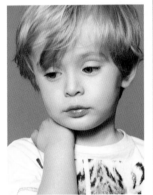

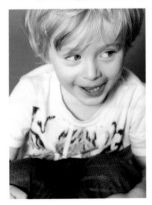

Models

Christina
Kuhlmann

Julia Zellerhoff

Julia Zellerhoff

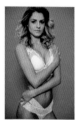

Luna Mercedes

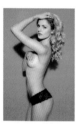

Luna Mercedes

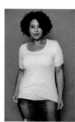

Tanya Gouraige

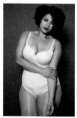

Tanya Gouraige

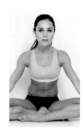

Angelina
Kylyvnyk

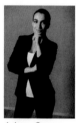

Ariana Cena

Angelina
Kylyvnyk

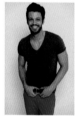

Marcel Valentino

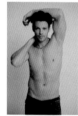

Marcel Valentino

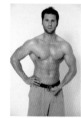

Marcel Valentino

Florian
Schuhmacher

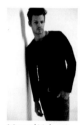

Andreas
Schröder

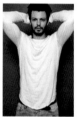

Marcel Valentino

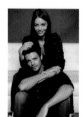

Marcel Valentino
Mirja Holsten

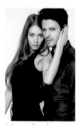

Marcel Valentino
Mirja Holsten

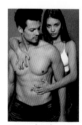

Marcel Valentino
Mirja Holsten

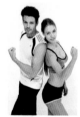

Marcel Valentino
Mirja Holsten

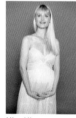

Kim Kira
Schluckwerder

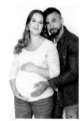

Kristina and
Cem Ay

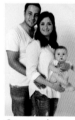

Cansu and
Kerem Ceylan

Noah Milz

Thanks

I'd like to thank a whole bunch of people:

Thanks go to my family, who keep me motivated and always support me when the going gets tough. Special thanks go to my mom and my aunt.

Of course, I want to thank all the models for their time and effort, and for their faith in me. Thanks also go out to Fauve Lex, our fantastic makeup artist.

And special thanks go to my pals:
SamArt: Thanks for your support and friendship. #highkick
Serra: Thank you for putting up with more than anyone else and for still being there.
Christian and Ricarda: Thanks for your faith and support.

Mehmet Eygi
eygi@sedcard24.com | www.sedcard24.com | facebook.com/mehmeteygi

Don't close the book on us yet!